OCT – – 2004

D0907231

Artist's
Photo Reference
SONGBIRDS &
OTHER FAVORITE BIRDS

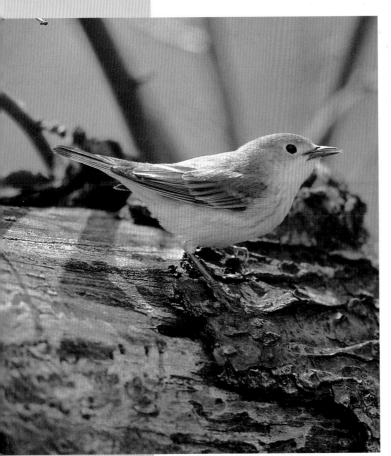

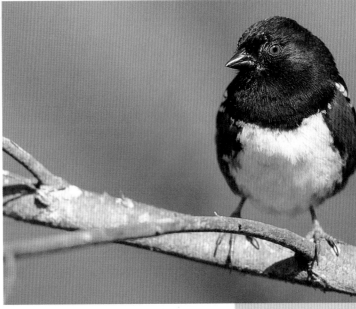

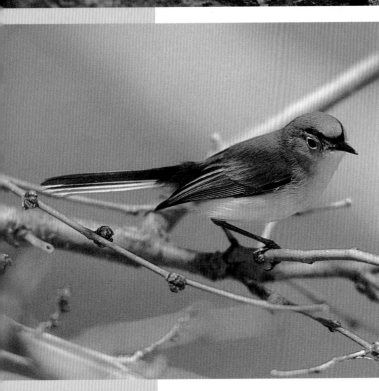

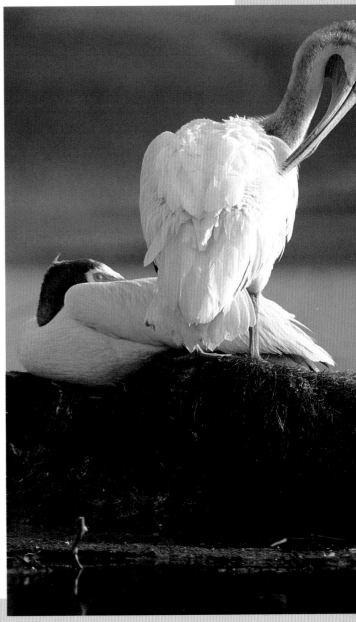

Artist's
Photo Reference
SONGBIRDS &
OTHER FAVORITE BIRDS

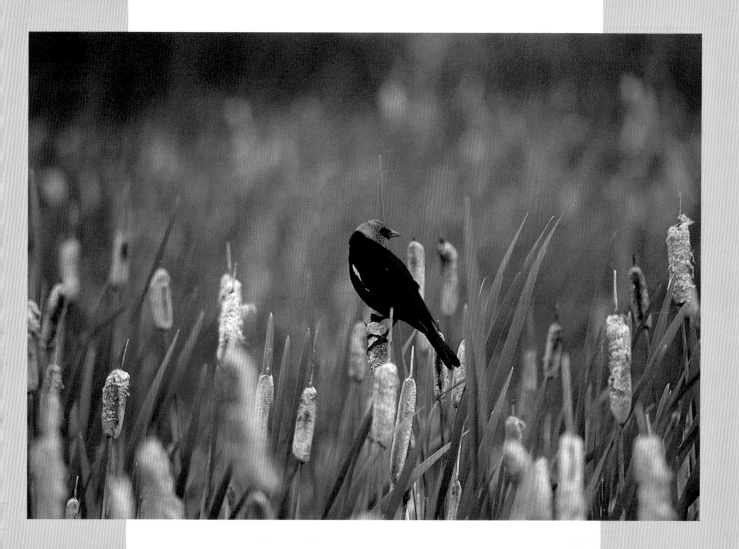

BART RULON

NORTH LIGHT BOOKS
Cincinnati, Ohio
www.artistsnetwork.com

Dedication

To God, for blessing me with just enough talent to make a living out of something I love.

Acknowledgments

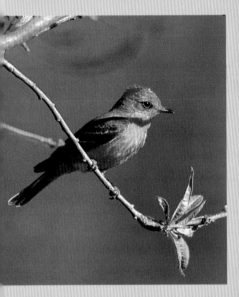

To Angie and Meagan, who were so patient with me even though my career demanded more than its fair share of my time; thanks for loving me, and teaching me so much about life. To Mark Boyle and Sueellen Ross for all the time and effort they put into their beautiful demos. To my mom and dad for putting out the bird feeders in advance of my visits to help bring the birds in. To Barron, who has done so much to help me with my career by designing my Web site, scanning slides for me and being so willing to help me all the time. To Dad for coming along on my trip to Point Pelee, Ontario, and to Kalon for joining me on photo trips to southeastern Arizona and Montana. To Dave Sellers for coming along on the trip to Montana, and for introducing me to Elkhorn Slough. To Ed Schulz for introducing me to all the nesting osprey near Everett. To Tim Williams of The Buckley Hills Nature Sanctuary for letting me set up my blind and rearrange the bird feeders for photography. To Craig Sullivan, who introduced me to a new wetlands that I didn't know about on Whidbey Island. To my development editor, Bethe Ferguson, for trusting me enough to let me turn everything in together on my final deadline instead of piece by piece throughout the year; it made my job much easier. To all the people at the Salato Wildlife Center in Frankfort, Kentucky, who allowed me to rearrange the hummingbird feeders for optimum photography potential.

Library of Congress Cataloging-in-Publication Data
Rulon, Bart.
 Artist's photo reference. Songbirds & other favorite birds / Bart Rulon.
 p. cm.
 Includes index.
 ISBN 1-58180-467-9 (pob: alk. paper)
 1. Birds in art. 2. Painting from photographs. I. Title.

ND1380.R774 2004
758'.3—dc22 2004041488

Edited by Bethe Ferguson, Jennifer Long and Mona Michael
Interior design by Lisa Holstein
Interior production by Lisa Holstein
Production coordinated by Mark Griffin

Metric Conversion Chart

To convert	to	multiply by
Inches	Centimeters	2.54
Centimeters	Inches	0.4
Feet	Centimeters	30.5
Centimeters	Feet	0.03
Yards	Meters	0.9
Meters	Yards	1.1
Sq. Inches	Sq. Centimeters	6.45
Sq. Centimeters	Sq. Inches	0.16
Sq. Feet	Sq. Meters	0.09
Sq. Meters	Sq. Feet	10.8
Sq. Yards	Sq. Meters	0.8
Sq. Meters	Sq. Yards	1.2
Pounds	Kilograms	0.45
Kilograms	Pounds	2.2
Ounces	Grams	28.3
Grams	Ounces	0.035

About the Author

Photo by Angie Longdon

Born in 1968, Bart Rulon lives and works on Whidbey Island in Washington State's Puget Sound. He received a bachelor's degree from the University of Kentucky in a self-made scientific illustration major. He graduated with honors and has been a full-time professional artist ever since, focusing on wildlife and landscape subjects and specializing in birds. His original artwork, prints, photos and books are all available at www.bartrulon.com. Contact him through his Web site to order enlargements of any photo in this book.

Rulon's works have been shown in many of the finest exhibitions, museums and galleries displaying wildlife and landscape art in the United States, Canada, Sweden, Japan and England. His paintings are part of the permanent collection of the Leigh Yawkey Woodson Art Museum and have been featured in fourteen special exhibitions there, including ten times in their prestigious *Birds in Art* exhibit. He is a member of the Society of Animal Artists' and has been included in ten of their annual *Art and the Animal* exhibitions. His paintings have been included in the *Arts for the Parks Top 100* exhibition and national tour seven times, and in 1994 he won their *Bird Art Award*. Other recent awards include the Rocky Mountain Elk Foundation Featured Artist of 2001 and the Audubon Alliance Artist of the Year Award for 1998. Other recent exhibits include the *2003 Western Visions: Miniatures and More Show and Sale* at the National Museum of Wildlife Art and the *Art of the Animal Kingdom* exhibitions in 1999, 2000 and 2001 at the Bennington Center for the Arts. His paintings of birds are also included in the permanent collections of the Bennington Center for the Arts and the Massachusetts Audubon Society. His paintings have been exhibited in over thirty-five different museums, including the National Wildlife Art Museum, The Gilcrease Museum, The Carnegie Museum of Natural History and the National Geographic Society's Explorers Hall.

Rulon is the author and illustrator of *Painting Birds Step by Step* (North Light Books, 1996), *Artist's Photo Reference: Birds* (North Light Books, 1999), *Artist's Photo Reference: Water & Skies* (North Light Books, 2002) and *Artist's Photo Reference: Wildlife* (North Light Books, 2003). His work has been featured in four other North Light Books: *Wildlife Painting Step by Step* (1995), *The Best of Wildlife Art* (1999), *The Keys to Painting Fur & Feathers* (1999) and *Painting the Faces of Wildlife Step by Step* (2000). His work is also included in the book *Wildlife Art* (Rockport Publishers, 1999). Rulon's paintings have been featured on the cover and in the interior of many *Bird Watcher's Digest* issues, and he was commissioned to paint the cover for their special twenty-fifth anniversary issue in 2003. His illustrations of seabirds appear in the field guide *All the Birds of North America* (HarperCollins, 1997), and he was commissioned to paint a variety of birds for *A Guide to the Birds of the West Indies* (Princeton University Press, 1998).

Rulon's primary interest is experiencing animals firsthand in the wild. He prides himself on the time he spends in the field researching wildlife, because this is what he enjoys most about being an artist. His travels have taken him to new places every year, including long trips to Alaska, India, Africa and South America, and he has traveled extensively all over the contiguous United States and Canada.

Table of Contents

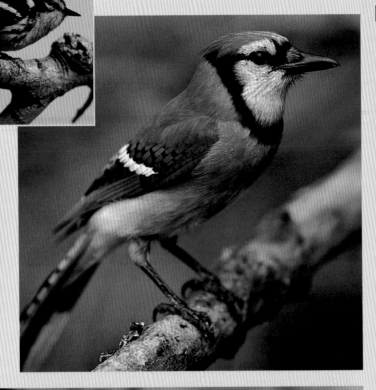

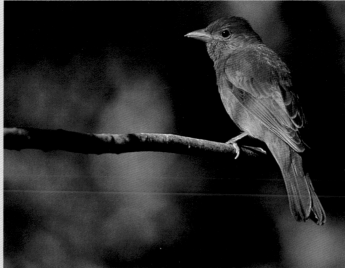

STEP-BY-STEP DEMONSTRATION

PART TWO

Other Favorite Birds

STEP-BY-STEP DEMONSTRATION

STEP-BY-STEP DEMONSTRATION

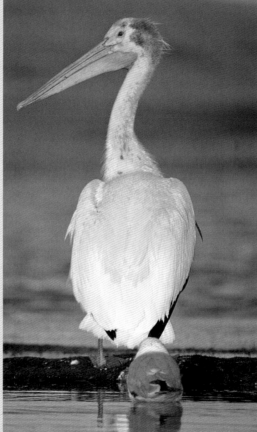

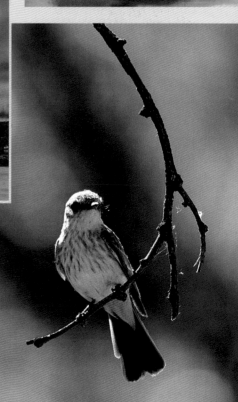

How To Use This Book

Artist's Photo Reference: Songbirds & Other Favorite Birds is in response to requests from readers who wanted to see more songbirds than were covered in my first photo reference book, *Artist's Photo Reference: Birds*. Putting together a book focusing on songbirds also gave me a chance to cover many other popular birds that I didn't have room for in the first book. Together, the two photo reference books cover many of America's most popular bird species.

Use the reference photos in this book to enhance your artwork. Take the pose of a bird from here and put it in your own landscape, or use one of these photos as supplemental reference for the details of feathers, legs or eyes. In order to do this you must always keep in mind that the colors in any scene constantly

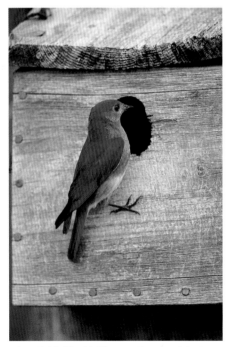

I found this bluebird house on a tree right next to a country road. Using my car as a blind was the perfect solution for photographing the bluebirds as they came and went from the nest.

change during the day due to different lighting situations. Try to match the situation in your painting with the situation in the reference photographs. For example, if your habitat reference depicts lighting on a cloudy day, use a reference photograph of your subject on a cloudy day rather than on a sunny day. Keep in mind when trying to match reference photos from different locations that colors in the landscape are often reflected on a bird and affect its appearance. For instance, a bird perched in a rhododendron next to a red flower might have red reflected on its feathers, but that same bird perched near green leaves in a tree would more likely have a glow of green on its belly.

Try not to copy the photographs in this book exactly, especially if you exhibit your work publicly or sell your work. (It is not a copyright infringement to copy a reference photograph if the artwork is not put up for sale, exhibited publicly or claimed to be original art.) Instead, take parts of the photographs to enhance your work. Add things, take things out and use the photographs to help build your own vision.

A Note on Flash Photography

Many of the songbird pictures that appear in books and magazines are taken with artificial flash. In fact, professional wildlife photographers use flash to photograph songbirds more than any other wildlife subject. Flash photographs are not as useful for artists because they show artificial lighting on the birds that is not true to life. Be careful about the songbird photographs you see in books and magazines. Many a painter has inaccurately painted two highlights in the eye of a bird not knowing that the second highlight came from a flash bulb. For maximum accuracy in my paintings, I never use flash in my photography. All of the photographs in this book were taken with natural lighting only.

A Note on Male and Female Birds

As you peruse this book, you will notice that male and female birds are sometimes labeled and sometimes not. It happens the same way in nature. Some male and female birds wear quite different markings and colors, while some are virtually identical. I have labeled only those with notable differences.

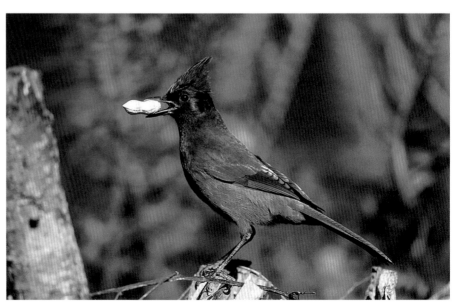

I keep Steller's Jays coming to my feeder with peanuts so they are always around whenever I need a photo.

I recommend that all artists try to take their own reference photos as much as possible, because it allows you 100 percent freedom to use them as you like. Taking your own photos of birds is a great way to gather reference material and, with songbirds, sometimes it can be as easy as pointing your camera out the window of your house or car.

The most challenging part about photographing songbirds is that they are so little and tend to move around faster than larger birds. The challenge is getting close enough for a good picture, then, once you are close enough, getting them to sit still. The easy part about photographing songbirds is that many of them can be lured into your backyard with bird feeders.

Camera

An SLR 35mm camera system is a must for bird photography. If you don't want to miss any action, you should make sure your camera has an automatic motor drive and autofocus. Songbirds often flit from branch to branch so quickly that autofocus can make a huge difference between getting the photograph you want or not.

Not all autofocus systems are the same though. The old saying "you get what you pay for" holds true. Some cheaper autofocus cameras and lenses can be so slow that it would almost be better to stick with manual focus. On the other hand, the autofocus cameras and lenses that are made for serious amateur and professional photographers can be amazingly fast. Always test a camera out before you buy it.

Many camera brands will work well, but, if you are starting from scratch, I recommend Nikon or Canon. These two companies offer high-quality lenses and cameras, large selections and a full line of important accessories. If you become very serious about your photography, these things will be very important to you.

Lenses

Large focal length lenses are best for small bird photography in the range of 400mm to 800mm. In addition, having a 1.4x or 2x teleconverter can add length to your lens when you need it. As a rule I usually try to use my 400mm lens to photograph birds, but there are many situations where I have to add the 1.4 or 2x teleconverter to bring in a small bird. When the 400mm lens is combined with the 1.4x teleconverter it makes a 560mm lens, and with the 2x teleconverter it makes an 800mm lens. It's almost like I have three different lenses in my arsenal at one-third the cost. However, there is a trade-off. Teleconverters reduce the light coming into the camera, resulting in slower shutter speeds. They usually slow down the autofocusing accuracy, and they also reduce the image sharpness. For these reasons I try to avoid using teleconverters whenever possible, but sometimes you have no choice. Starting with top-quality equipment, combining a high-quality lens and a high-quality teleconverter helps to keep photos sharp.

Tripod

For maximum stability when using a camera with a long telephoto lens, you should use a tripod. I never go without some kind of support under my camera to keep my images as sharp as possible.

Most bird photographers use either a ball head or a Wimberly head on top of their tripods. The Wimberly head was designed specifically for a big, heavy camera and lens. If your lens isn't that heavy, the ball head would be a more economical choice.

Choose a tripod that will bring the camera to your eye level by extending the legs, without having to extend the center column of the tripod. This will give you maximum stability and speed in setting up your tripod in any situation,

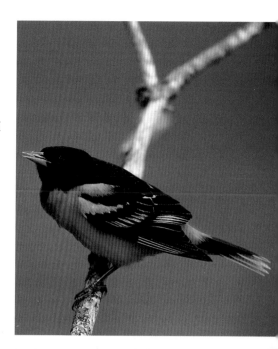

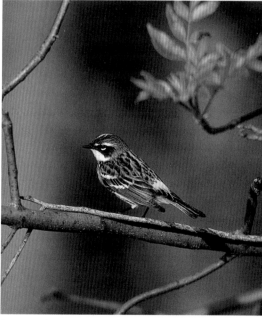

A 400mm lens would be adequate for a northern oriole (top), which can be lured in close using an orange placed nearby. You will probably have to add a 1.4x or 2x teleconverter for very small birds like this yellow-rumped warbler (bottom) that can't be lured in with bird feeders.

Photo by Sarah Scott

Tripod

Choose a tripod that comes to eye level or higher without having to raise the center column. Your camera will be more stable, you will be more comfortable taking photographs, and the tripod will be quicker to set up because of it.

since extending the center column reduces stability and takes extra time. Also, it's good to have a tripod that will let you get as close to ground level as possible, in case you need to get down low to set up a shot.

If you don't like using a tripod, try using a monopod for at least some assistance in camera stabilization.

Image Stabilization

Currently, a few camera companies have come out with image stabilization technology for their lenses. Canon was first to introduce it, and Nikon followed with their own version, called vibration reduction. By the time this book is printed other manufacturers will probably have similar technology. The vibration reducers are built into certain lenses to reduce camera shake. This allows you to hand hold a camera with sharp results, using slower shutter speeds than ever before. The general rule is that you can shoot at shutter speeds two aperture stops slower than with conventional lenses. So, for example, the long-held rule of thumb with a regular lens is that you can only hand hold a 300mm lens successfully at shutter speeds over 300th of a second. With image stabilization you can hand hold a 300mm lens at 125th of a second shutter speed. I have a couple of these image stabilization lenses and they work very well. They are particularly useful when shooting from a car or boat, or when using a monopod. This technology is great news for those who refuse to use a tripod.

Film

I prefer to use slide film because it is more accurate and detailed than print film. With print film you are partially at the mercy of the film developer as to how the color and contrast turn out in your pictures. With slide film you have more control over how the picture turns out.

Slow speed films are sharper than higher speed films. If you use a tripod you can use films with slow ISO ratings of 50, 64 or 100. If you hand hold, you might have to use 200 or 400 speed film, resulting in less detailed pictures. I prefer 50–100 ISO speed films, with 100 speed being my favorite.

Choosing the right film can be very difficult. You can photograph the same scene with a number of different films and get vastly different color results. Some will be closer to reality than others. Today, many films are intentionally made to have supersaturated colors that are not accurate, but attractive. Also, some films render certain colors better than others. To find out more about how accurate or supersaturated a film is, look for information from the manufacturers at professional camera stores or call the film company. Several popular

Photo by Sarah Scott

Bean Bags

The stabilization tool of choice for me when I'm photographing from a car is a bean bag. This is a bag in the shape of a small bed pillow filled with beans or something similar. I fill mine with buckwheat hulls because of their light weight compared to beans. To use a bean bag, lay it over the windowsill of your car door or on the roof and nestle your camera and lens into the bag for stability. I used to use a window mount, but I found that bean bags are just as, if not more, stable and they are quicker to set up and move around.

I photographed many of the water birds in the second part of this book from a floating blind. Here my friend Kalon Baughan demonstrates how well it can work on avocets and swans.

photography magazines do annual film comparisons that list film characteristics.

Where to Photograph

Now that you have your equipment, it's time for the fun part. Many songbirds can be lured to your backyard for close-up photography using a variety of bird feeders or bird baths. You'll want to place your feeders or bird bath in a spot with good lighting and natural vegetation nearby that is within shooting distance of your camera.

Most people set up feeders so they can be seen from their house windows; therefore the easiest strategy is to photograph from the window. When doing so, it's best not to have the window glass between your camera and the birds because it will decrease the quality of your photographs. Even if your windows are clean, the image will often turn out cloudy and blurry. Be sure to use a window that can be opened when you want to photograph. In most cases you will still need to conceal yourself from the birds with some type of camouflage. It helps that most of your body will be hidden inside the house, but you will probably have to use something to hide your head and arms. The easiest solution is to fill the window with a block of fabric or a piece of cardboard, then cut a hole for the lens and a peep-

hole so you can keep an eye on the birds. This way the birds don't see you while you're clicking away.

In order to make your photographs most useful for paintings, you want to photograph the birds on natural objects instead of on the bird feeder itself. I always place my feeder near some natural vegetation or set up props, like an interesting branch or log, for the birds to land on. Songbirds often like to land on a prominent perch close to the feeder to take a look before they fly in to eat. This is the perfect opportunity to make a photo that looks natural enough for a painting. Once you have your props set up, point your camera at the exact spot where the birds prefer to perch as they approach the feeder.

There are a lot of songbirds that you can't lure into a bird feeder or bird bath, so you'll have to go out and find them elsewhere. Watch birds from a distance with binoculars to see if they have favorite perches or even a nest nearby where you could set up a blind for some close-up photos. Always be cautious that your presence doesn't cause the birds to abandon their nests or alter their normal behavior. As with other wildlife species, birds are most active in early morning and late afternoon, with early morning being the very best. These times also happen to coincide with the best lighting for photography.

Bird Feeders
Place bird feeders near vegetation that you want the birds to land on for your pictures. Here I was trying to photograph a variety of birds landing on my mom's roses as they approached the feeders. Notice that I have several different feeders out to attract a variety of different birds.

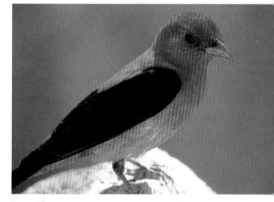

Location
Sometimes location means everything. For years I tried to photograph the neon red color of male scarlet tanagers in my old home state, Kentucky, without any luck. However, at the famous migration hot-spot, Point Pelee National Park in Ontario, I had this beauty practically landing at my feet without a worry of my presence.

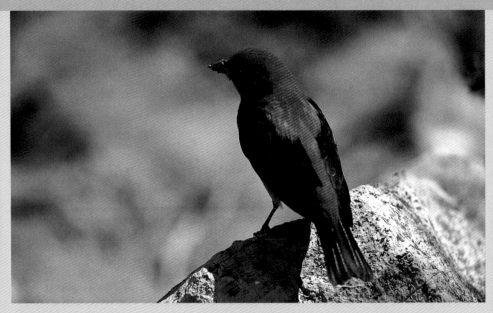

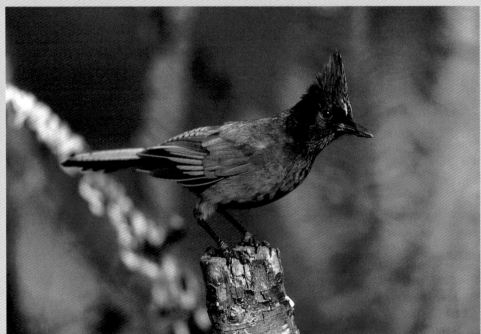

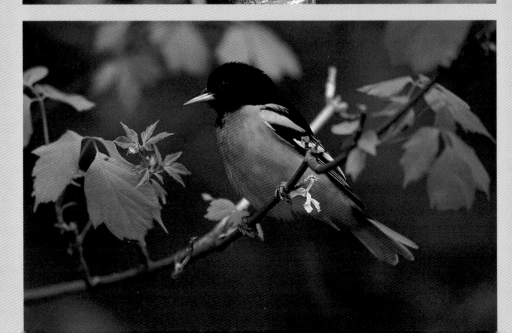

PART ONE

Songbirds

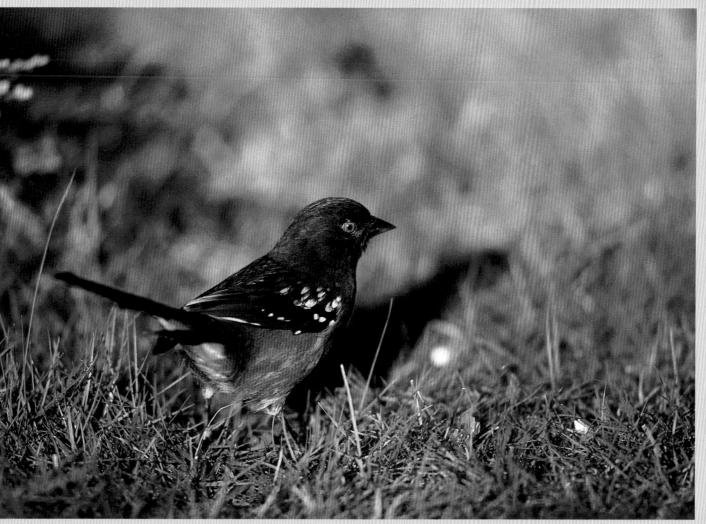

The word songbird usually refers to the small perching birds, also called passerines, that you see at your bird feeder or flying from tree to tree out in the woods. Passerines make up the largest order of birds in the world and come in a rich variety of colors, shapes and sizes.

American Goldfinch

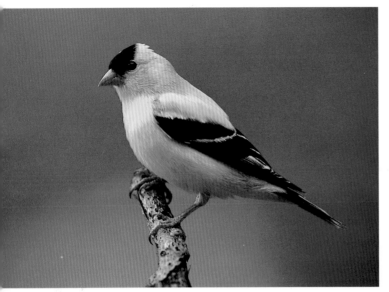

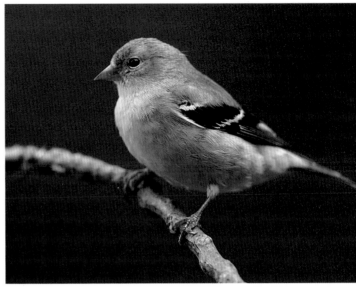

Male

Female

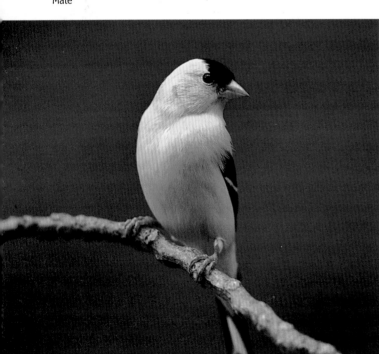

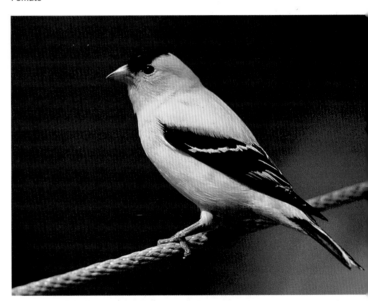

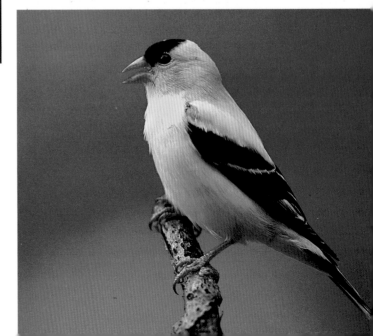

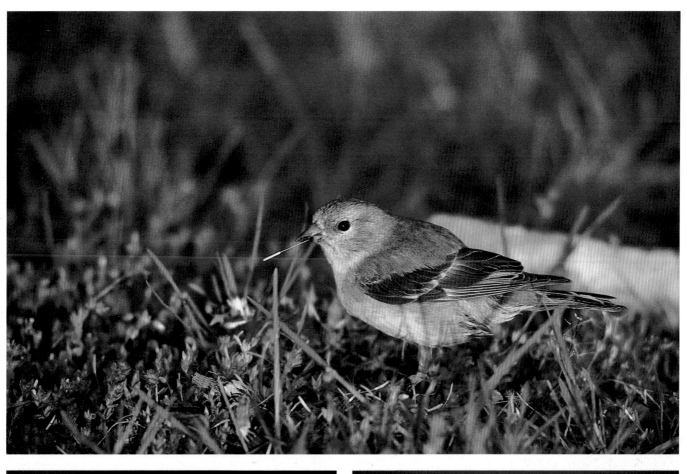

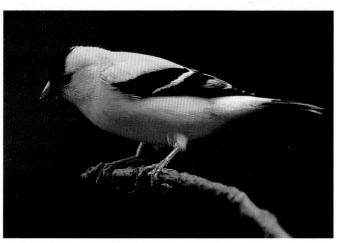

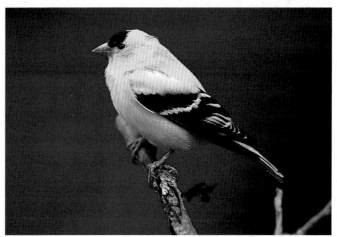

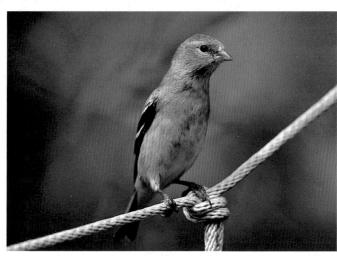

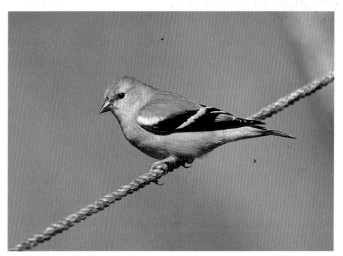

by Sueellen Ross

American Goldfinch in Mixed Media

Materials

Surface

Arches 140-lb. (300gsm) hot-pressed
watercolor paper, 24" x 16"
(61cm x 41 cm)

Palette

Winsor & Newton Watercolors —
Aureolin, Burnt Sienna, Cadmium
Yellow, Charcoal Grey, Indanthrene Blue,
New Gamboge, Quinacridone Gold, Raw
Umber, Rose Dore', Sepia

Liquitex Medium Viscosity Acrylic —
Neutral Gray Value 5

Prismacolor Colored Pencils — Black,
Burnt Ochre, Goldenrod, Light Blue,
Sepia, White

Brushes

Ink — round nos. 0 and 5

Watercolor — round nos. 0, 5 and 10

Other

Magic Rub eraser

Black drawing pen

FW Acrylic Artist's Black India ink

HB graphite pencil

S ueellen has developed a unique technique of combining ink, watercolor, acrylic and colored pencil that produces consistently beautiful results. Her signature technique has very distinct steps that are easy to follow. The photos she used as her main references for the goldfinch in this painting were taken by a friend of hers at a backyard bird feeder. She also used a goldfinch that hit a window in her neighborhood as a color and feather reference. Magazine photos from her clip files helped her fill in the rest of the details. Sueellen always keeps several bird field guides close at hand to double-check on colors that might not be true in the pictures.

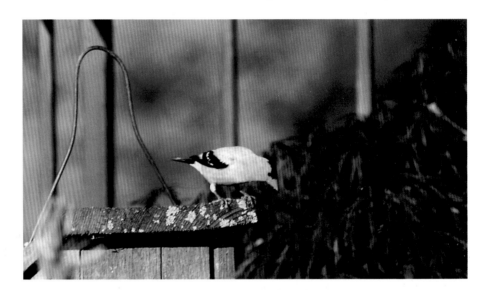

Reference photos

1. Drawing Step: Complete Drawing, Add Ink

Do a detailed and complete pencil drawing of the bird and the branch. Start with an overall outline sketch, then refine each area showing its exact structure and where the light and shadows will fall.

Place a small dot of waterproof India ink somewhere in each of the very darkest areas. This will serve as a reference as you fill in the darks. Now go back and outline each dark area with a pen. Fill in the outlines with a heavier pen or a small brush. Do not overuse the ink. It is only used for the very darkest areas.

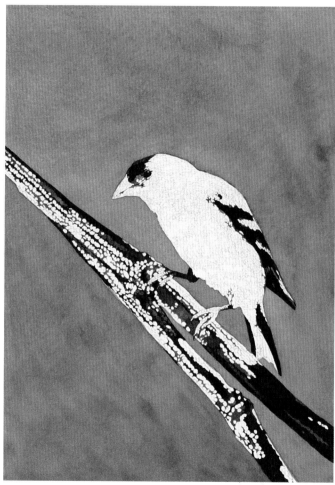

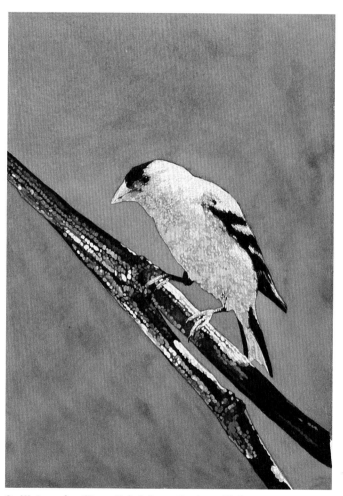

2. Watercolor Step: Do Background Wash, Start Grisaille

Paint a pale wash of Quinacridone Gold in the sky area. When dry, glaze Indanthrene Blue over the first color. (Don't worry if the wash isn't perfect; you can fix it later with colored pencil.)

Grisaille is a monochromatic underpainting, usually done in shades of gray, to be layered over with glazes. Start filling in tonal values on the bird and branch, going from dark to light. Build your painting one color at a time, getting lighter and lighter as you go. For the bird, paint three stages using Charcoal Grey watercolor. Begin with your darkest value and add water to create each following lighter shade. Paint the branch in the same manner using Sepia watercolor.

3. Watercolor Step: Paint From Dark to Light

Continue grisaille on the bird using a paler gray made with Neutral Gray acrylic. Paint three stages of color. Again, paint the darkest value. Then add water to create a lighter shade, and so on.

Paint two lighter values of Sepia watercolor on the branch.

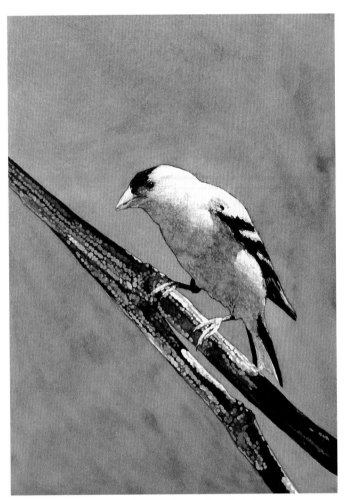

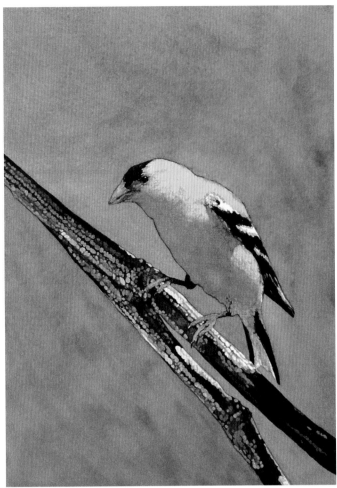

4. Watercolor Step: Adjust Values, Finish Color and Erase

Darken the shadows on the bird using Charcoal Gray watercolor.

Finish the watercolor stage on the branch, leaving the white paper as your lightest value. Use New Gamboge watercolor mixed with Burnt Sienna for your lightest, brightest values.

Now erase all traces of graphite pencil using a Magic Rub eraser.

5. Watercolor Step: Final Color

Carefully glaze yellow over your grisaille on the bird. Do not lift the undercoats by scrubbing or overworking. Use Aureolin on the lighter areas and Cadmium Yellow on the bottom. Avoid the white areas on the wings and under the tail.

For the bird's bill and feet, mix Rose Doré and Raw Umber watercolors and glaze the mixture over the grisaille.

On the branch, add a final pale, warm mixture of New Gamboge and Burnt Sienna.

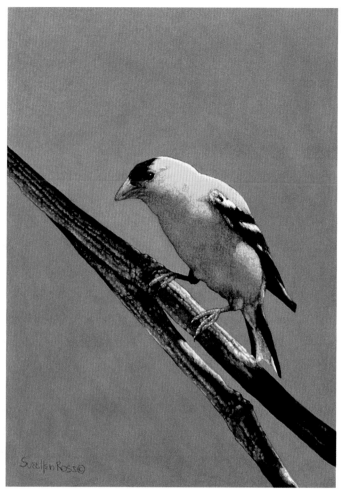

6. Colored Pencil Step: Add Lights, Brights and Details With Pencil, Fix Background Wash

Edge the top and back of the bird with White Prismacolor pencil. Use only along the edge; don't cover the bright yellow. Put white highlights on the bill and feet only where they are hit by light. Shade the bill and feet with Burnt Ochre pencil, and glaze lightly with Goldenrod pencil to warm the color. Darken and detail the shadowy areas around the bill, feet and eyes with Sepia pencil. Blend the shadow edges between the light and dark yellow on the bird with Goldenrod pencil. Warm the dark yellow shadows by glazing lightly with Burnt Ochre pencil. Clean and sharpen the inked areas with Black pencil when you are finished with the bird.

Blend and soften the darkest brown edges of the branch into the ink with a Sepia pencil. Blend and soften lighter areas with Burnt Ochre pencil. Glaze the branch with Goldenrod pencil to blend and warm the wood colors. With a Black pencil, sharpen the shadows around the bird's feet.

If your background sky wash needs evening up (and this one does), go over it with Light Blue pencil.

Finished Painting

Sueellen used the same sequence of steps to incorporate an interesting habitat for the goldfinch.

VINEYARD VISITOR
Sueellen Ross
Mixed media on watercolor paper
24" x 16" (61cm x 41cm)

Barn Swallow

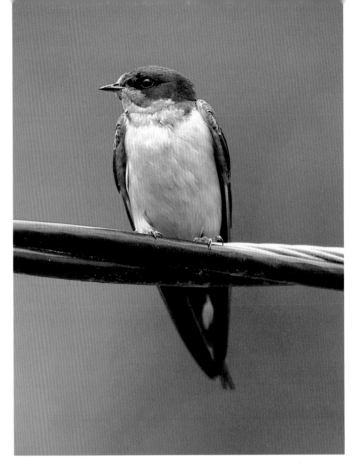

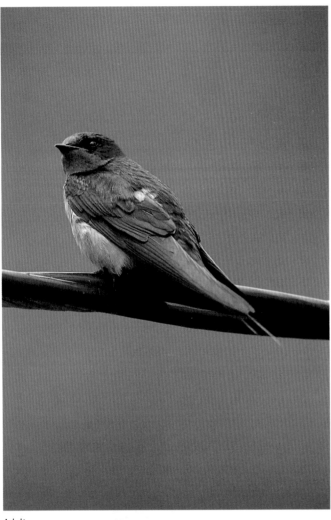

Adult

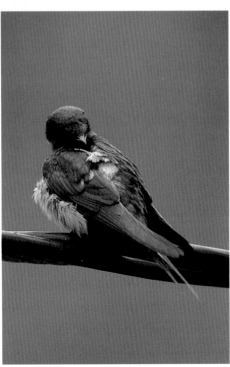

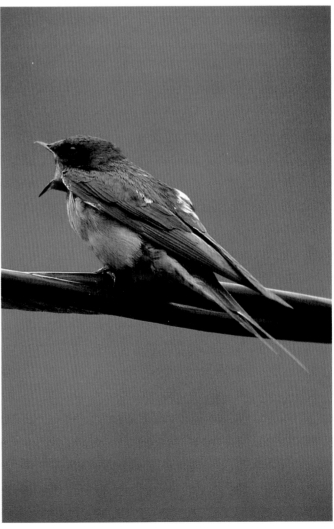

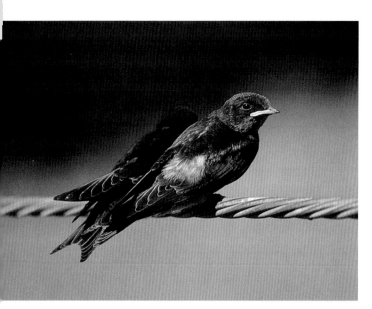

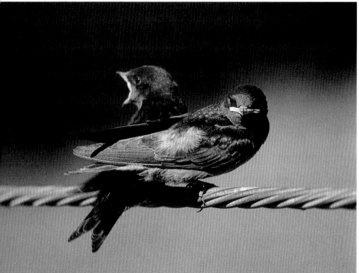

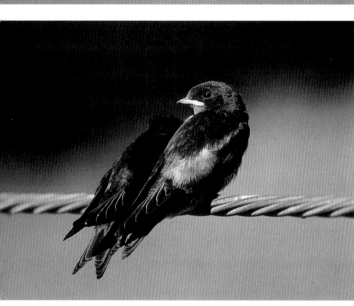

Young

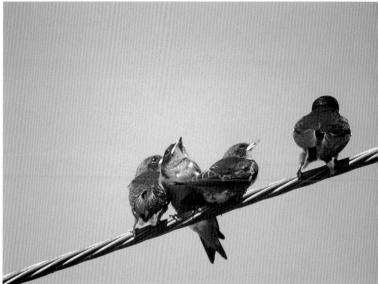

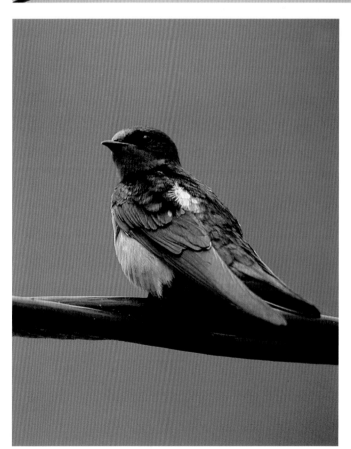

Blackburnian Warbler

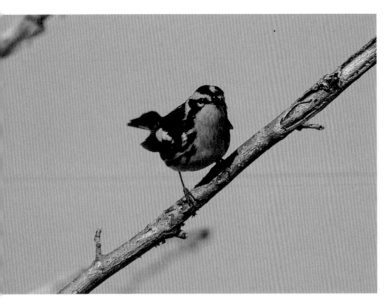

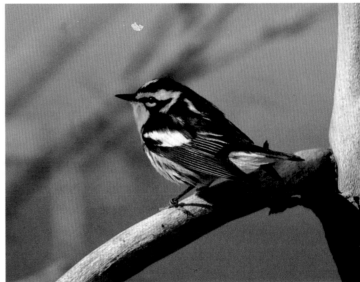

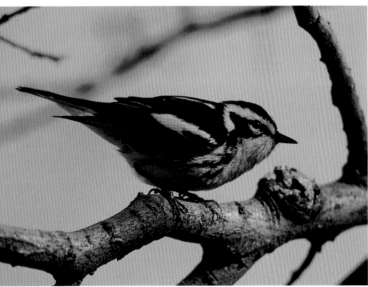

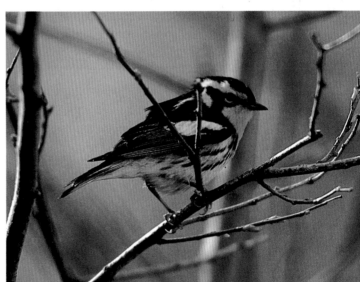

Male

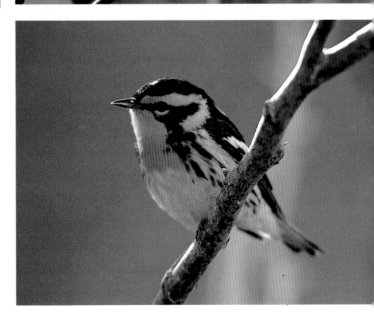

Black-Capped Chickadee

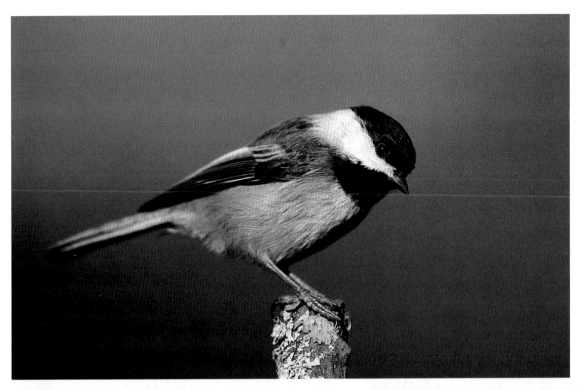

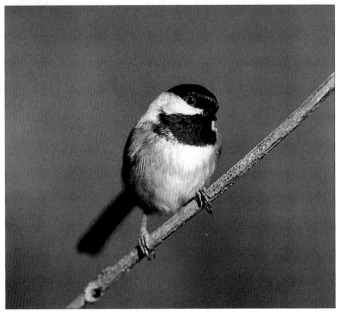

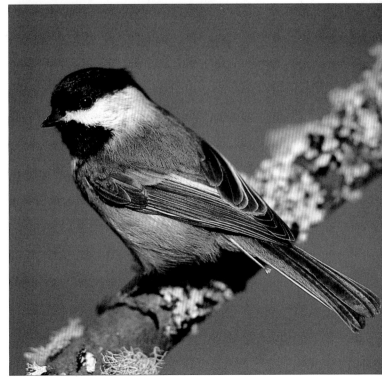

Black-Capped Chickadee

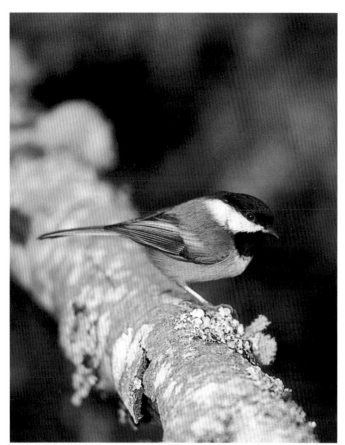

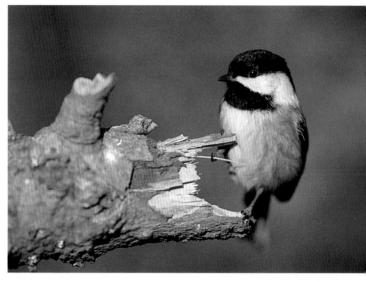

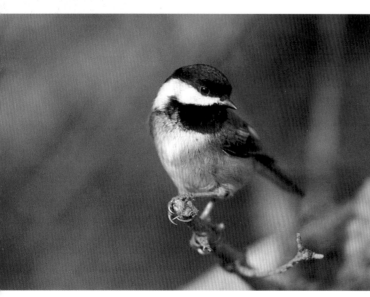

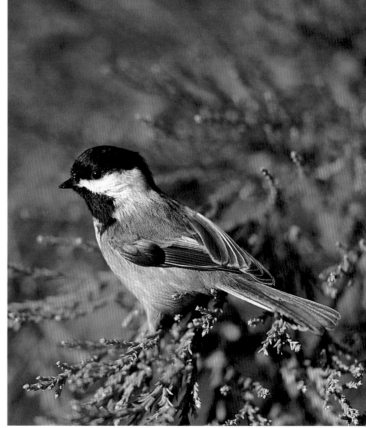

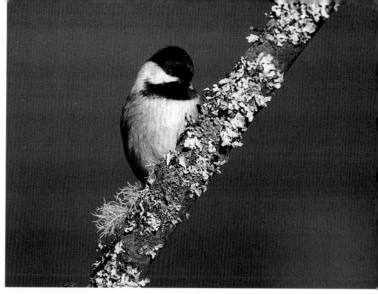

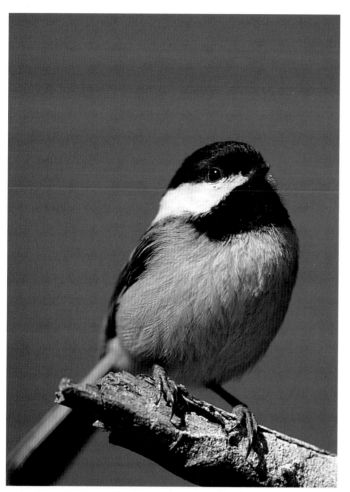

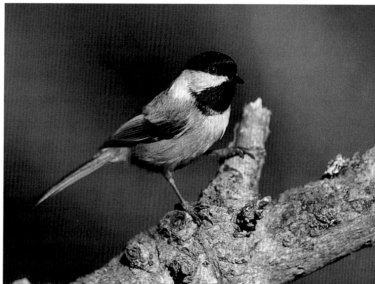

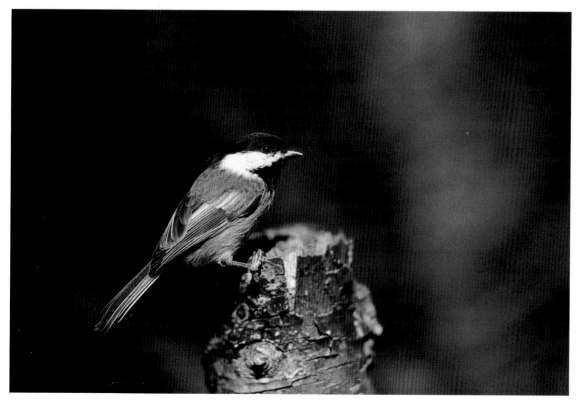

Black-Headed Grosbeak

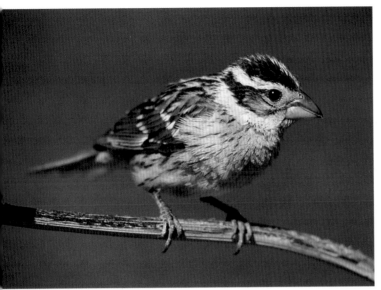

Female

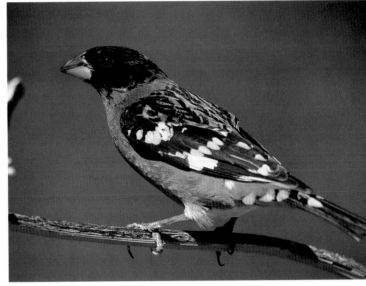

Male

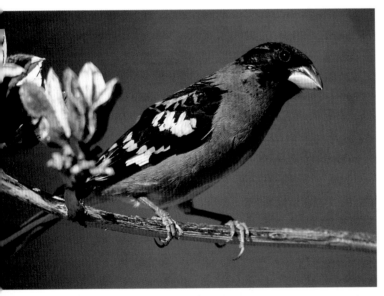

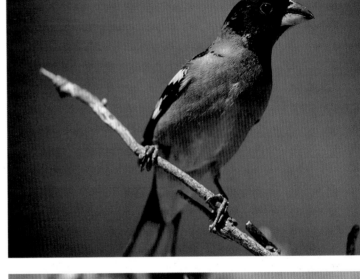

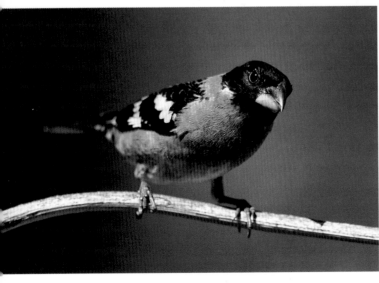

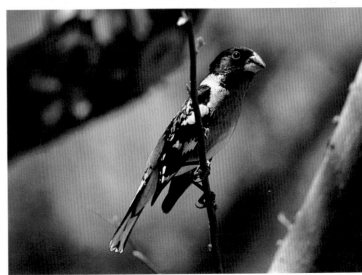

Black-Throated Green Warbler

Female

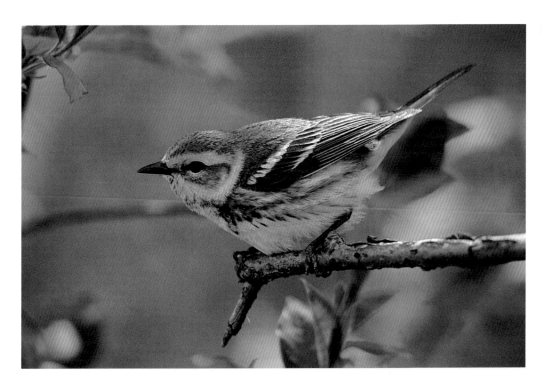

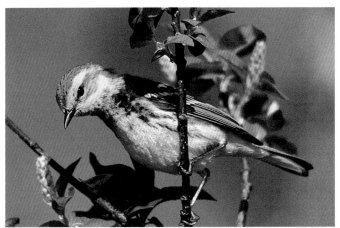

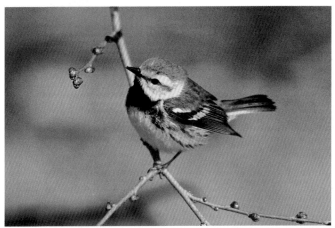

Male

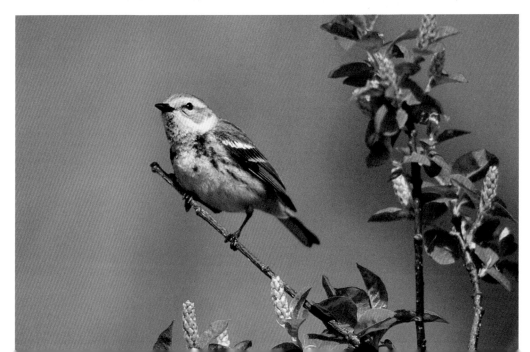

Blue-Gray Gnatcatcher

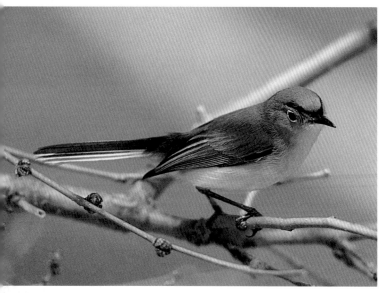

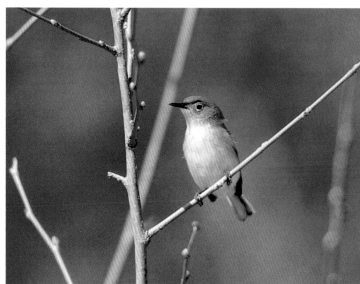

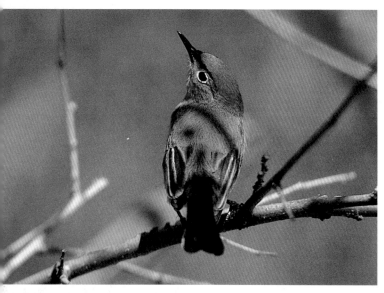

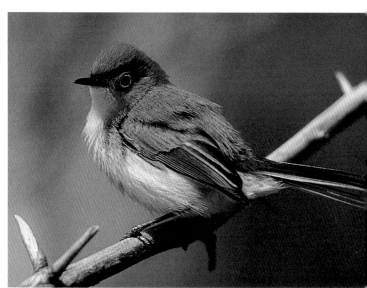

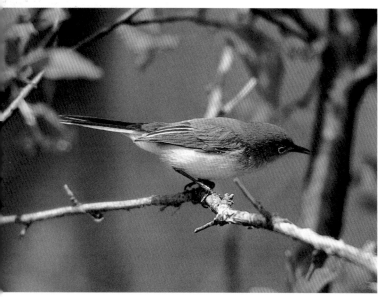

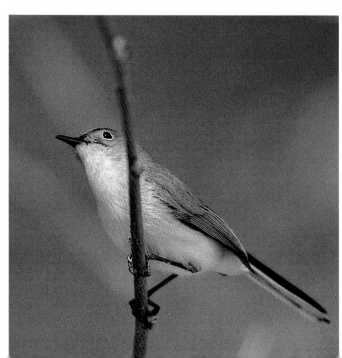

Blue Jay

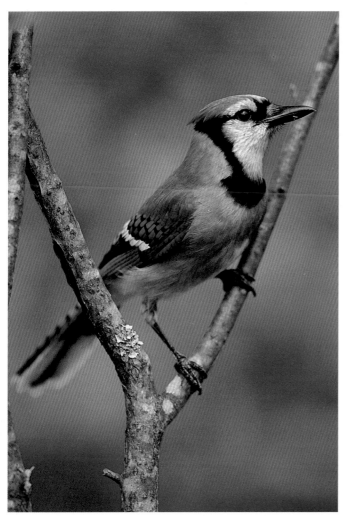

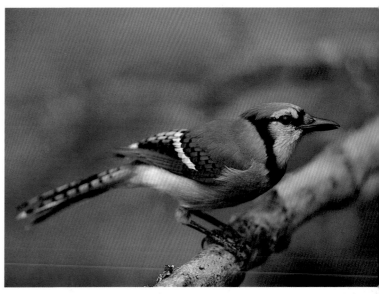

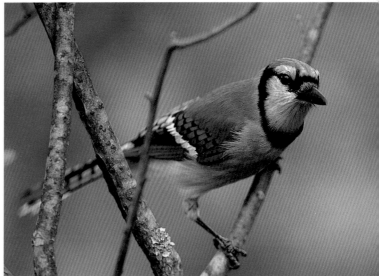

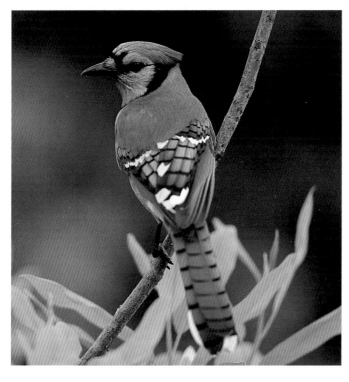

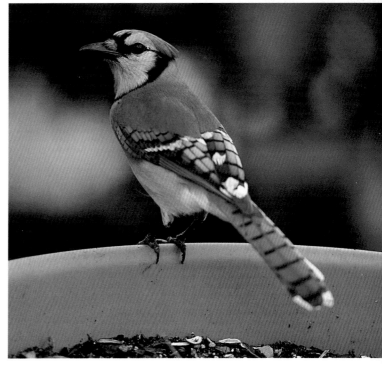

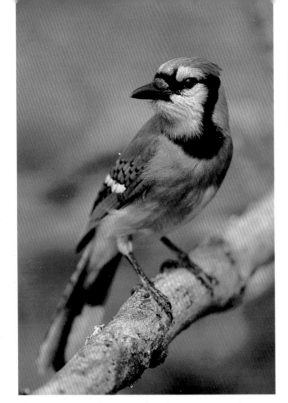

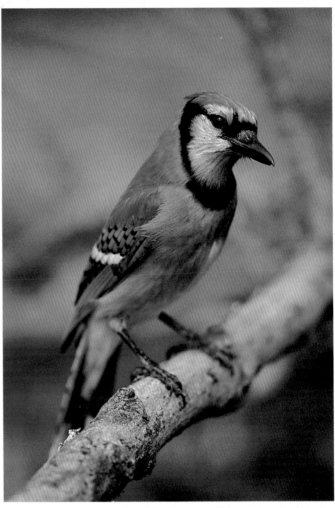

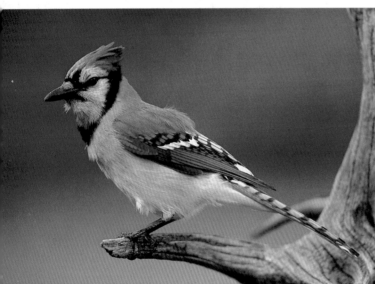

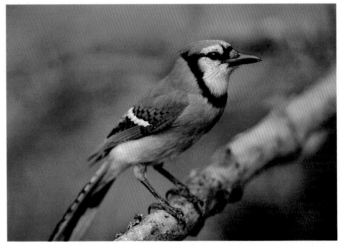

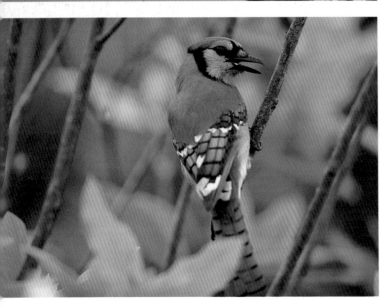

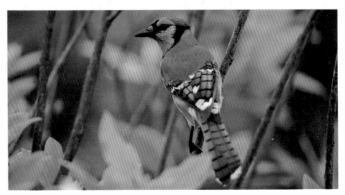

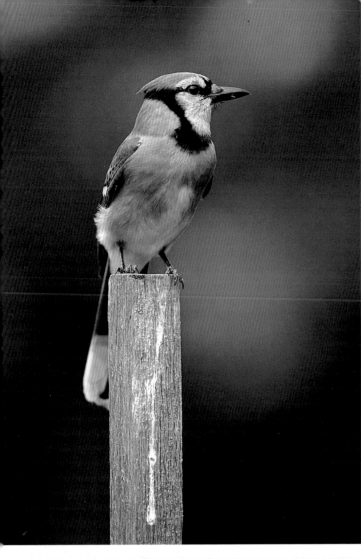

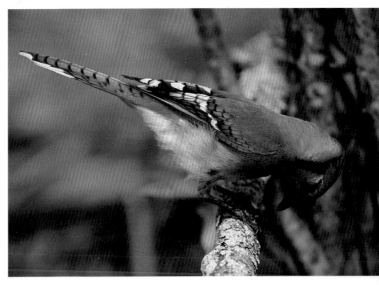

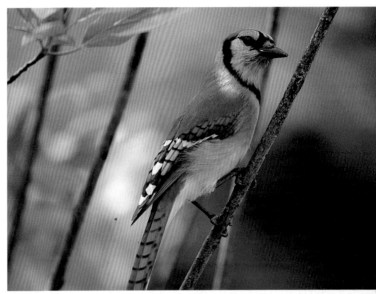

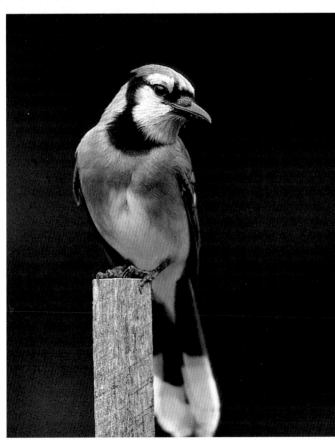

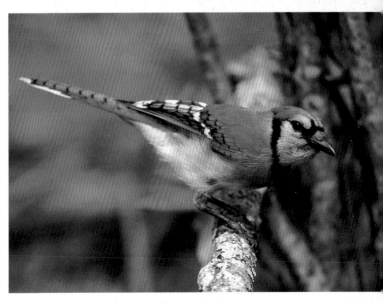

Bullock's Oriole

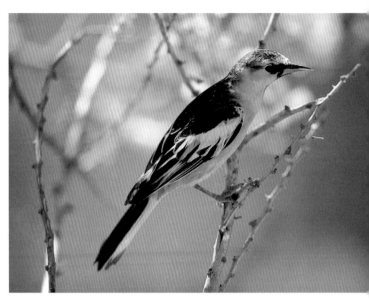

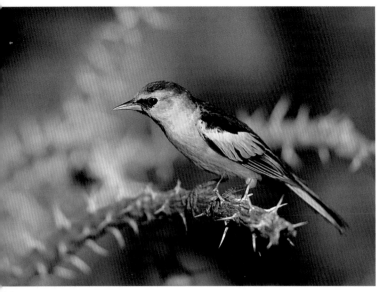

Male

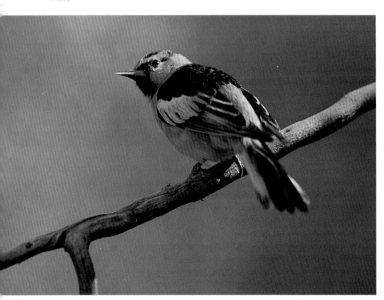

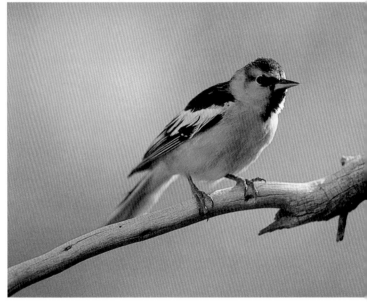

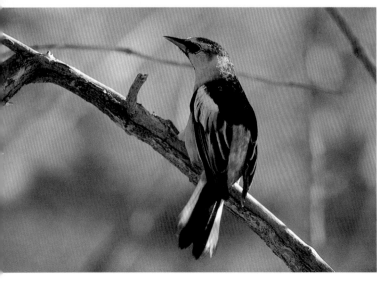

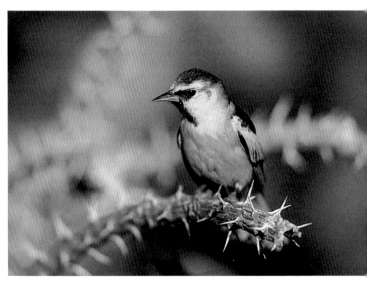

Cactus Wren

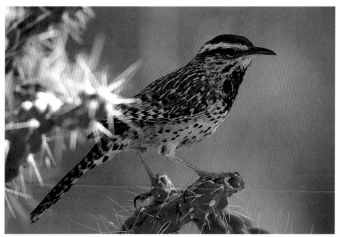

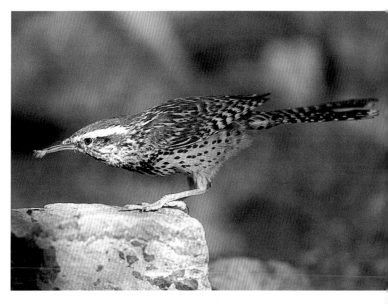

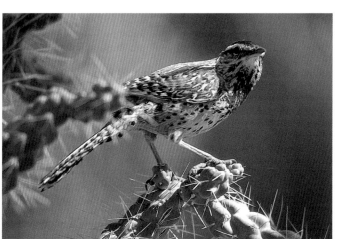

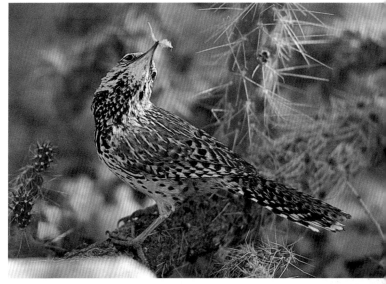

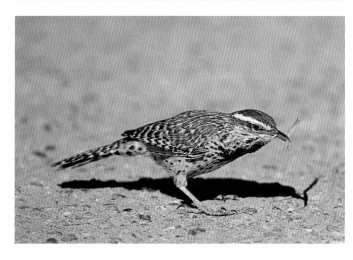

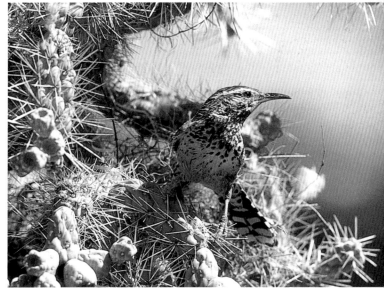

Cardinal

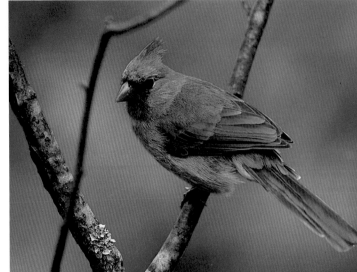

Male

Female

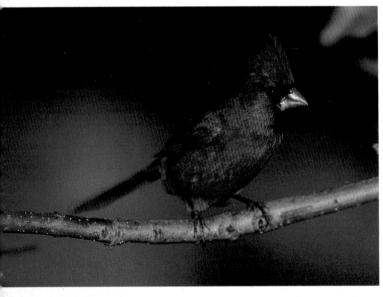

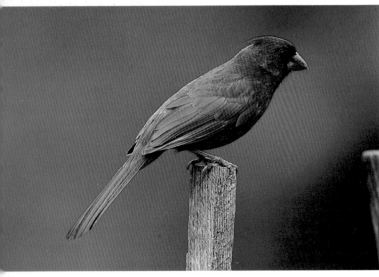

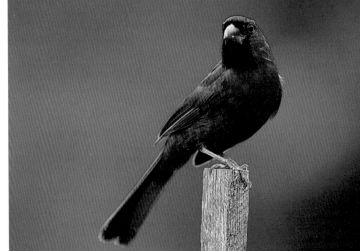

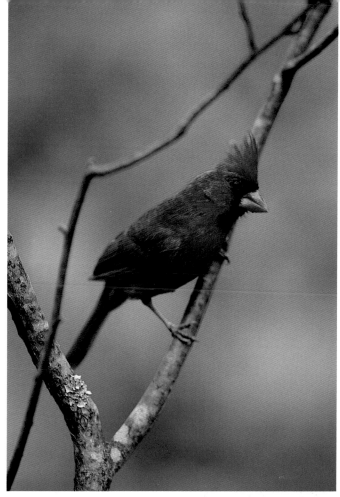

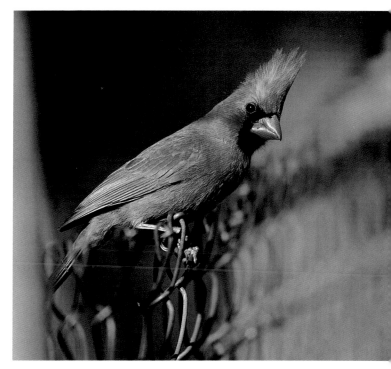

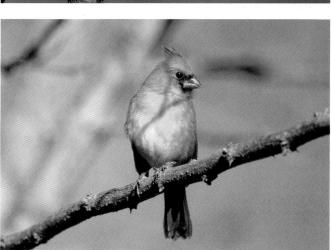

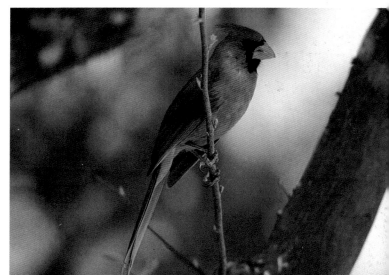

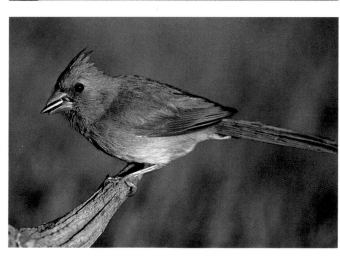

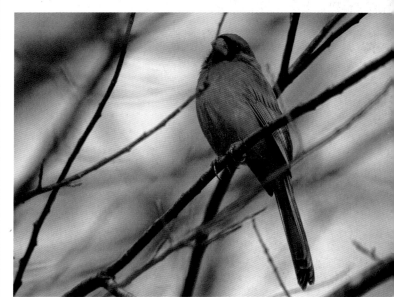

Cardinals in Water-Soluble Oil

Materials

Surface

12" x 9" (30cm x 23cm) hardboard panel primed with gesso

Palette

Max Grumbacher Oils — Burnt Sienna, Cadmium-Barium Red Light, Cadmium-Barium Yellow Light, Ivory Black, Permanent Blue, Raw Sienna, Raw Umber, Thio Violet, Titanium White

Brushes

Grumbacher Renoir 626-R — no. 10 filbert sable, nos. 4 and 7 round sables

Winsor & Newton Monarch — nos. 0 and 00 rounds

Medium

Water mixed with each painting mixture

Other

Plastic wrap

This painting demonstrates how to combine birds from two different photos to make one cohesive painting of a cardinal pair. This demo is a good example of learning what to leave in and what to take out of your photos. I photographed both the male and female cardinals from my photo blind near a bird feeder in central Kentucky. Both birds were photographed on the same day. I positioned my photo blind directly under the feeder so that the birds would approach it with caution and land in the trees nearby for a natural background.

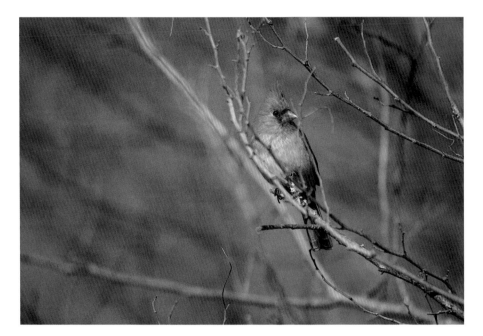

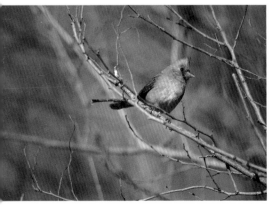

Additional reference for the branches

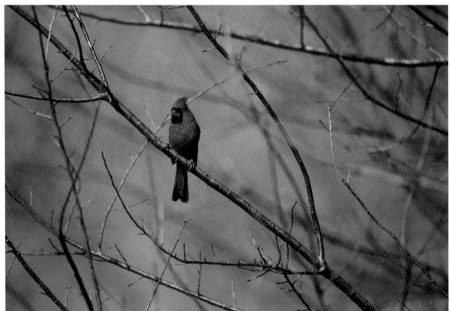

Reference photos for the birds and branches

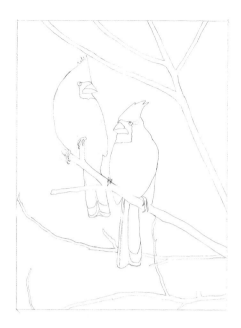

Idea Sketches and the Drawing

Draw simple outlines of the birds and place them in a variety of positions to come up with the best composition.

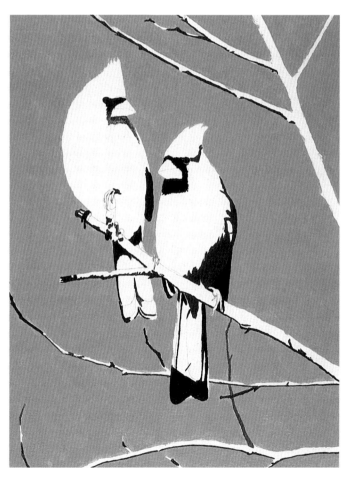

1. Block In Colors

In order to keep the focus on the birds in this painting, take out the busy background shown in the photos and replace it with clear blue sky. Keep the main branches shown in the foreground on the photo of the female. Block in the sky with a mix of Permanent Blue, Titanium White and Thio Violet using the no. 10 filbert. Use the no. 4 round for the rest of this step. Paint the undersides of the branches using various mixtures of brown consisting of Raw Umber, Permanent Blue, Burnt Sienna, Ivory Black and Titanium White.

For the shadows on the undersides of the cardinals' tails mix Raw Umber, Burnt Sienna, Thio Violet, Cadmium-Barium Red Light and Ivory Black. Add more Cadmium-Barium Red Light to this tail mix for the red on the male's lower belly. Mix Ivory Black, Raw Umber, Permanent Blue and a touch of Titanium White for the black bib around the male's beak. Add more Raw Umber and Titanium White to the mix for the female's bib. Block in the eyes on both birds with a mix of Burnt Sienna, Raw Umber and Ivory Black.

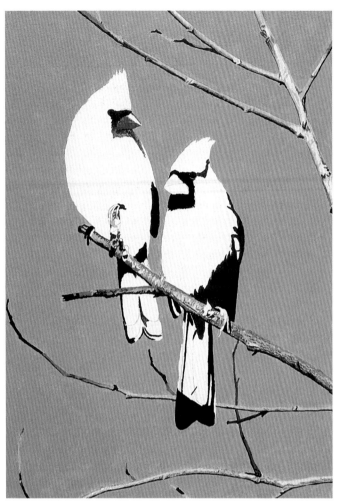

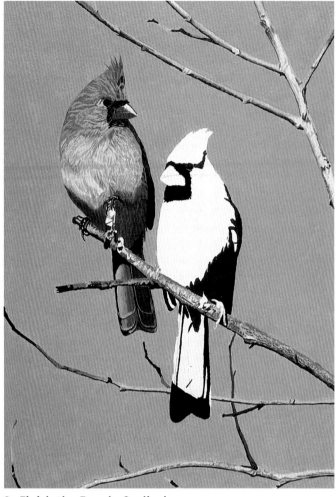

2. Paint and Blend the Branches

Create seven different mixtures of paint for the branches, ranging from the lightest lights to the darkest darks. The mixtures should contain various amounts of Raw Sienna, Thio Violet, Permanent Blue, Burnt Sienna, Raw Umber, Ivory Black and Titanium White. Use the no. 4 round to paint the colors on the branches wet-into-wet, blending colors where needed. Start with the dark colors on the branches and blend lighter colors on top of them. Underpaint the female's beak with a mix of Cadmium-Barium Red Light and a touch of Cadmium-Barium Yellow Light.

3. Finish the Female Cardinal

Use the no. 7 round to block in the color on the head and neck of the female cardinal with a mix of Raw Sienna, Raw Umber, Permanent Blue and Titanium White. Make a darker mixture for the lower belly by adding less Raw Sienna and less Titanium White to the previous mix. Paint the dark feather details on the bib around her beak with a mix of Ivory Black, Raw Umber and Titanium White, using the no. 00 round. Use the no. 00 round and a mix of Ivory Black, Raw Umber and Permanent Blue to paint the dark pupil and the outside edges of the eye. Mix Cadmium-Barium Yellow Light, Raw Sienna and Titanium White for the base color on the chest. Blend to a lighter mix, with Raw Umber added, for the middle belly. On top of this base you will paint darker and lighter colors wet-into-wet with the no. 00. Pay close attention to the feather directions shown in the photo and concentrate on the patterns caused by the feathers. Continue working on the tail with a mix of Cadmium-Barium Red Light, Thio Violet, Burnt Sienna, Raw Umber and Ivory Black for a base color. Then, add more Titanium White and Cadmium-Barium Red for the lighter areas, mixing wet-into-wet.

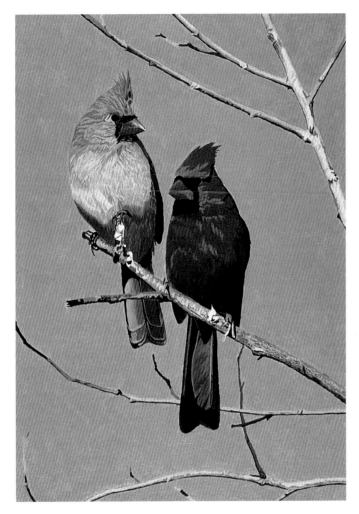

4. Finish the Male Cardinal

Start by painting the underside of the beak with a mixture of Cadmium-Barium Red Light, Thio Violet, Burnt Sienna and Ivory Black. Use a mix of Cadmium-Barium Red Light, Cadmium-Barium Yellow Light, Thio Violet and Titanium White for the lighter parts of the beak. On the beak, use enough water mixed in with the paint so you can paint thinly enough for the white gesso to show through and brighten the colors.

For the red plumage of the male, create seven different mixtures of red ranging from the darkest red in the body to the lightest highlights. The mixtures should have different combinations of Cadmium-Barium Red Light, Thio Violet, Cadmium-Barium Yellow Light and Titanium White, plus Burnt Sienna and Ivory Black added for the darkest mixtures. Paint a base coat of the medium red color (see the palette photo below) and let this coat dry partially overnight. Put plastic wrap over your palette to keep your colors from drying out. The next day the undercoat should still be a little wet, but thickened, and you can paint the lighter and darker colors wet-into-wet on top of it with the no. 00. Pay close attention to the direction of the feathers indicated in the photo here. Paint the dark pupil and edges of the eye with a mix of Ivory Black and Raw Umber using the no. 00 round brush. Start the tail with a dark mixture of Cadmium-Barium Red Light, Thio Violet, Burnt Sienna and Ivory Black, then work from dark to light, wet-into-wet, adding more Titanium White to the mixture for lighter areas. Use the no. 4, no. 0 and no. 00 rounds for the tail.

Base coat color

Color mixtures for the male cardinal

5. Refine the Details and Redo the Sky

Brighten up the highlights on the eyes of both cardinals with another dab of Titanium White using the no. 00 round. Add more details to the head of the female using the no. 00 round and a light mix of Cadmium-Barium Yellow Light, Raw Sienna and Titanium White. Finish the edges of both birds' bibs with the no. 00 round, emphasizing the fine lines of feathers sticking out from the edges of the bibs.

Reevaluate the branches and add details where needed to make them look realistic. The sky needs more punch to make this painting work. Mix Permanent Blue, Titanium White and a touch of Cadmium-Barium Yellow Light to make the sky bluer. Use the small round brushes near the edges of the birds and the branches, being careful not to mess up what you've already completed. In open areas, use the no. 10 filbert.

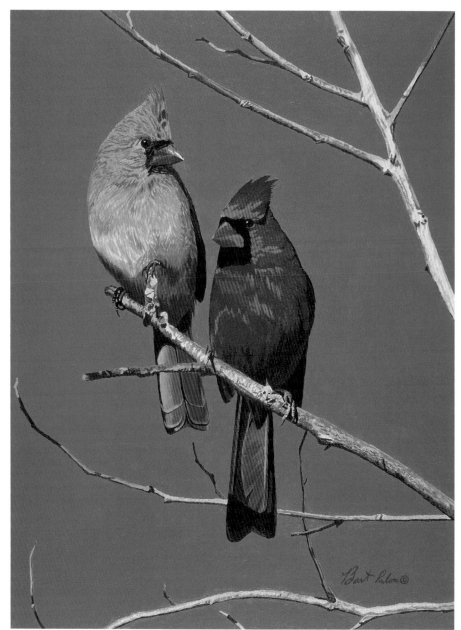

WINTER CARDINALS
Bart Rulon
oil on hardboard panel
12" x 9" (30cm x 23cm)
Private collection

Catbird

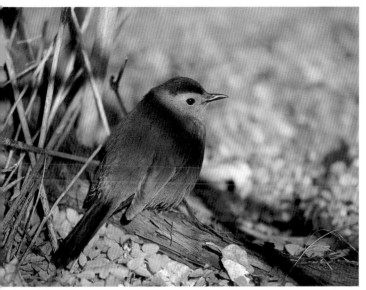

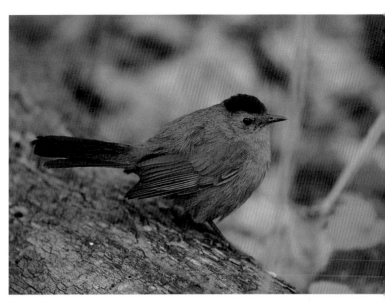

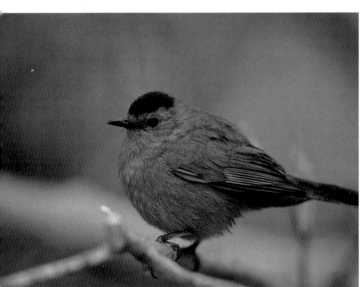

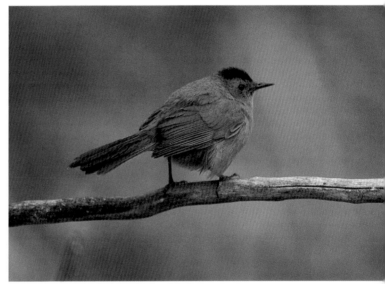

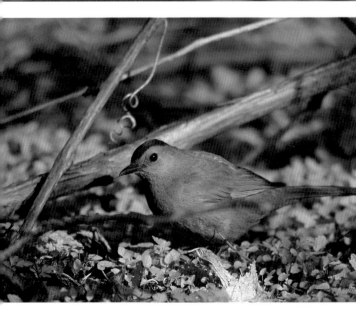

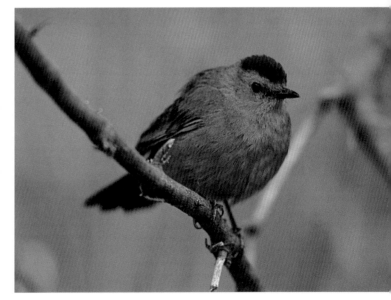

Chestnut-Backed Chickadee

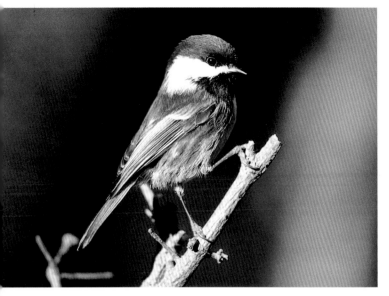

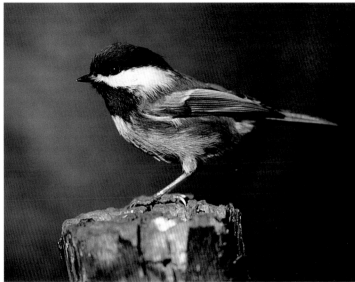

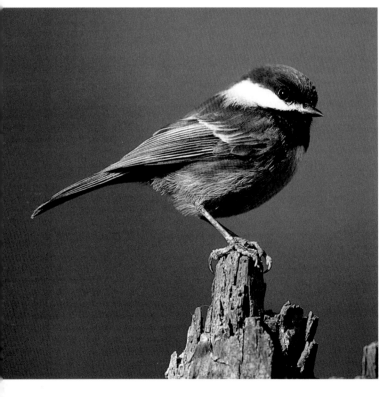

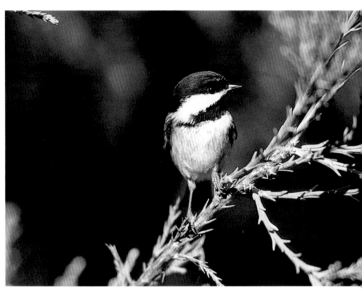

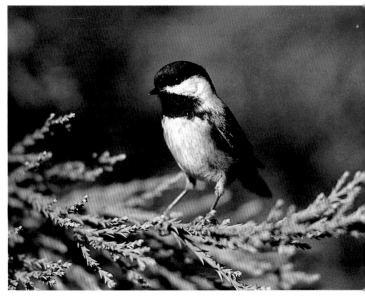

Chestnut-Sided Warbler

Male

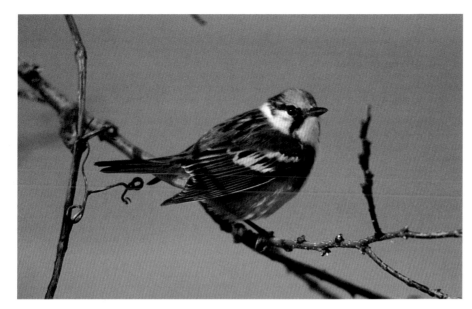

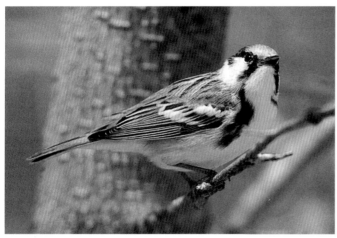

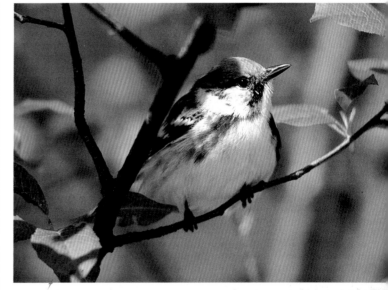

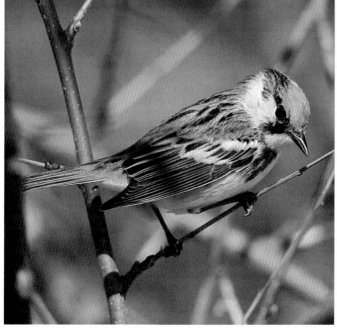

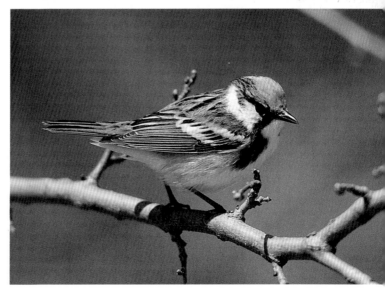

Common Grackle

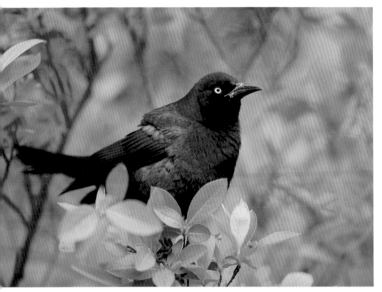

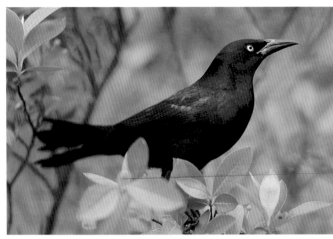

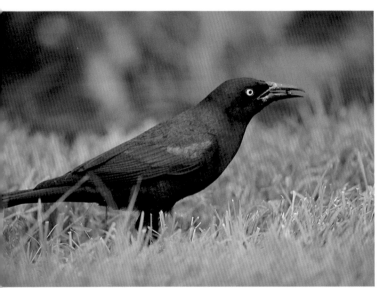

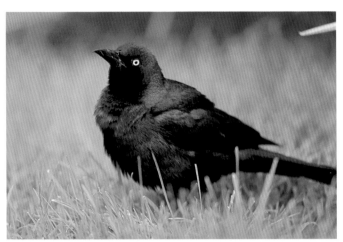

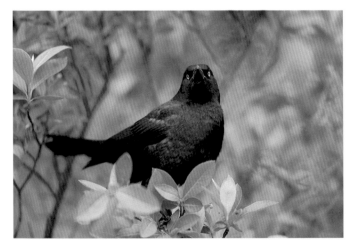

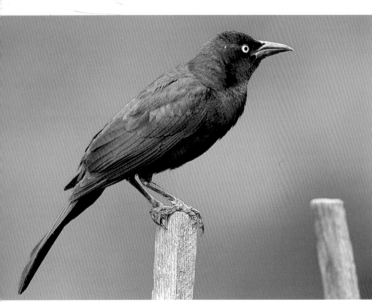

Dark-Eyed Junco

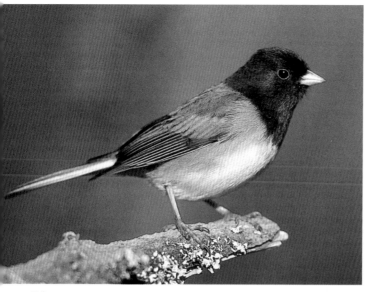

Male

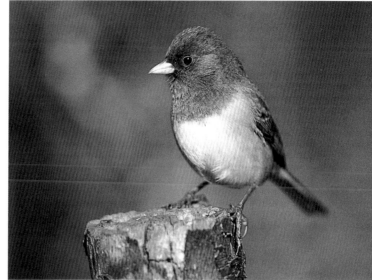

Female

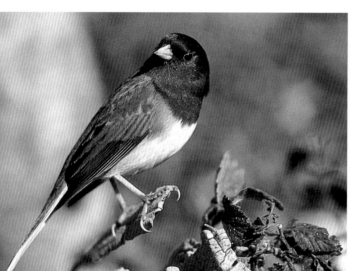

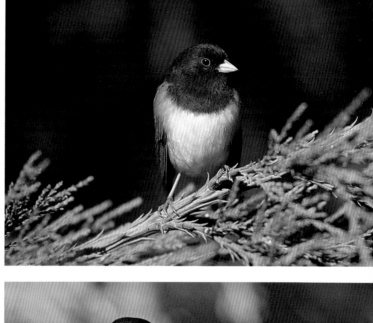

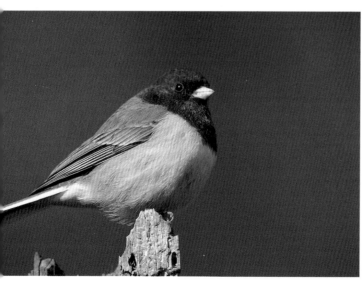

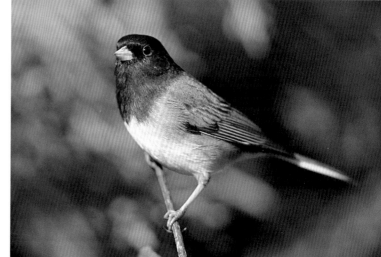

Eastern Bluebird

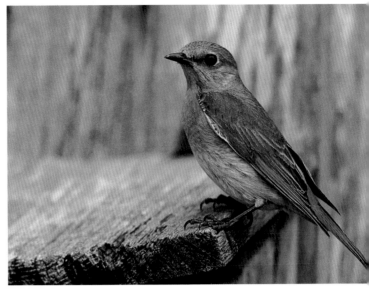

Female

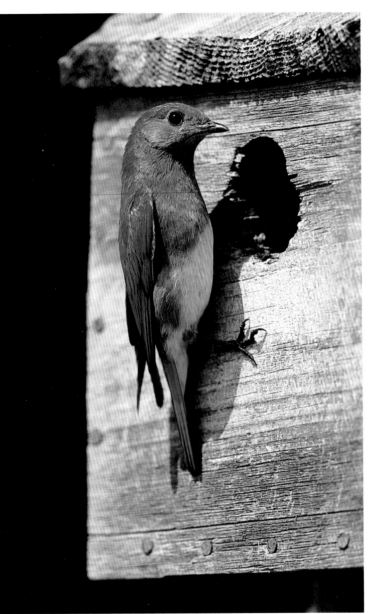

Male

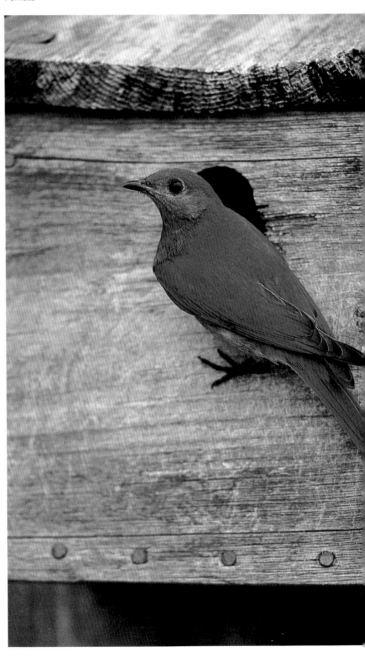

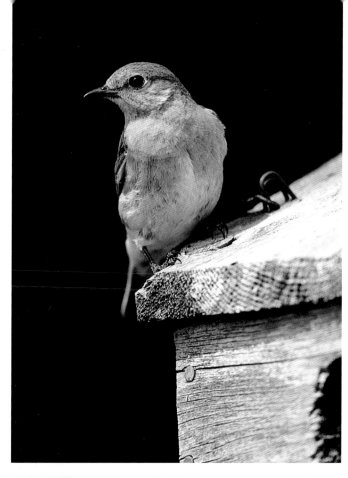

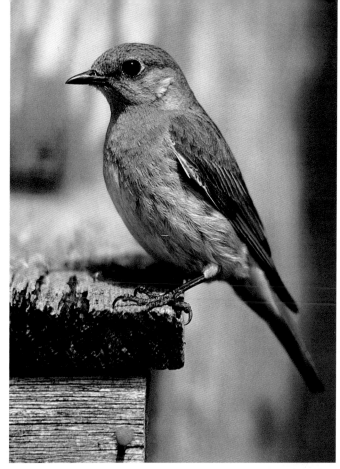

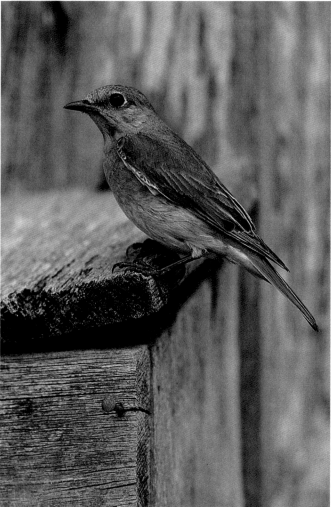

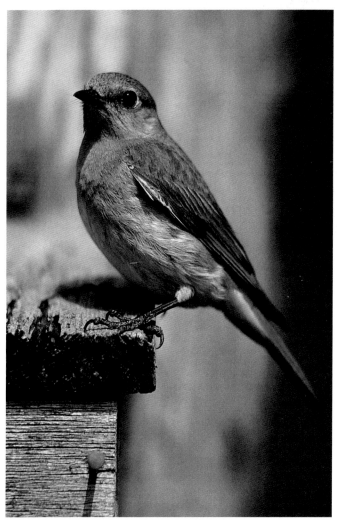

Eastern Bluebird

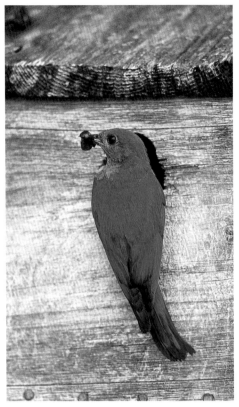

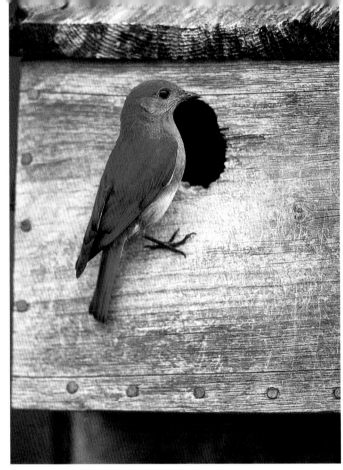

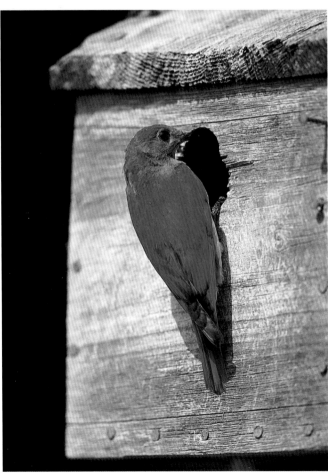

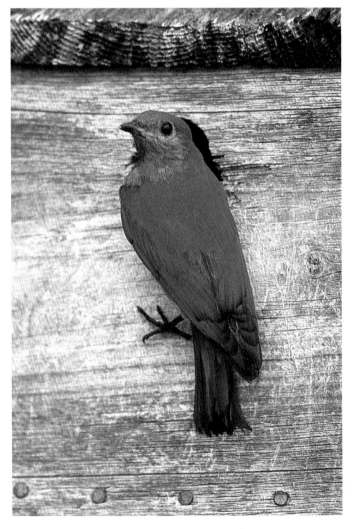

Fox Sparrow

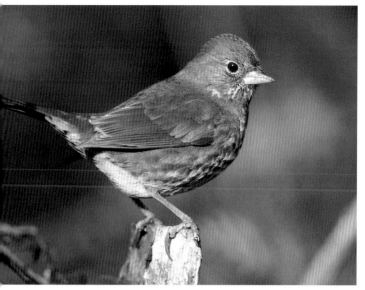

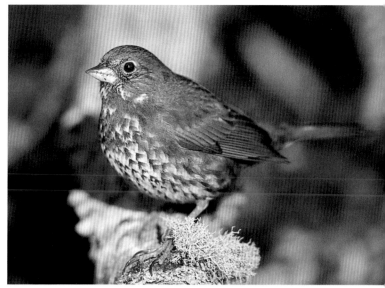

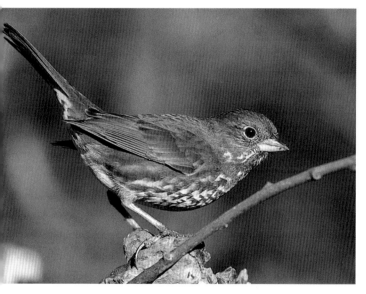

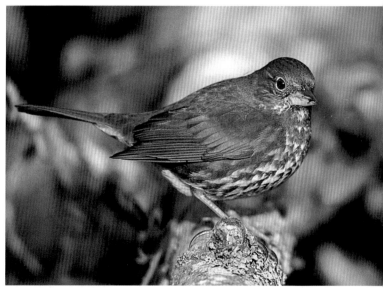

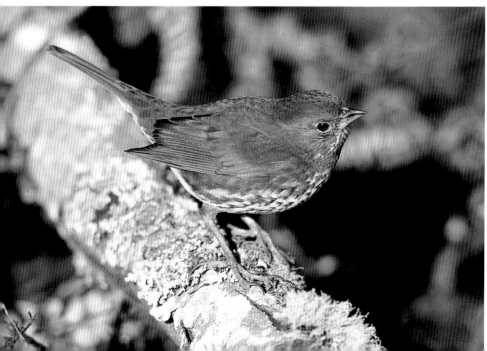

Hermit Thrush

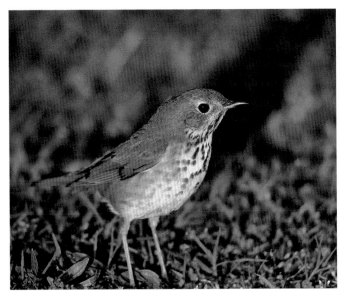

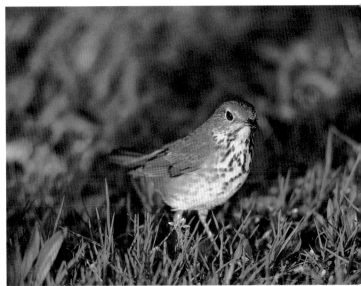

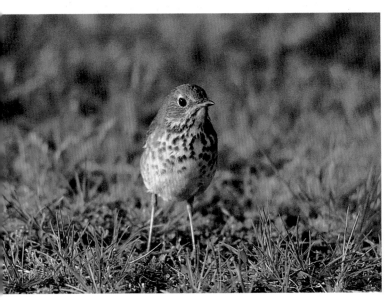

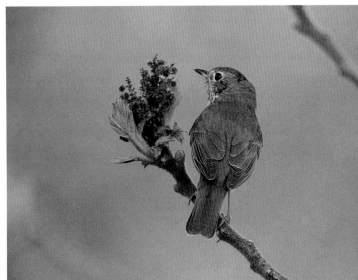

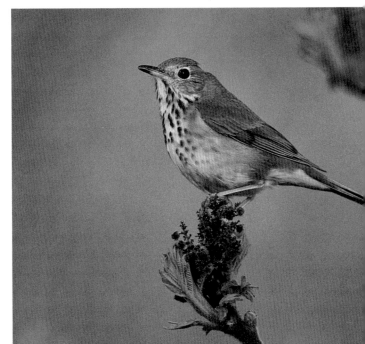

Hooded Oriole

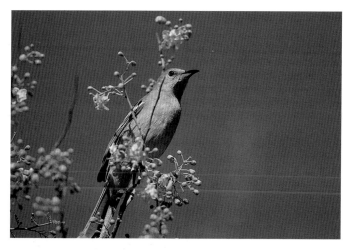

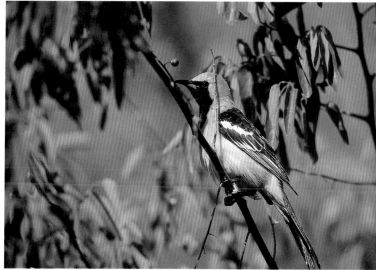

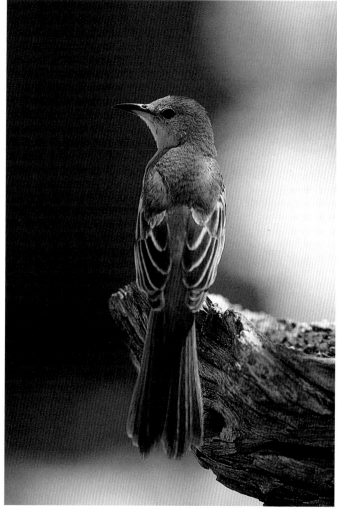

Female

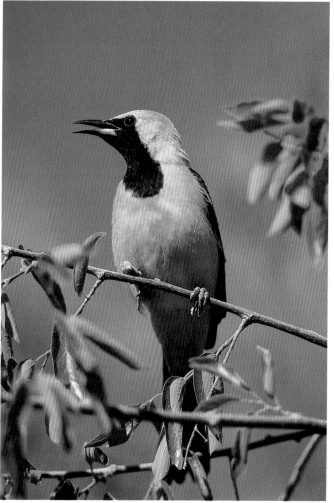

Male

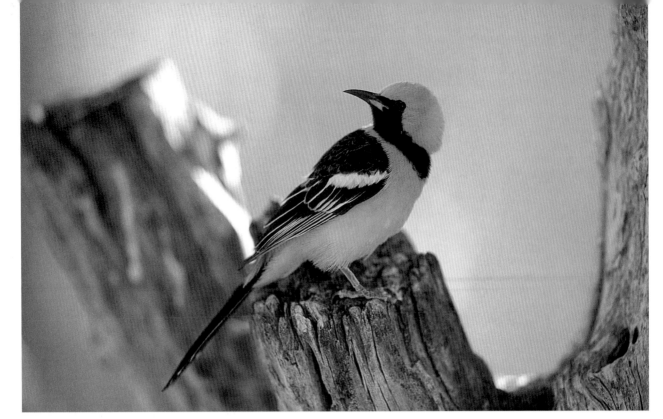

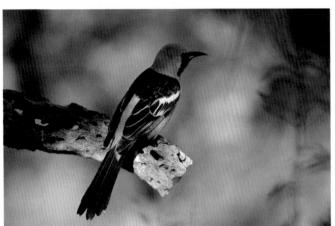

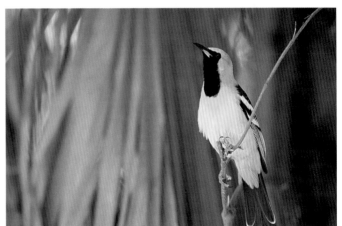

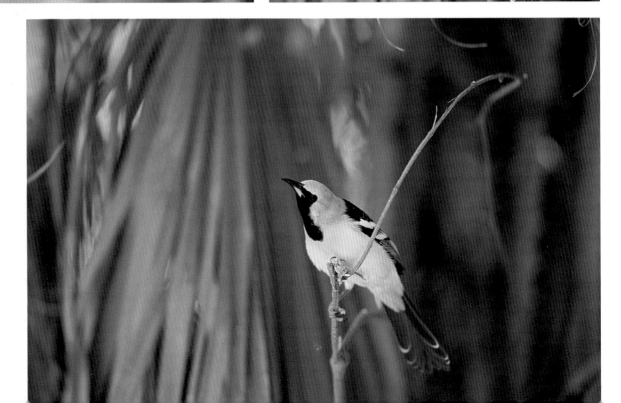

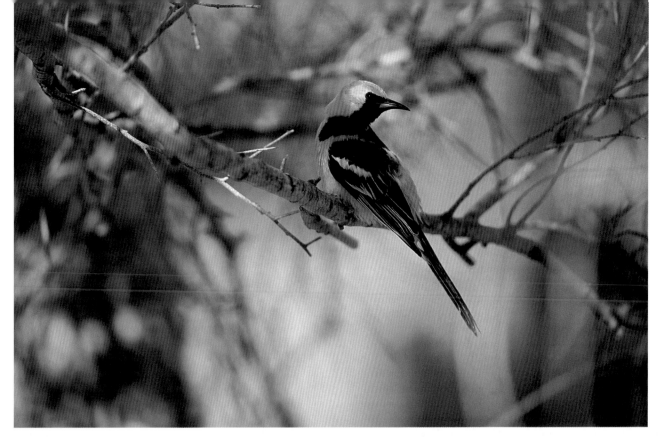

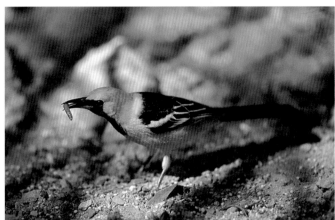

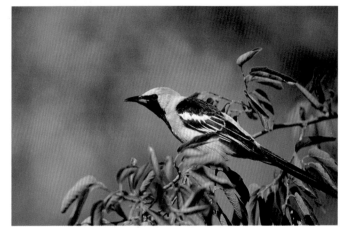

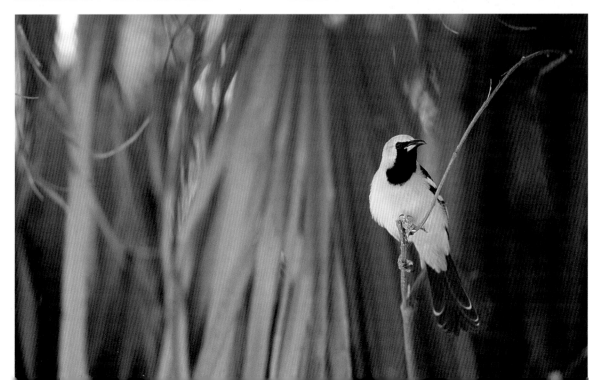

House Finch

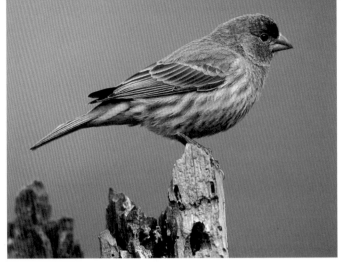

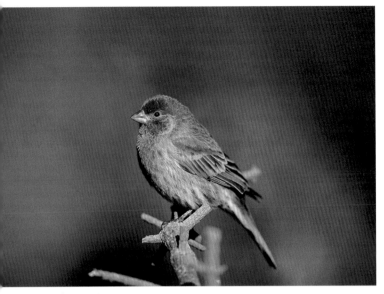

Male

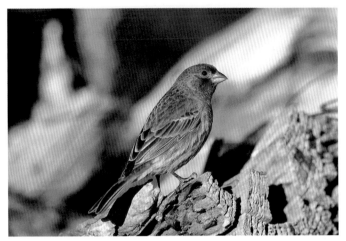

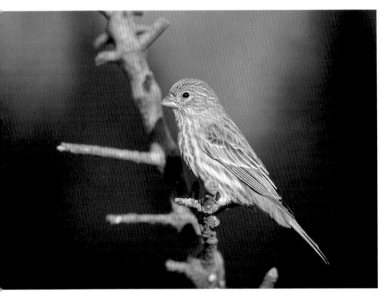

Female

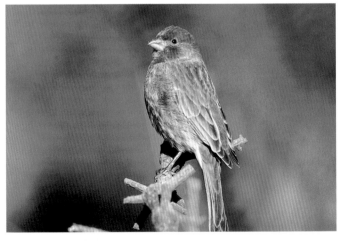

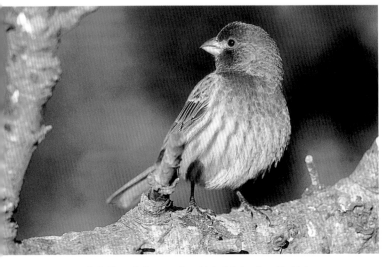

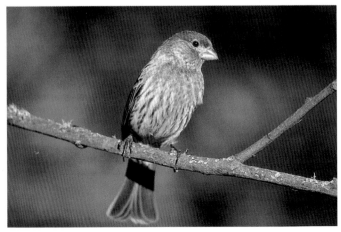

Inca Dove

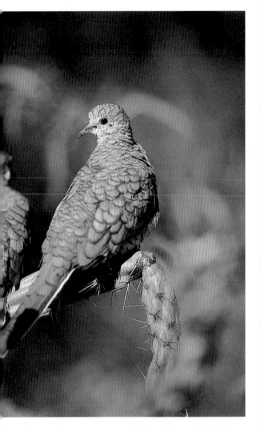

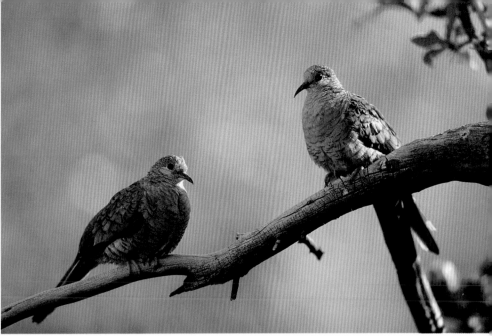

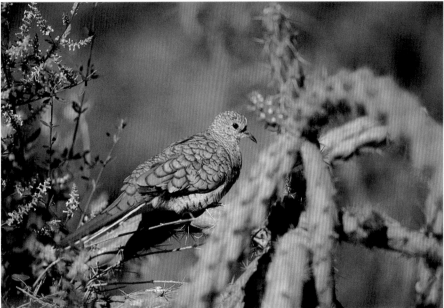

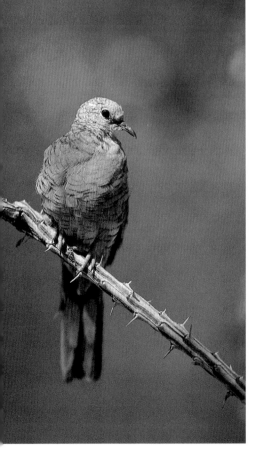

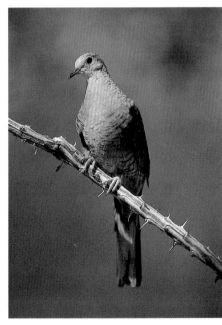

Indigo Bunting

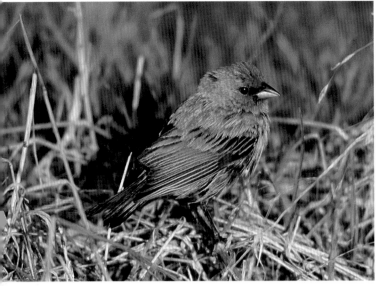

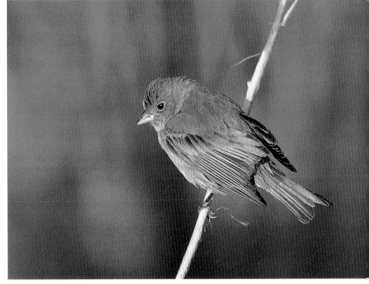

Male

Female

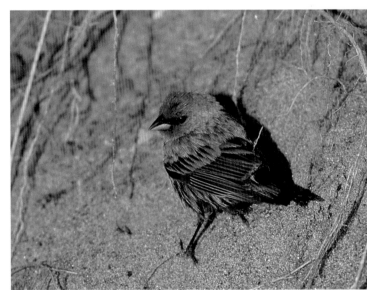

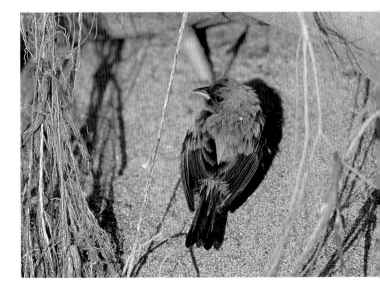

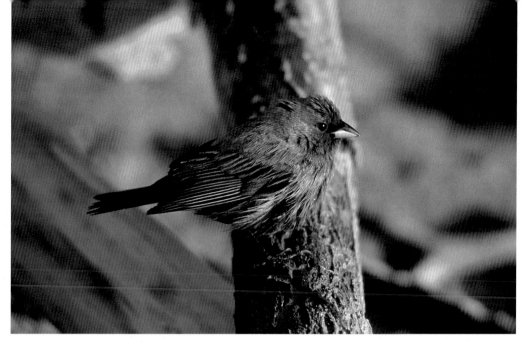

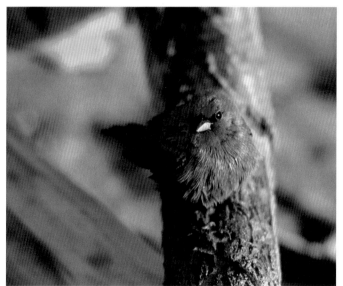

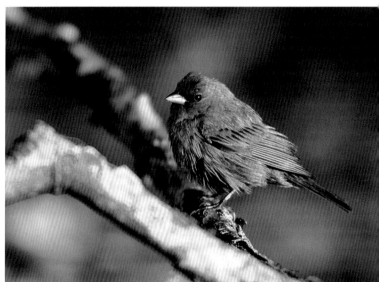

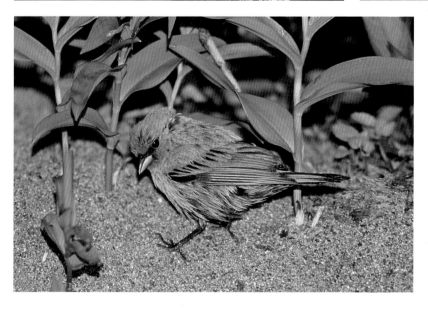

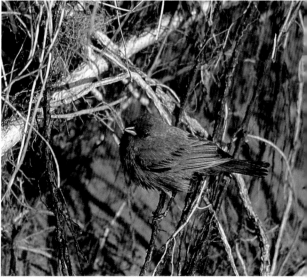

Lark Sparrow

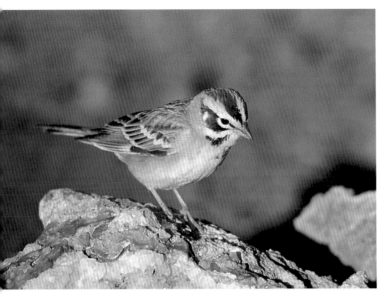

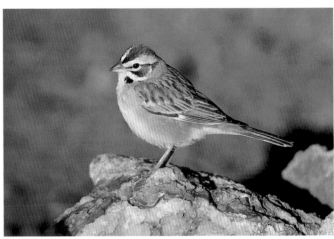

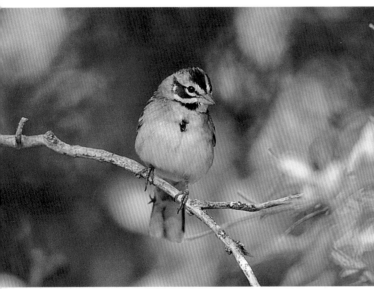

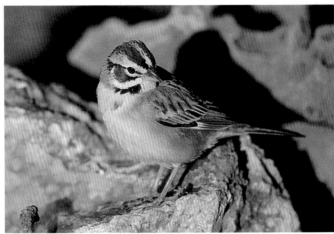

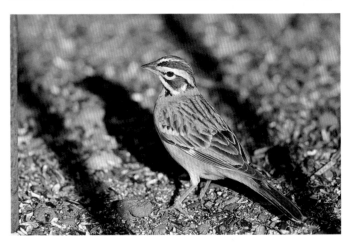

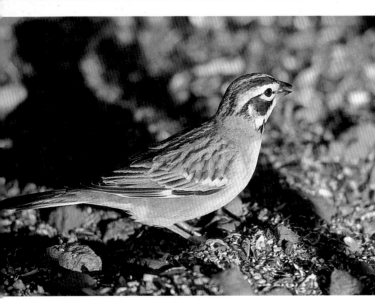

Lazuli Bunting

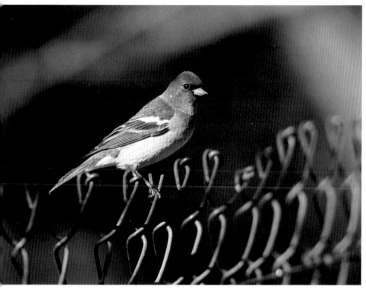

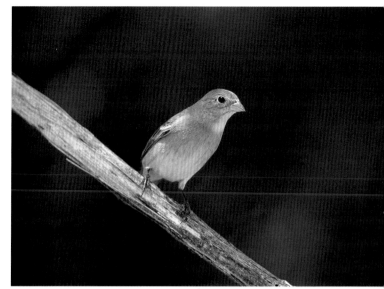

Male

Female

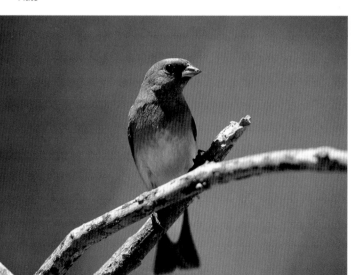

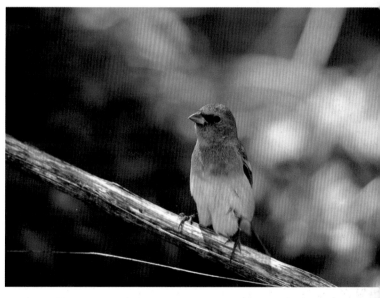

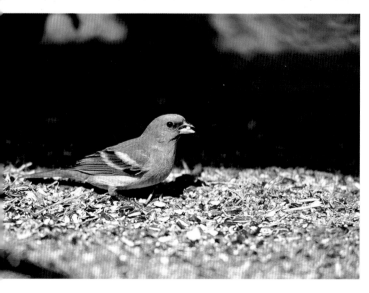

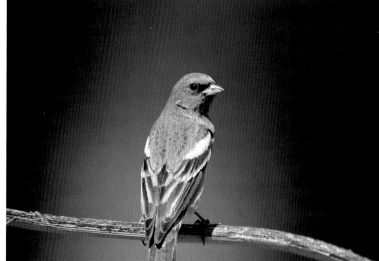

Lesser Goldfinch

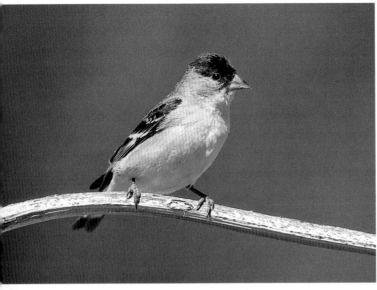

Male

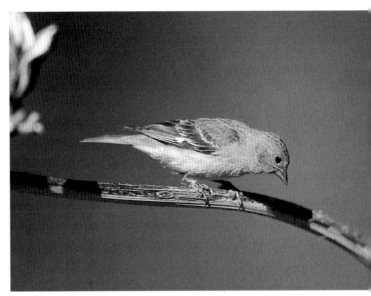

Female

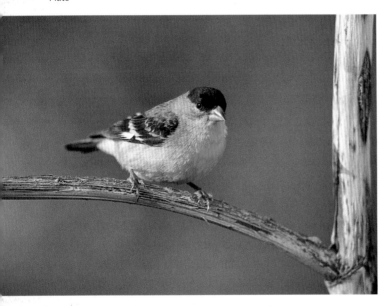

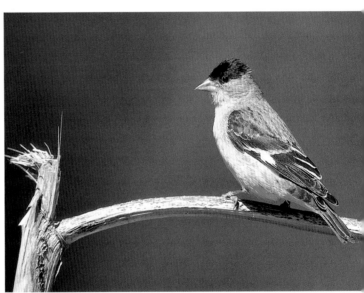

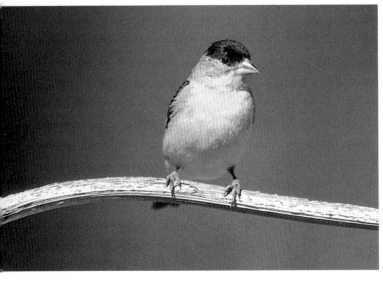

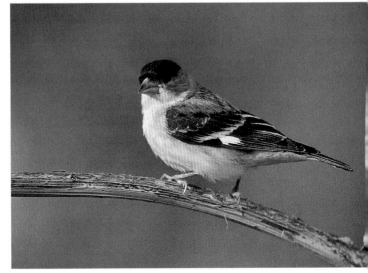

Magnolia Warbler

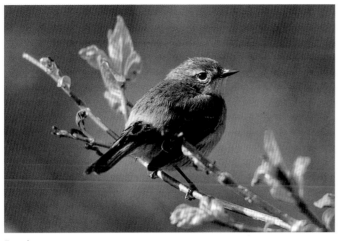

Female

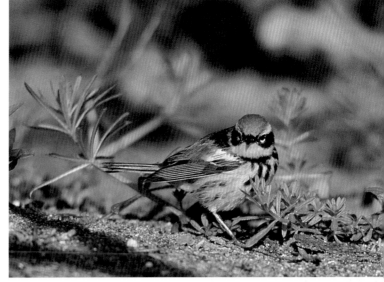

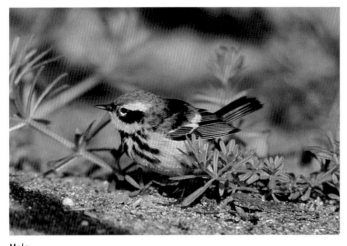

Male

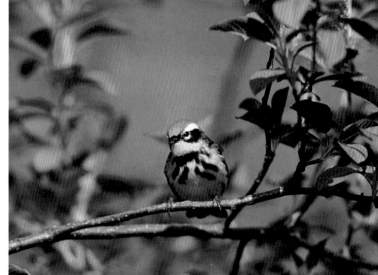

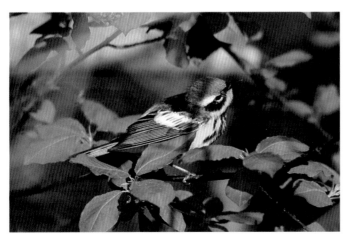

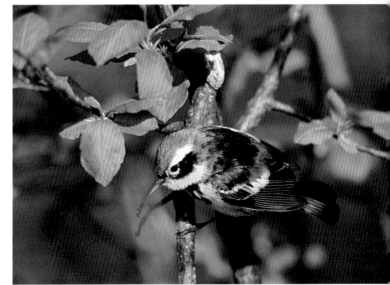

Marsh Wren

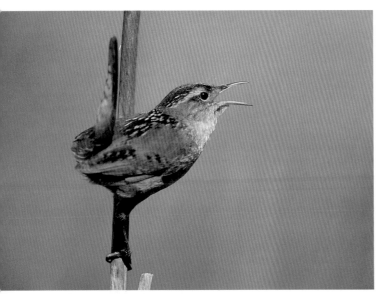

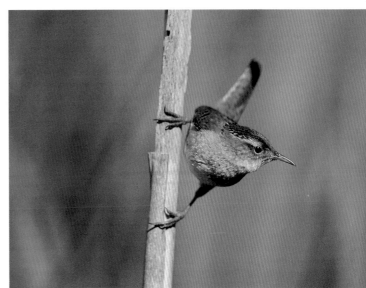

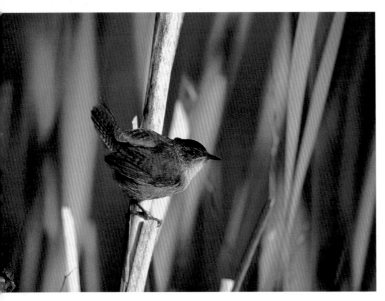

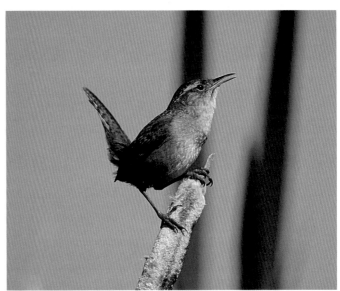

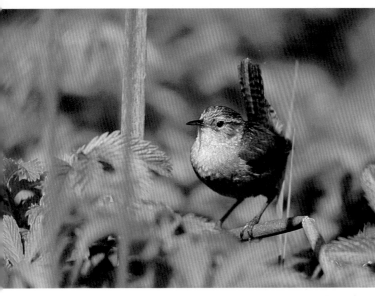

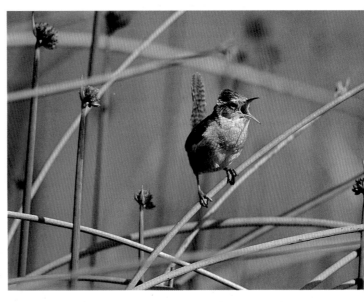

Mockingbird

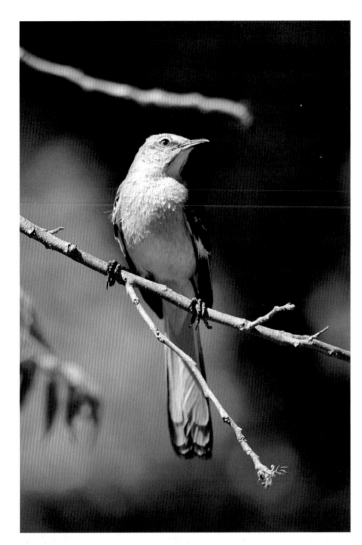

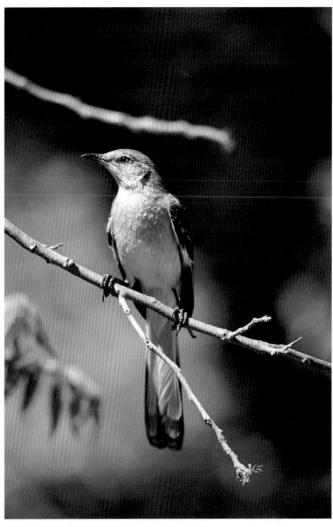

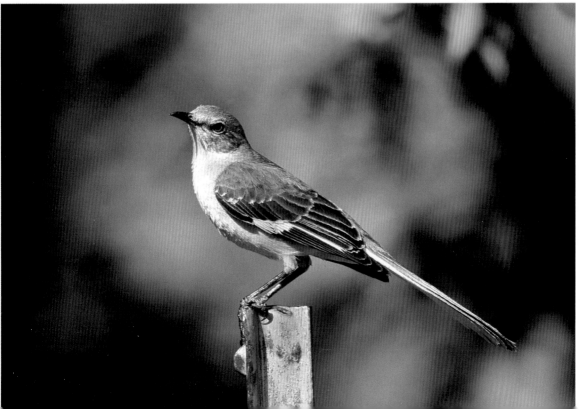

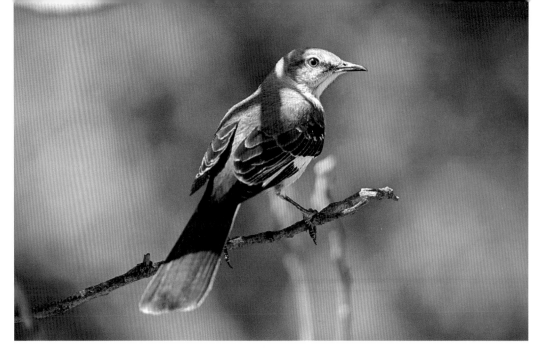

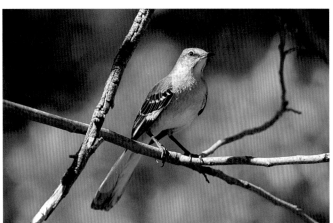

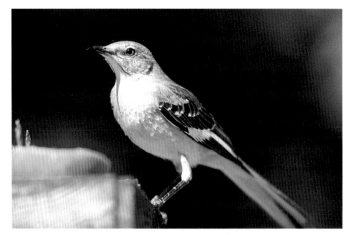

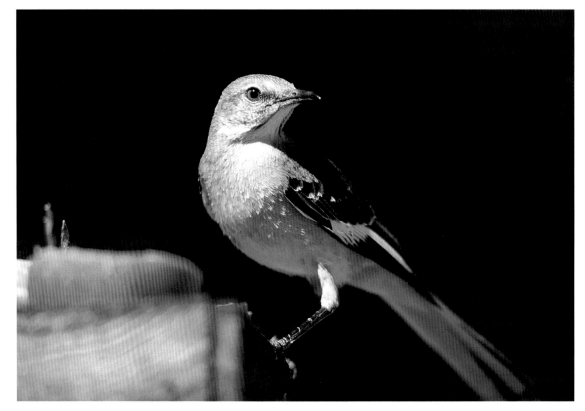

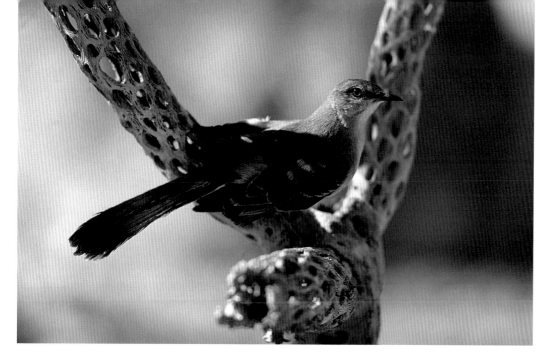

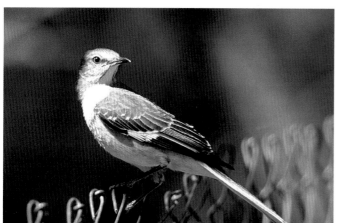

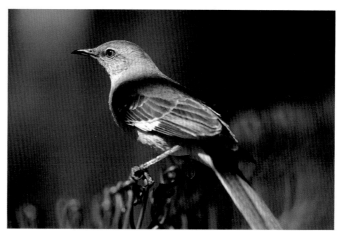

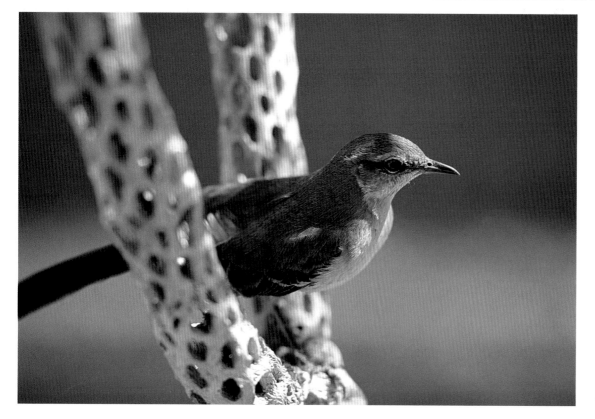

Mourning Dove

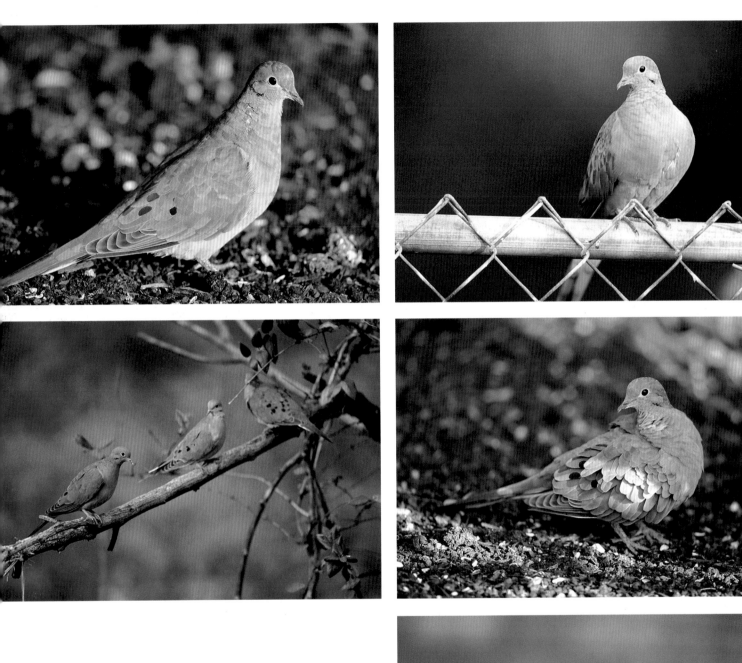

Northern Oriole

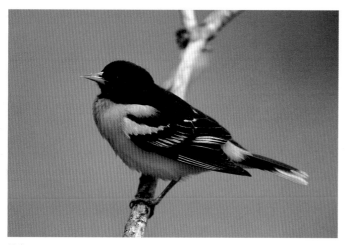

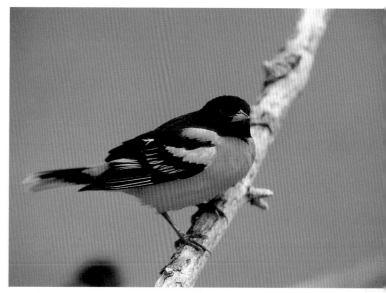

Male

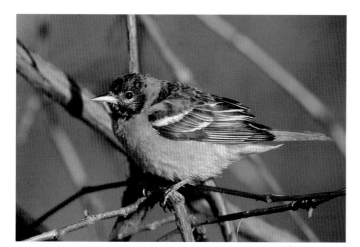

Female

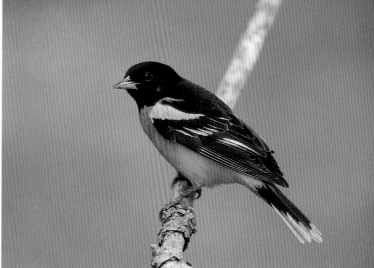

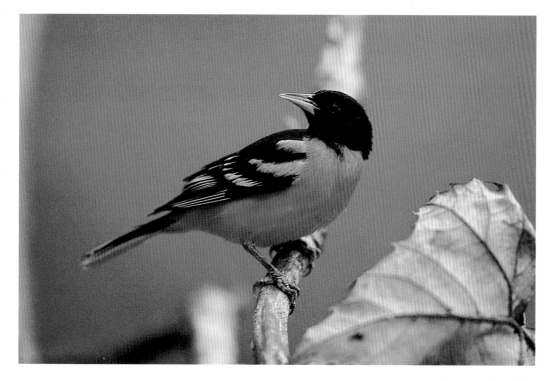

Northern Oriole

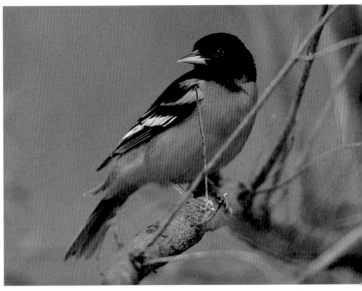

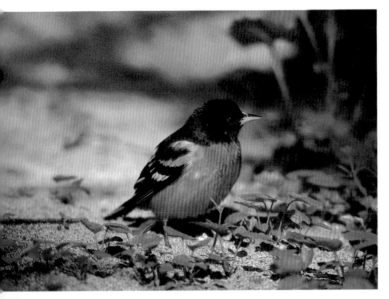

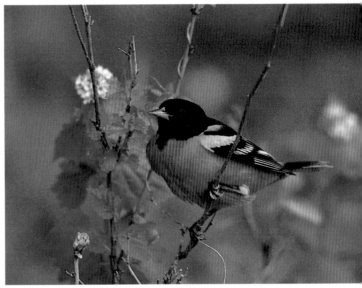

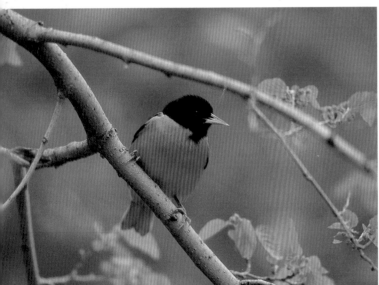

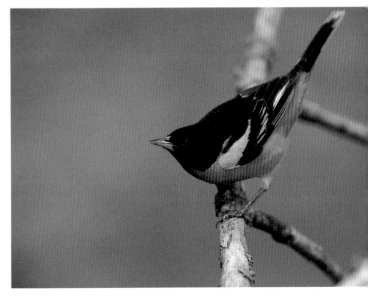

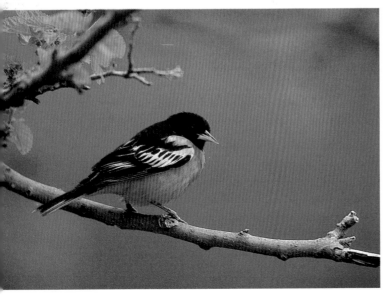

Palm Warbler

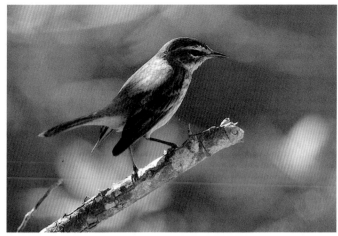

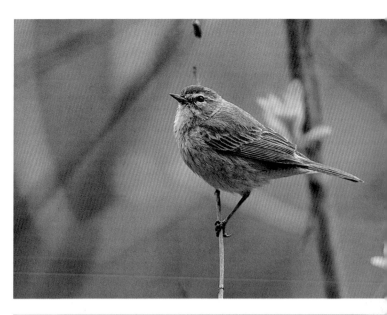

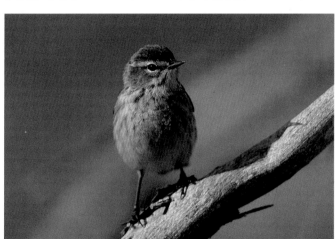

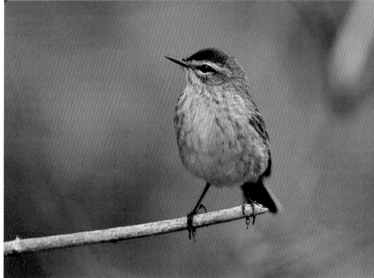

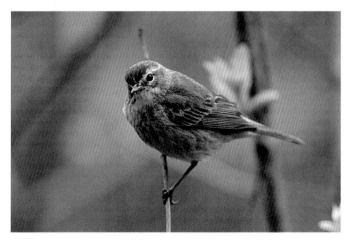

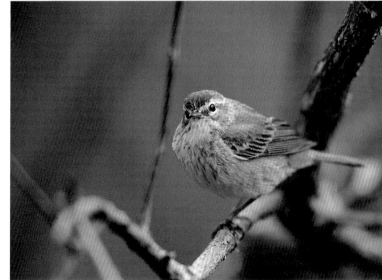

Pine Siskin

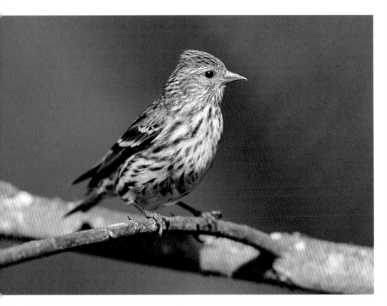

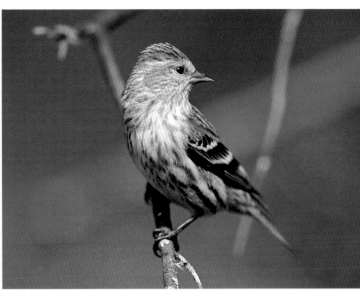

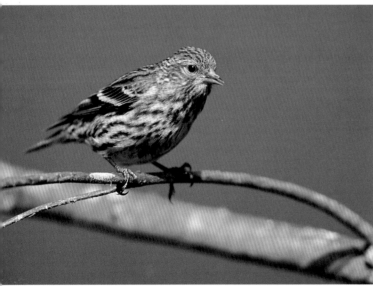

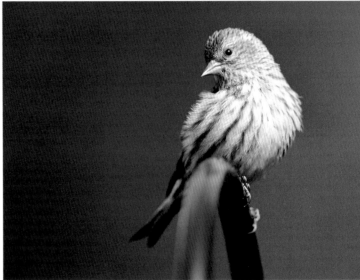

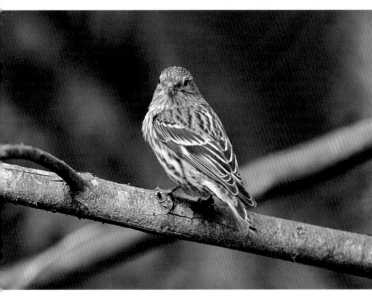

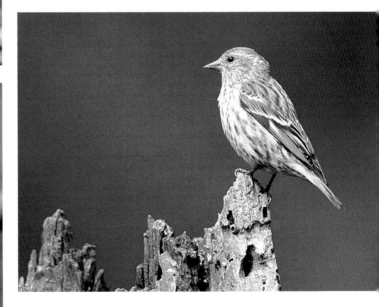

Pyrrhuloxia

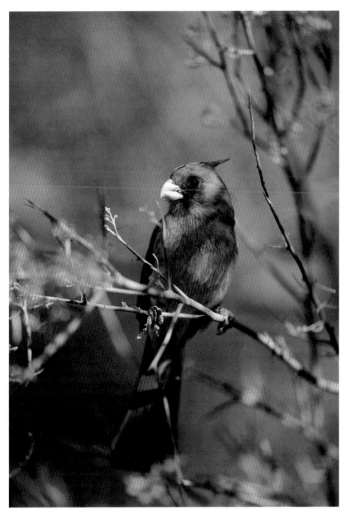

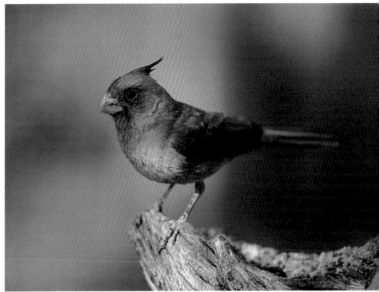

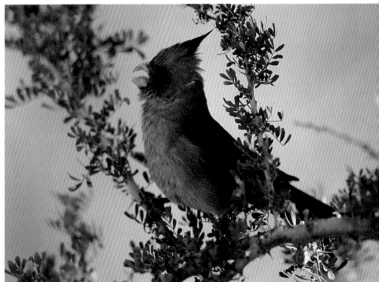

Male

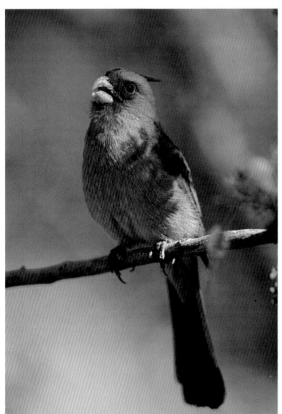

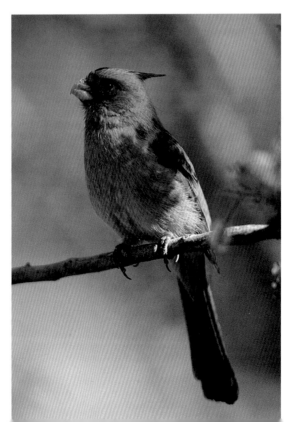

Red-Breasted Nuthatch

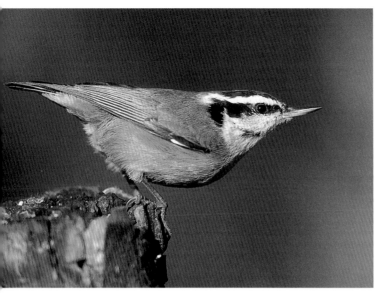

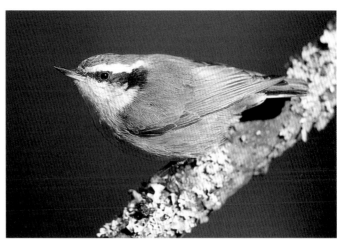

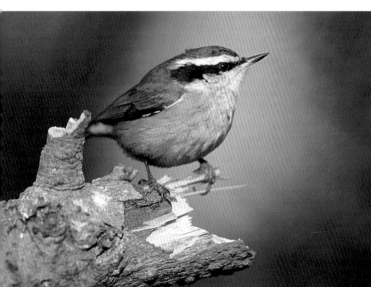

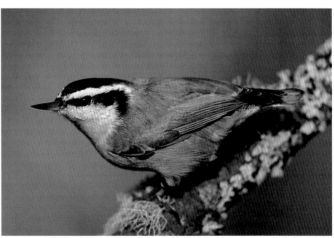

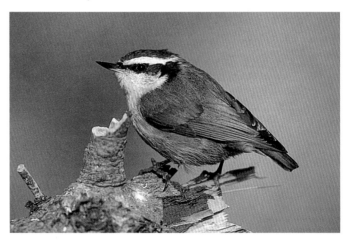

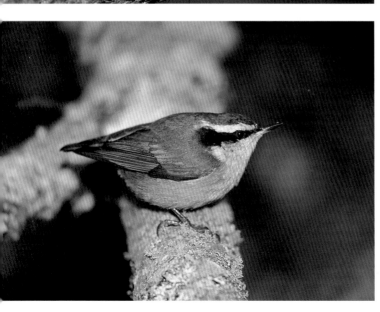

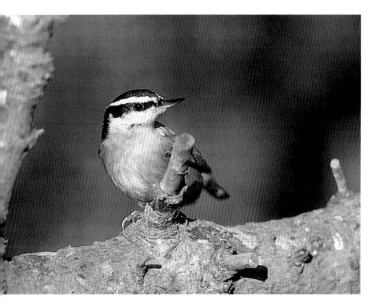

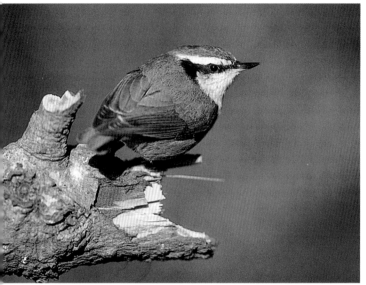

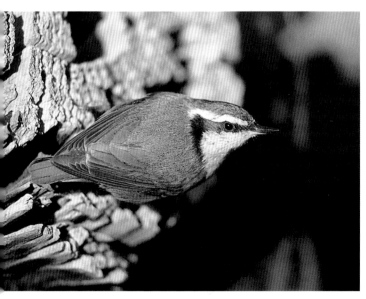

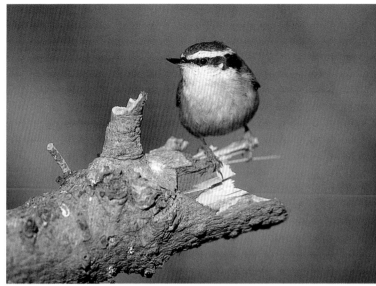

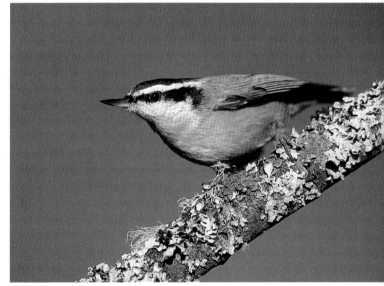

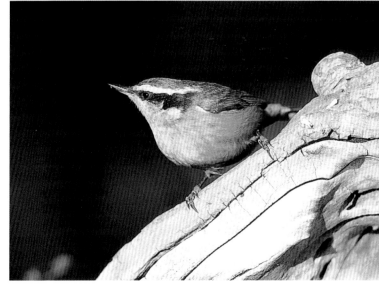

Red-Winged Blackbird

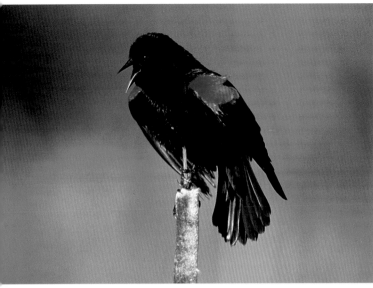

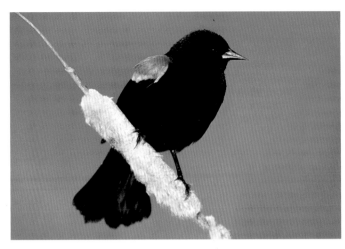

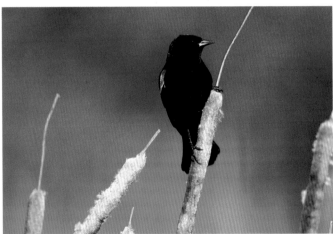

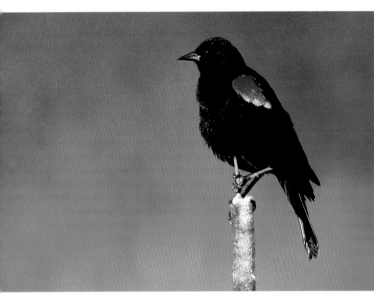

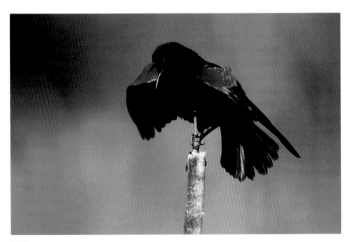

Male

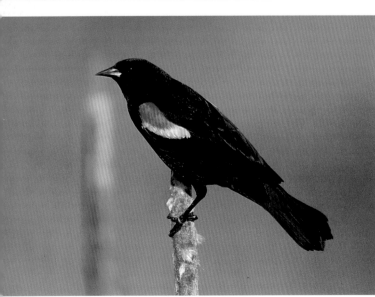

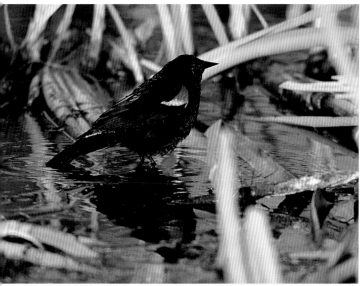

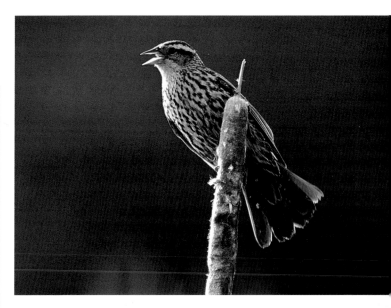

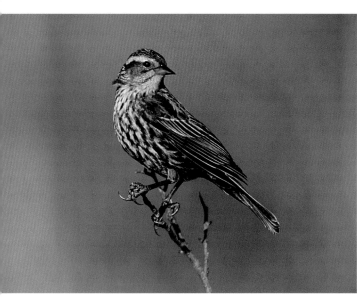

Female

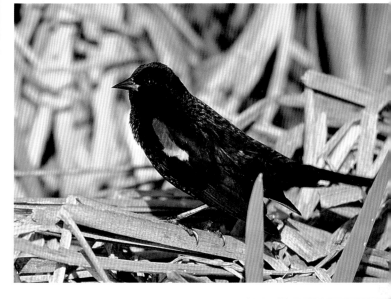

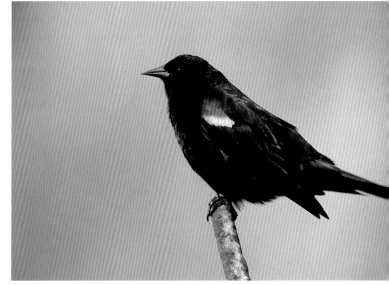

Robin

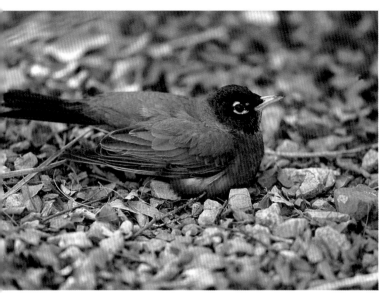

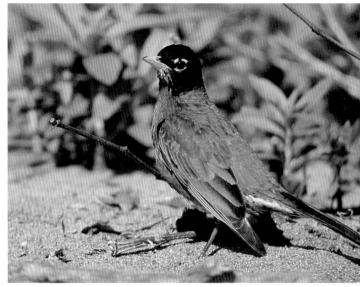

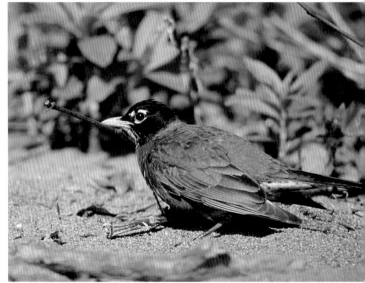

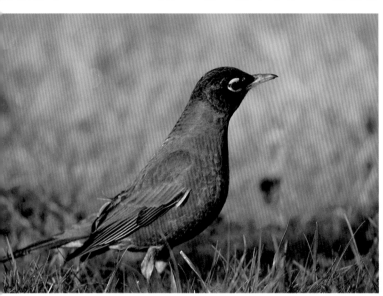

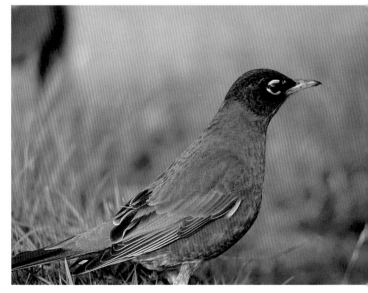

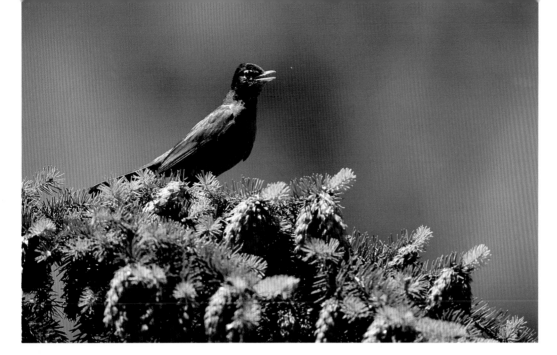

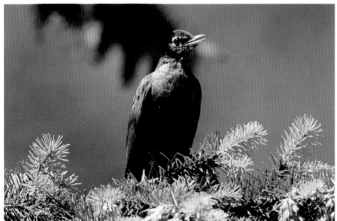

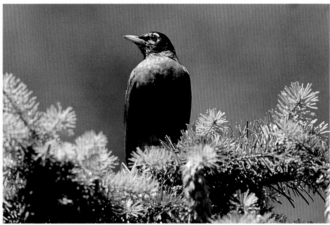

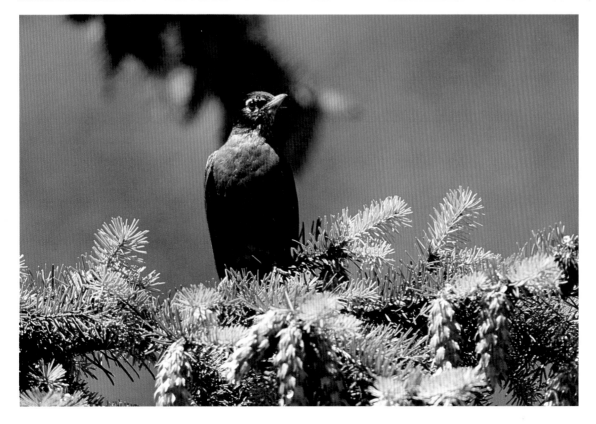

Scarlet Tanager

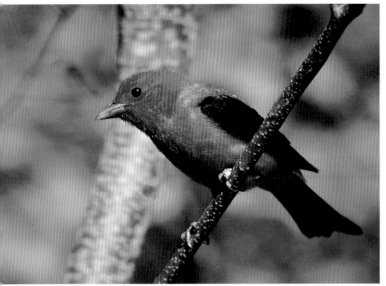

Male

Female

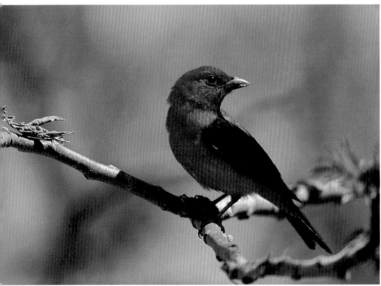

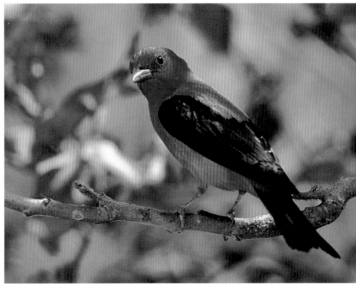

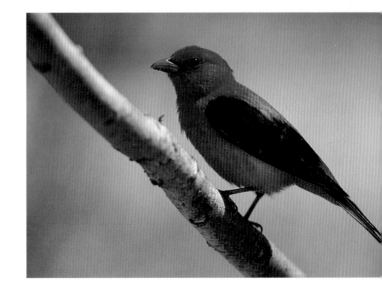

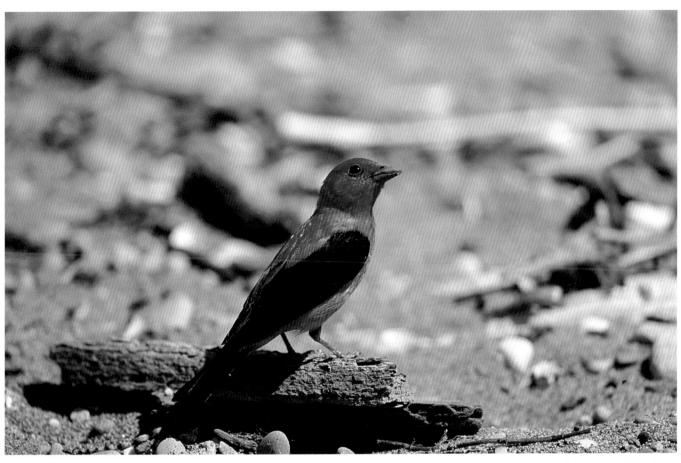

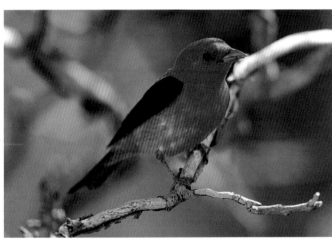

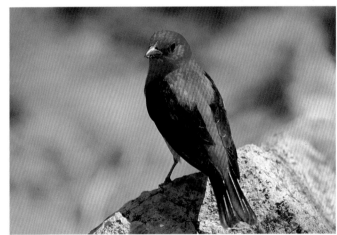

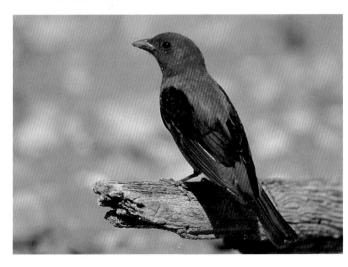

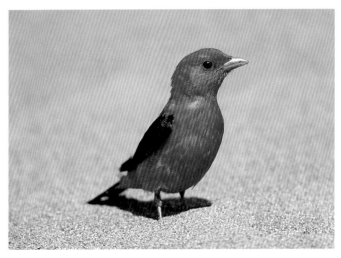

Scarlet Tanager

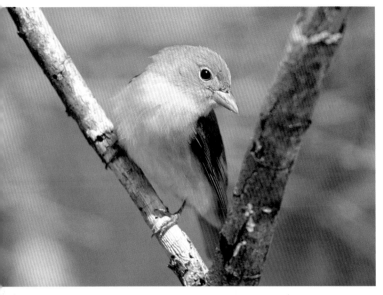

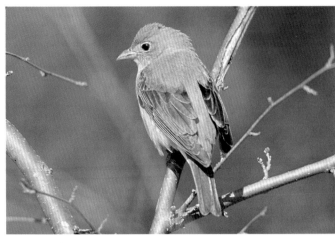

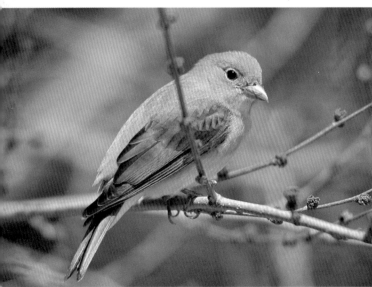

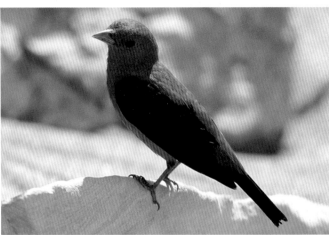

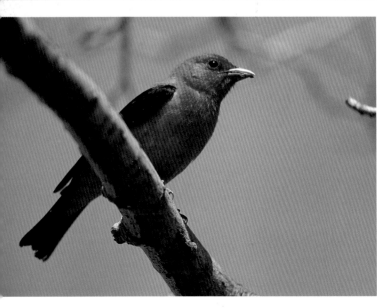

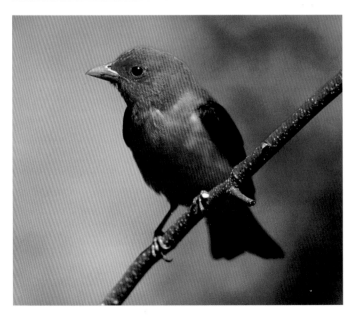

Song Sparrow

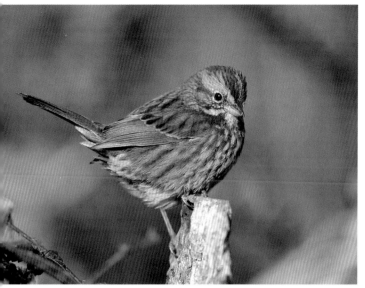

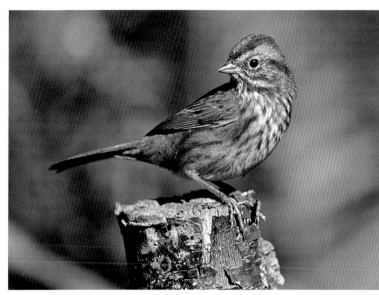

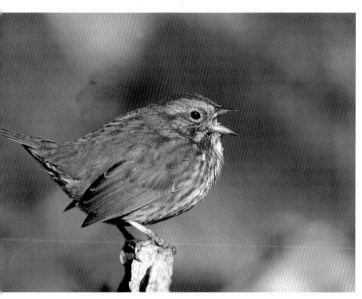

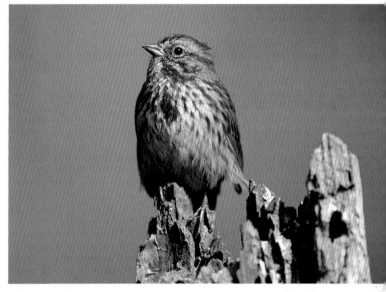

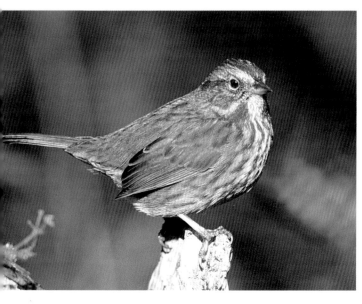

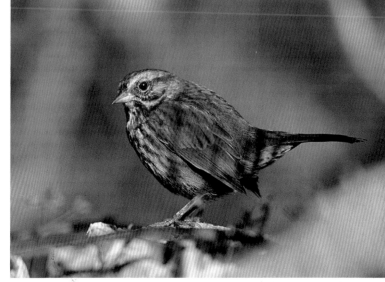

Spotted Towhee

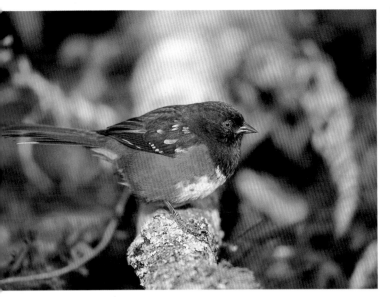

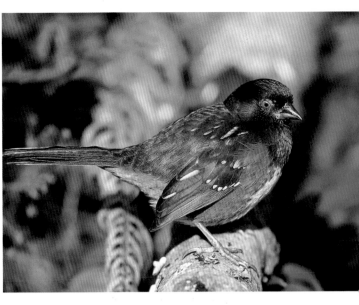

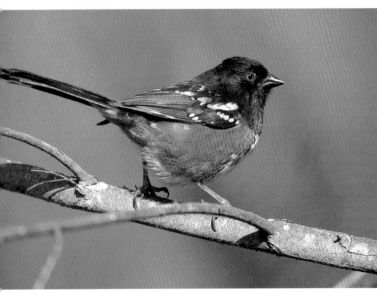

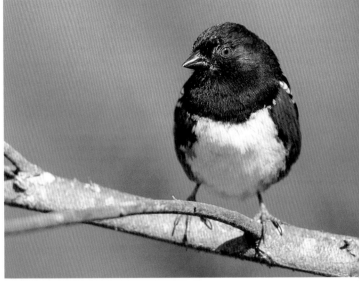

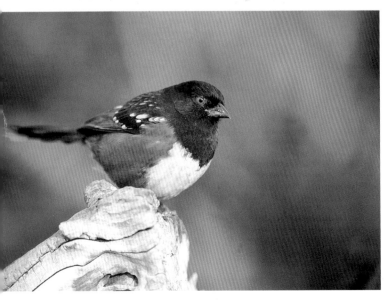

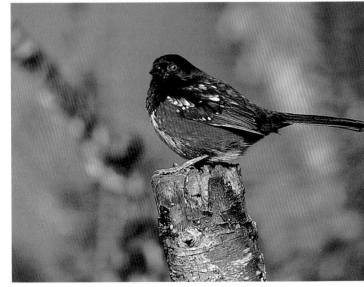

Steller's Jay

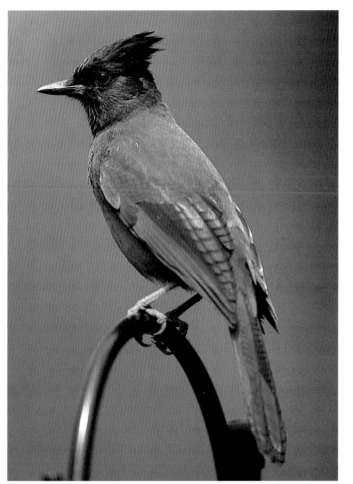

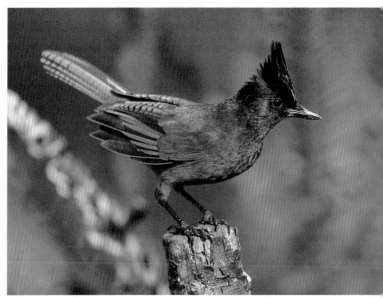

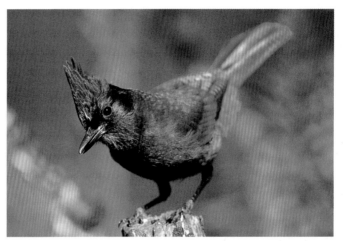

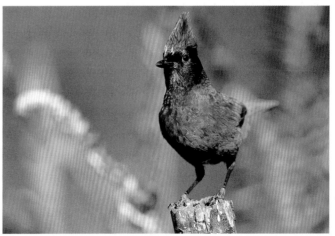

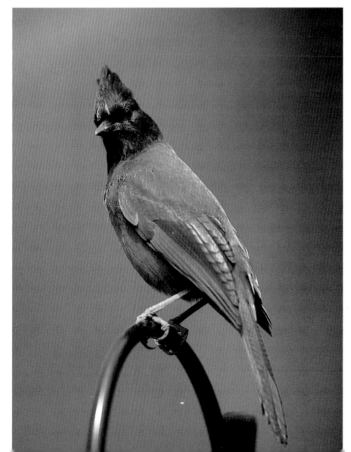

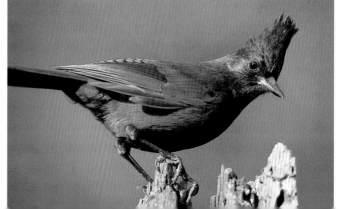

Summer Tanager

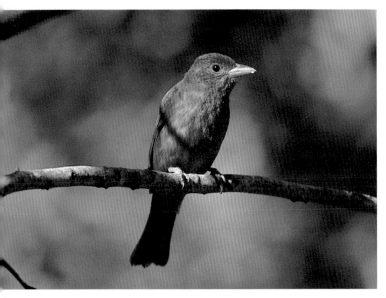

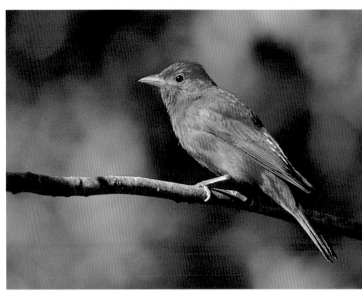

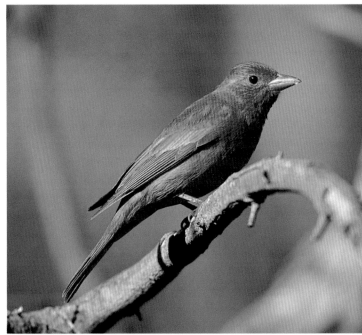

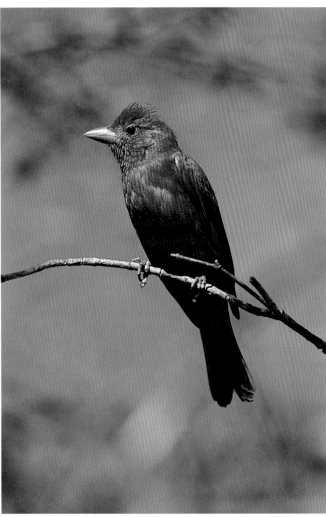

Male

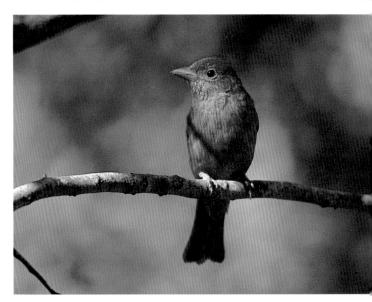

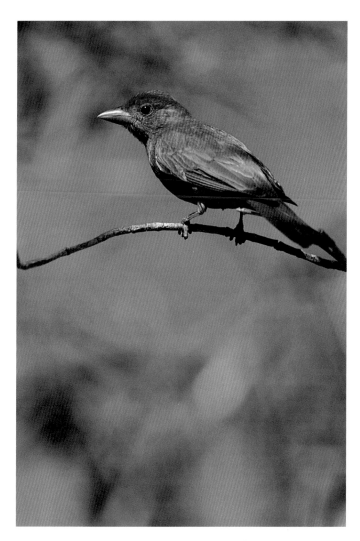

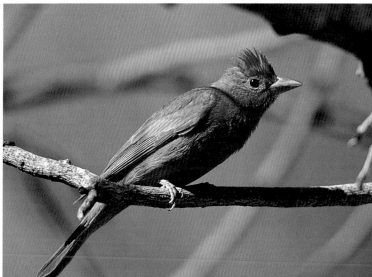

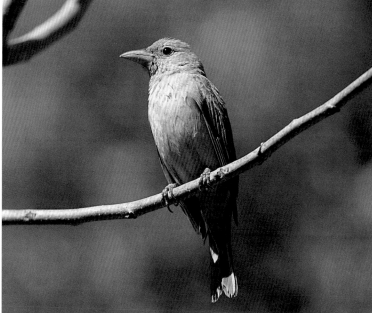

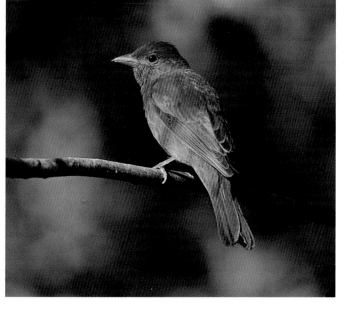

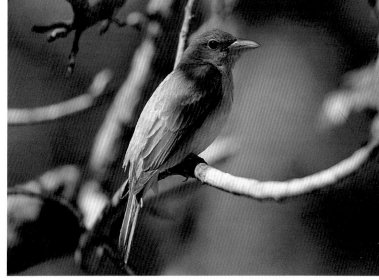

Female

Swainson's Thrush

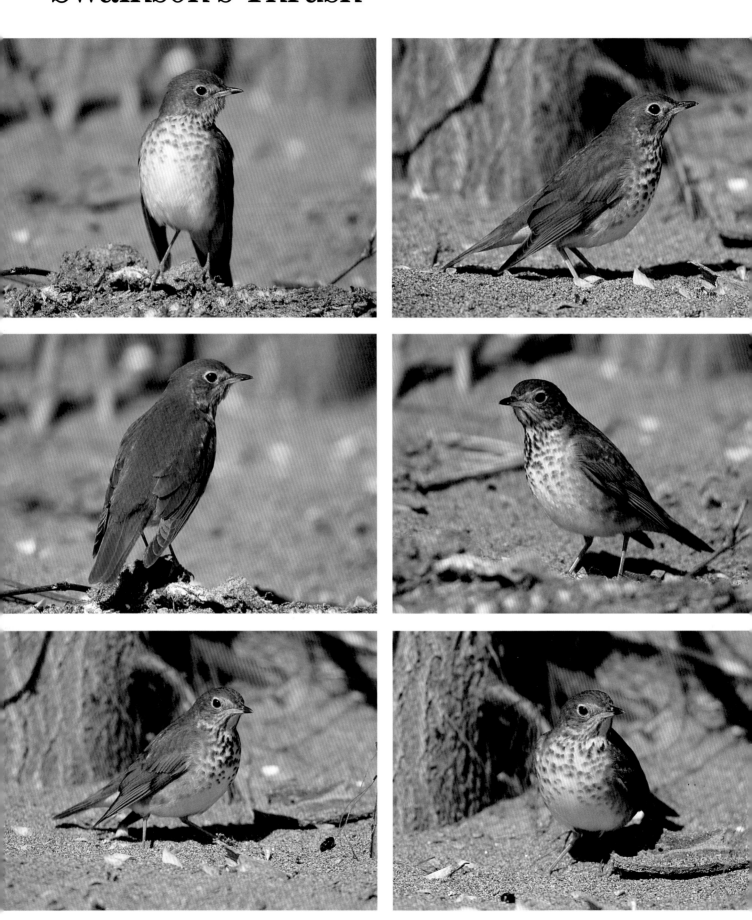

Vermilion Flycatcher

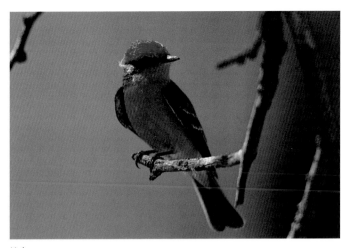

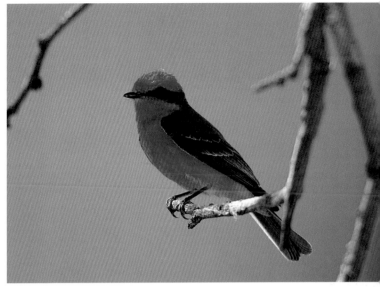

Male

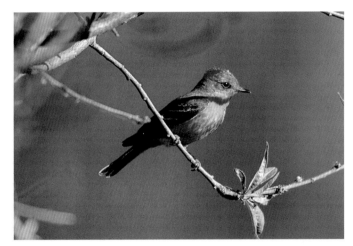

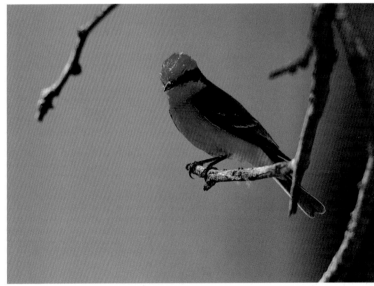

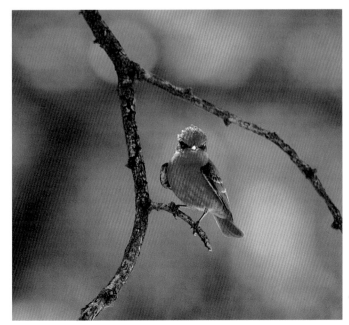

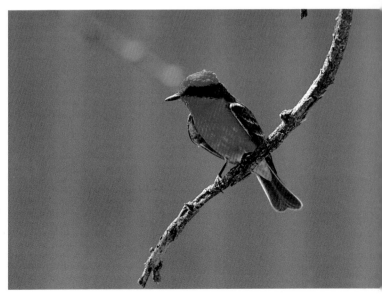

Vermilion Flycatcher

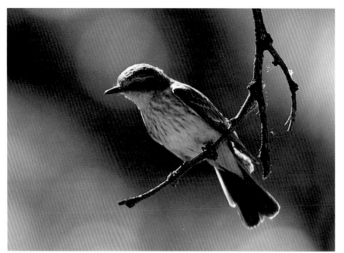

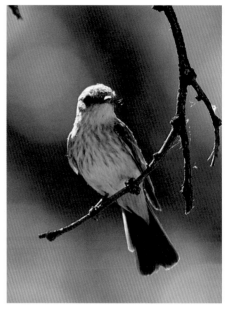

Female

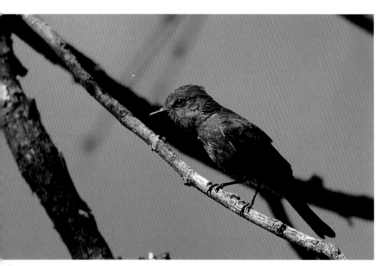

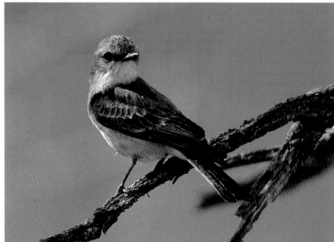

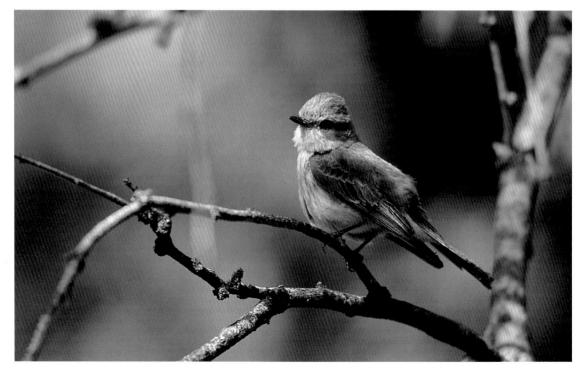

Western Tanager

Female

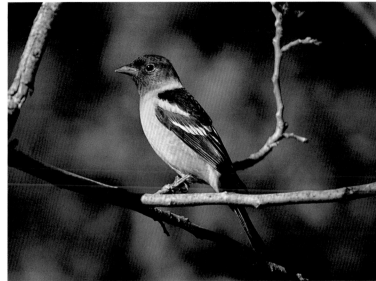

Male

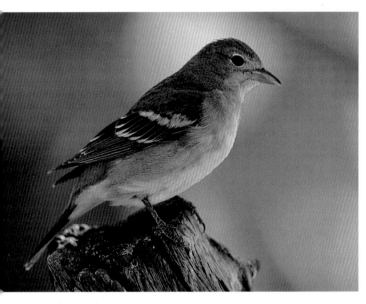

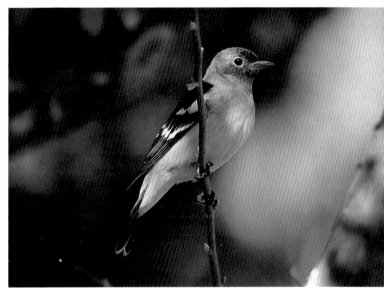

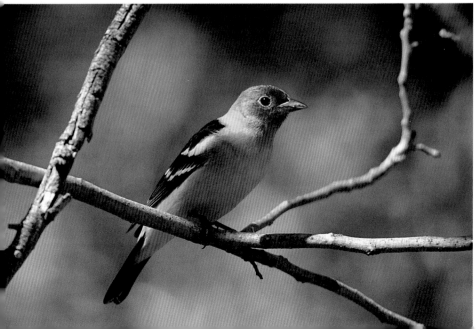

Western Tanager

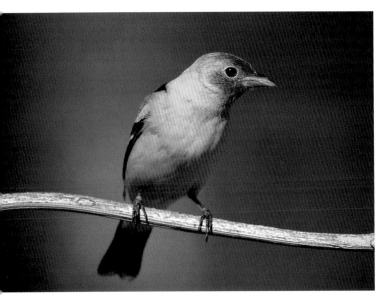

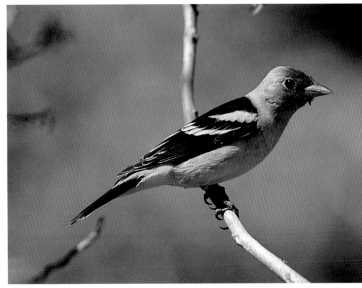

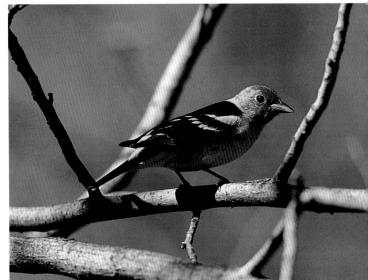

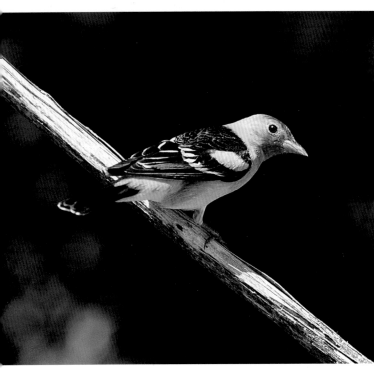

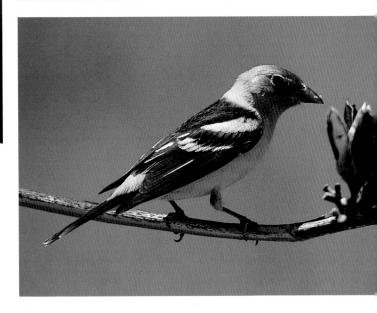

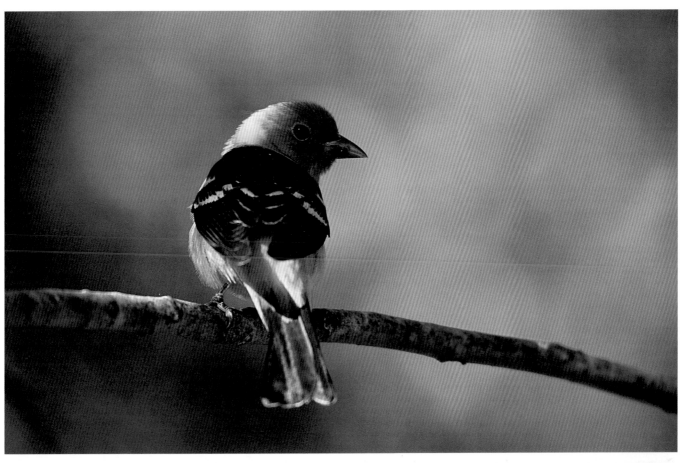

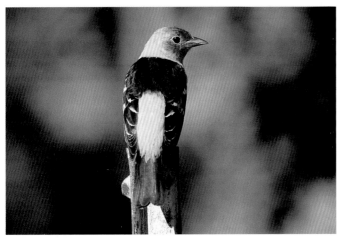

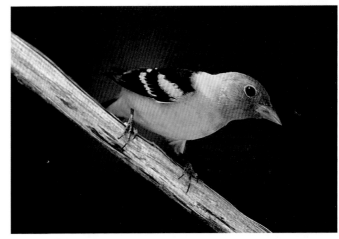

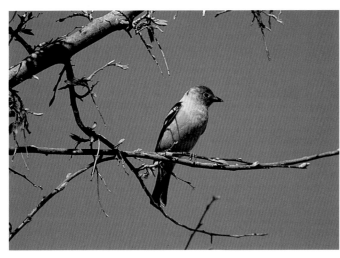

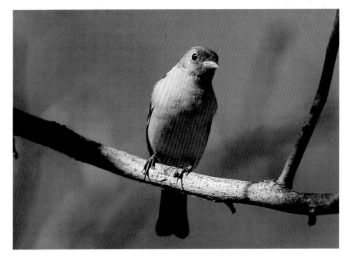

White-Crowned Sparrow

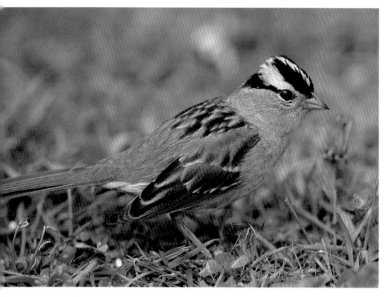

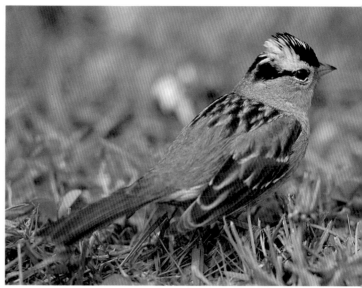

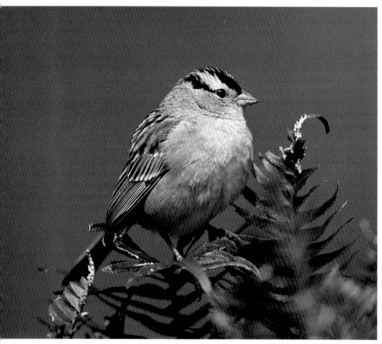

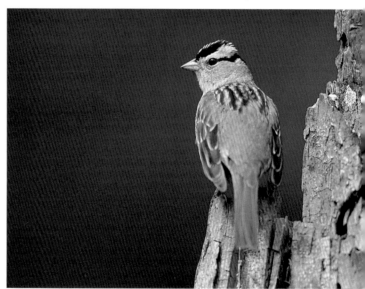

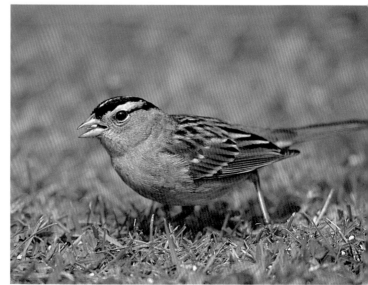

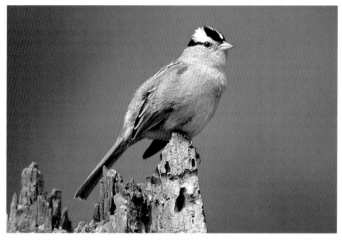

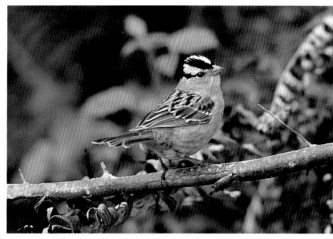

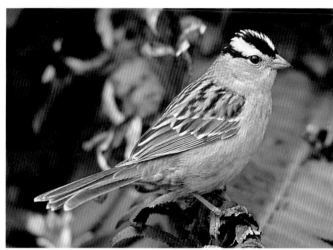

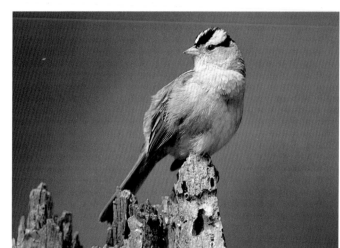

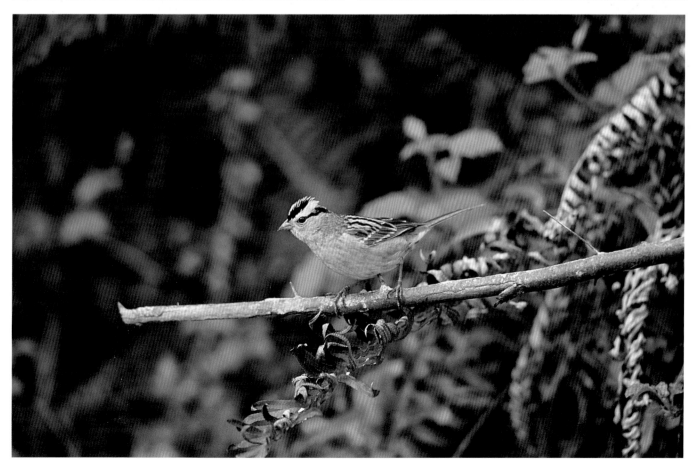

Yellow-Headed Blackbird

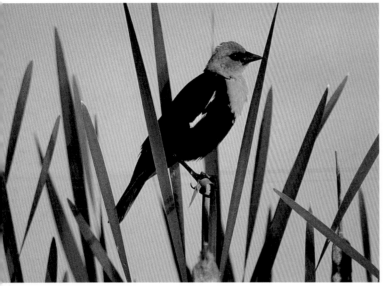

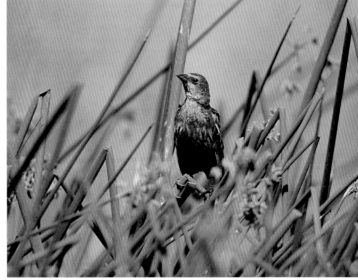

Male

Female

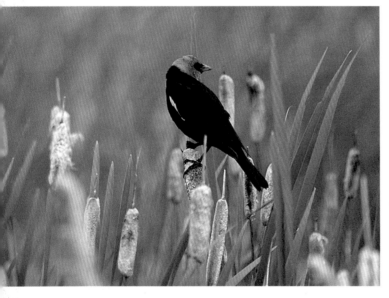

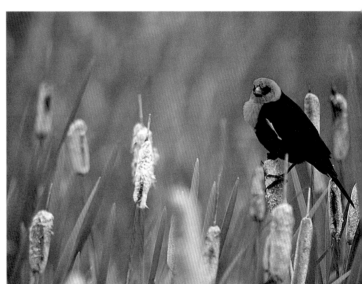

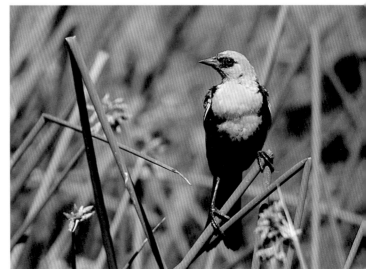

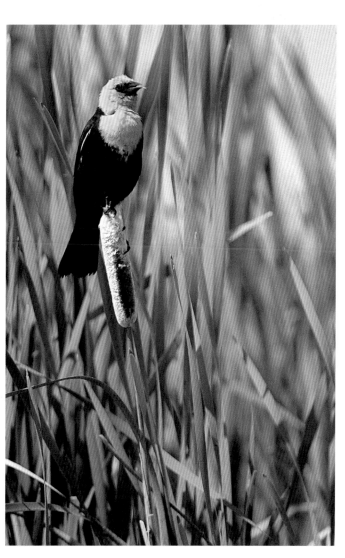

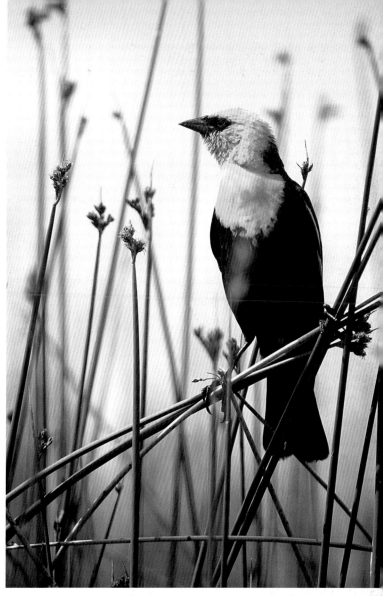

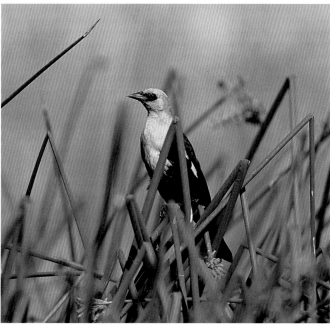

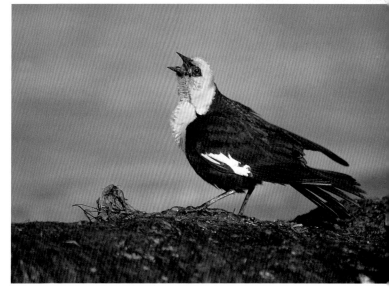

Yellow-Headed Blackbird in Pastel

by Mark Boyle

Materials

Surface

24" x 18" (61cm x 46cm) Ersta sanded pastel paper, 400-grit (medium)

Palette

Winsor & Newton Gouache — Alizarin Crimson Series 3A, Burnt Umber, Chinese Orange, Havannah Lake, Indigo, Yellow Ochre Series 1AA

Rembrandt Pastels — Burnt Umber, Chrome Green Deep 608.3, Orange 235.3, Raw Sienna 234.5, Turquoise Blue 522.8, Yellow Ochre Tints 227.5, 227.7 and 231.3

Rowney Pastels — Green Gray Tint 6

Sennelier Pastels — Apple Green 208, Black Green 177, Burnt Madder 375, Ivory Black 513, Moss Green 169, Prussian Blue 467, Reseda Gray Green 210 and 211, Turquoise 742, Vermilion 80, White 525

Schminke Pastels — Burnt Sienna 018, Greenish Gray Tint 2, Sunproof Yellow 1 Lemon, Sunproof Yellow 3 Deep, Ultramarine Deep, Yellow Ochre Light

Unisom Pastels — Purple A29 and A30

Brushes

Round ½-inch (12mm) Sumi camel hair brush

Other

Charcoal stick, ¼-inch (6mm)

Masking tape, 3 inches (8cm) wide

Stiff plywood board

Black permanent marker

Tracing paper

Mark Boyle photographed the yellow-headed blackbird for this painting in Eastern Washington. Yellow-headed blackbirds are one of his favorite subjects. He offers this advice: "Do as much research as possible for your paintings. Yellow-headed blackbirds are scattered throughout the western United States, usually in dry terrain on the shores of a pond or lake. The birds are easier to photograph during the courting and nesting phases."

Reference photo

Plan the Composition

In this painting Mark wanted to paint a single male yellow-headed blackbird. The females tend to be more pale in appearance. Start by using a black permanent marker to draw your layout sketches on tracing paper. Place the main weight of the subject on either the left or right side of the composition. Mark did three sketches, but ultimately he chose the above middle sketch due to the overall pose and angle of the bird.

1. Apply a Coat of Gouache

Tape the sanded pastel paper to a plywood board or other flat surface. Mark usually covers the paper with warm washes of gouache first. This will rid the paper of its starkness, and the warm colors will show through the pastel texture at the end. Start by applying Winsor & Newton Havannah Lake, Burnt Umber, Indigo, Chinese Orange, Yellow Ochre and Alizarin Crimson with the camel hair brush. As the paint begins to dry, splash on water droplets to create additional texture.

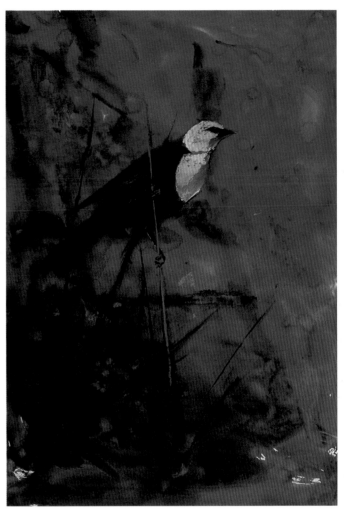

2. Block In the Outline

Use a charcoal stick to sketch the bird. The charcoal is easy to sweep away if you make a mistake. Lay in the direction and angles of the marsh grasses.

3. Block In the Yellow and Black

Start the bird by laying in Schminke Sunproof Yellow 3 Deep as the base color for the blackbird's head. In the light areas lay in Sunproof Yellow 1 Lemon. In the shadow areas of the bird's head lay in Schminke Yellow Ochre Light, Rembrandt Raw Sienna 234.5 and a touch of Rembrandt Turquoise Blue 522.8 for reflected light under the breast. Fill in the dark shadow area's on his body with Sennelier Ivory Black. Apply a coat of Rembrandt Burnt Umber on the light areas of the bird. Be sure to soften the edges of the light areas of the bird on the back and belly. Sweep in light strokes of Sennelier Moss Green at different angles for the grasses.

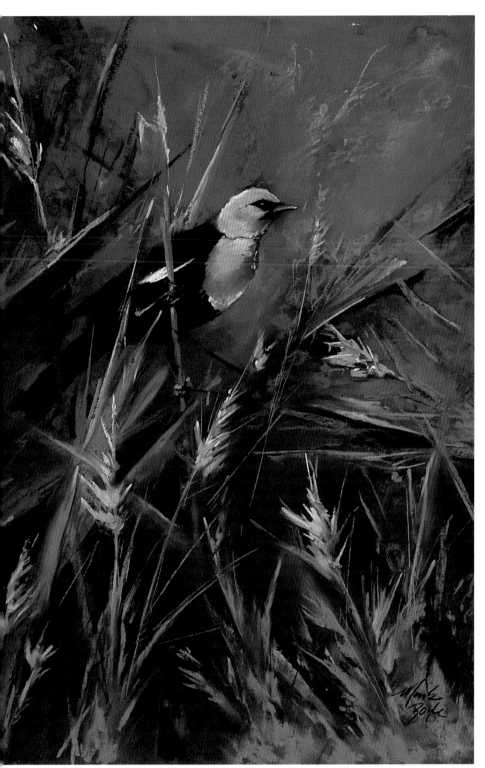

4. Complete the Background and Add Final Touches

For the background, be spontaneous with the angles of the grasses and placement of the seed heads in order to lead your eye into the painting. Mark completely changed the background from what he saw in his reference photograph. Paint the seed heads with Rembrandt Orange 235.3, Raw Sienna 334.5, Yellow Ochre Tints 227.5, 227.7 and 231.3. Apply sweeping base strokes for the grasses using Sennelier Moss Green 169, Reseda Grey Green Tints 210 and 211, Rowney Green Gray Tint 6, Schminke Greenish Gray Tint 2 and Rembrandt Chrome Green Deep 608.3. Next, use Sennelier Apple Green 208 and Sennelier Turquoise 742 for the highlights on the grasses. Use Sennelier Black Green 177 for the dark shadows under the grasses.

The background contains Schminke Ultramarine Deep, Sennelier Prussian Blue 467, Vermilion 80 and Burnt Madder 375, and Unisom Purple A29 and A30. Soften transitions between colors by blending lightly with your fingers. Lay Schminke Burnt Sienna 018 and Rembrandt Orange 235.3 onto the stick where the bird is perched. Lay Sennelier White 525 onto the bird's feathers underneath and behind the stick. To finish the painting, touch up the highlight areas on the bird with Schminke Sunproof Yellow 1 Lemon.

BLACKBIRD STUDY
Mark Boyle
Pastel over gouache on pastel paper
24" x 18" (61cm x 46cm)

Yellow-Rumped Warbler

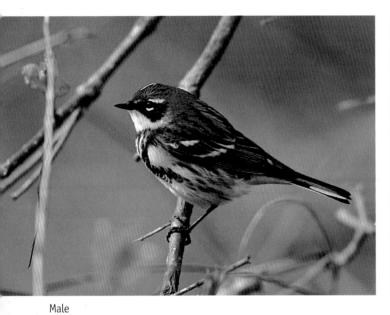

Male

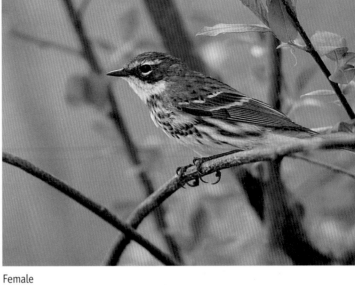

Female

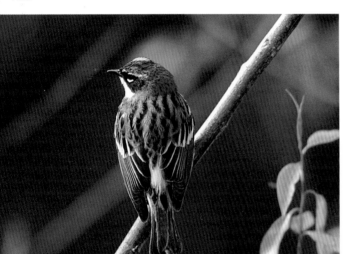

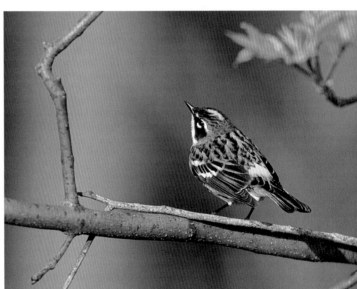

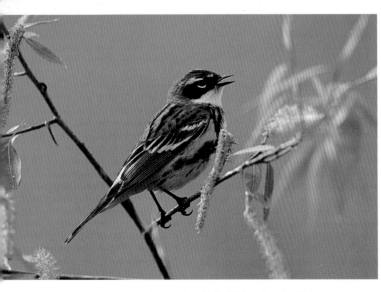

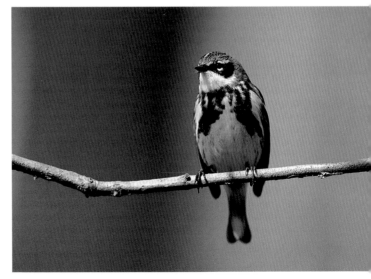

Yellow Warbler

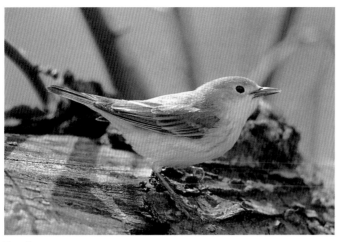

Female

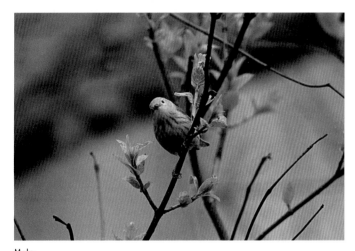

Male

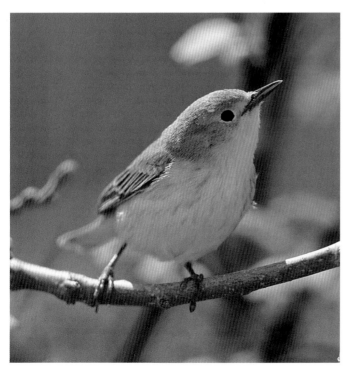

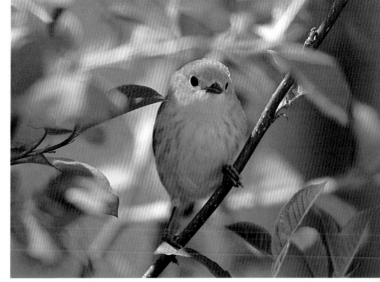

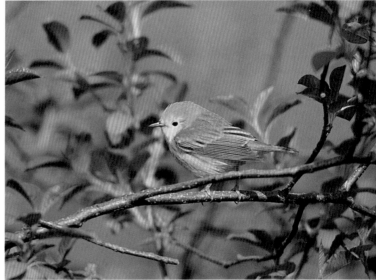

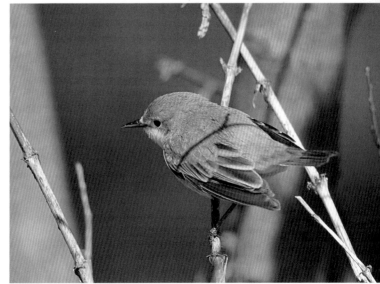

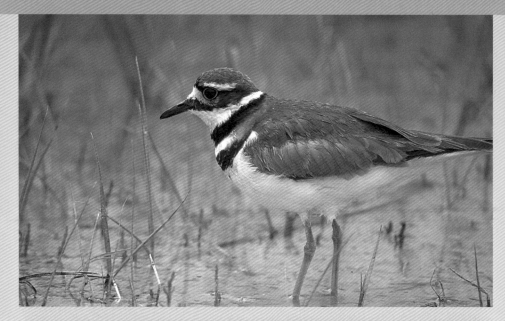

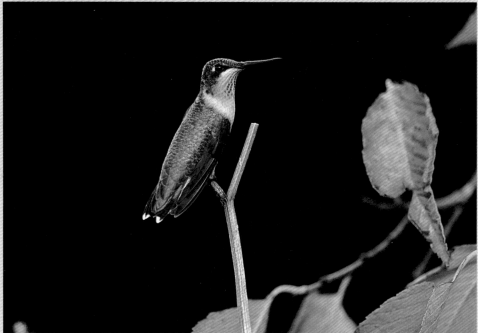

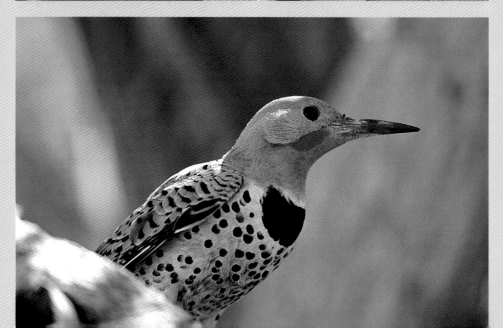

PART TWO

Other Favorite Birds

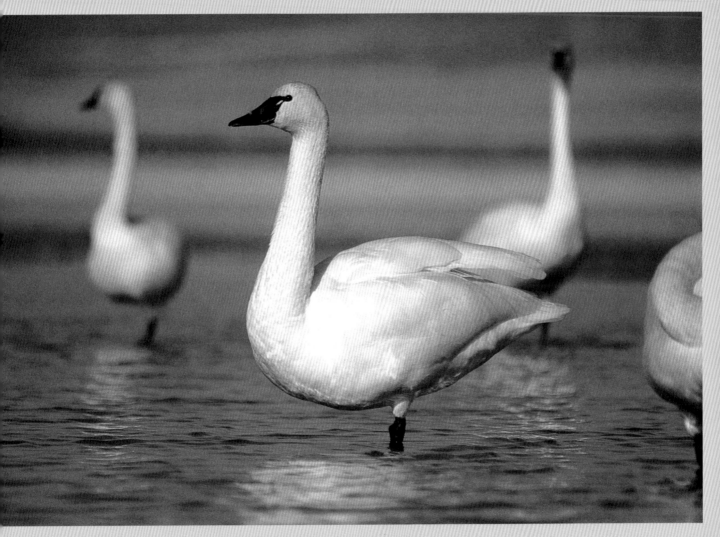

You'll find many artists' favorites in this section, from the bald eagle and osprey to swans, pelicans and the ruby-throated hummingbird.

Anhinga

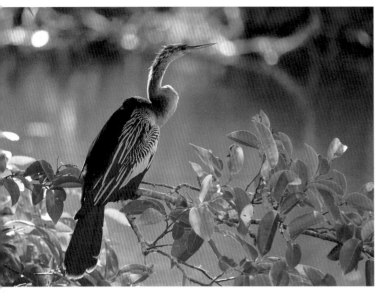

Female

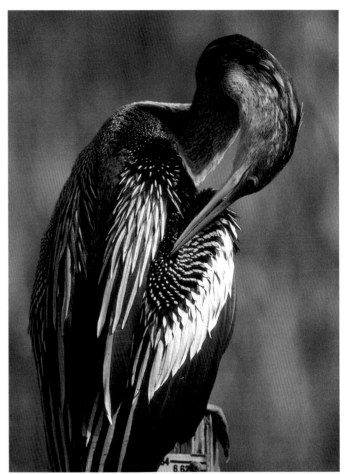

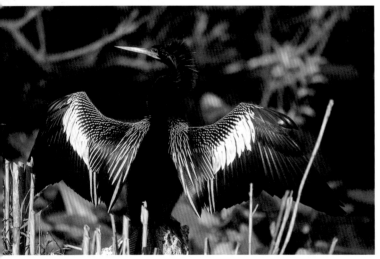

Male

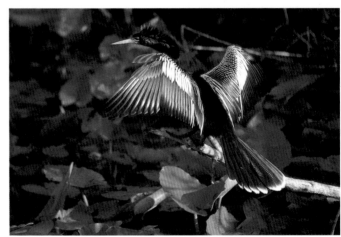

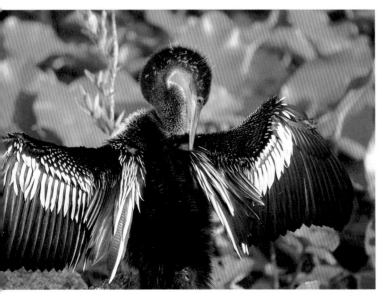

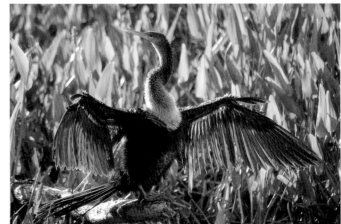

Bald Eagle

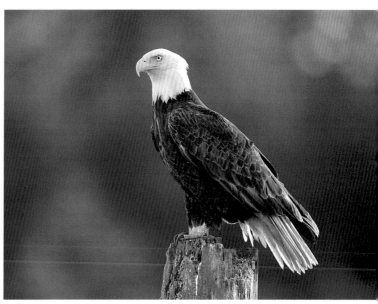

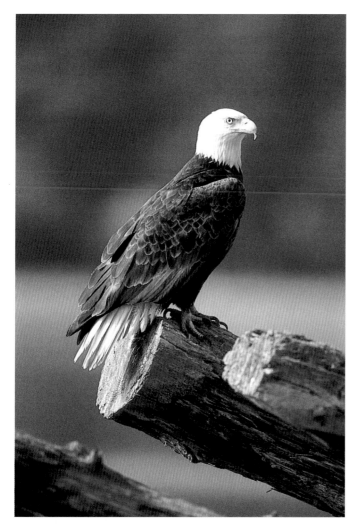

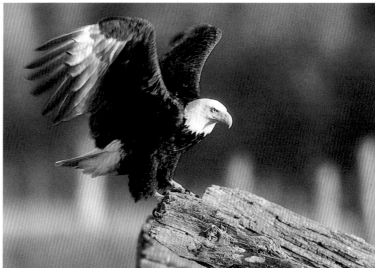

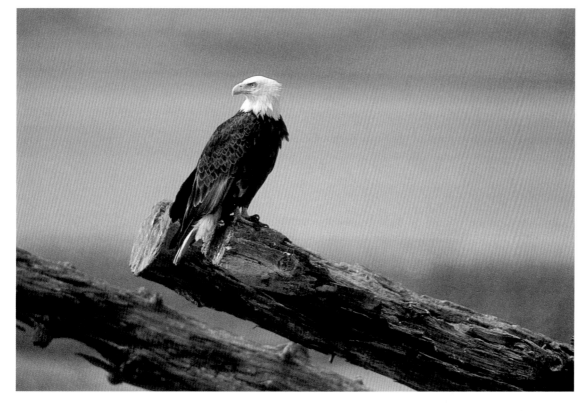

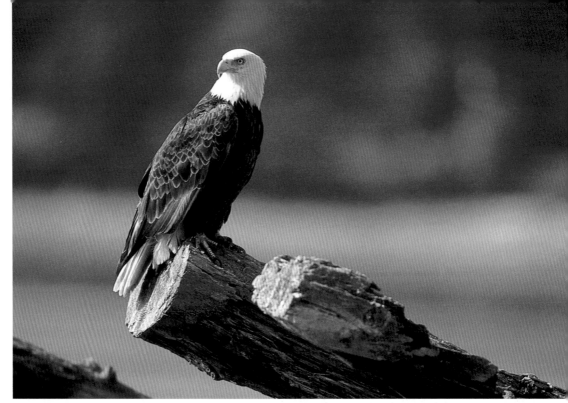

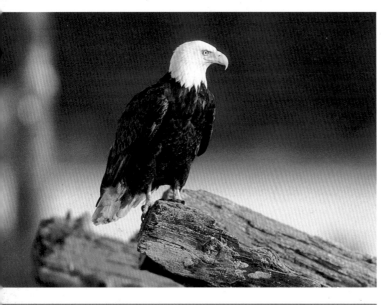

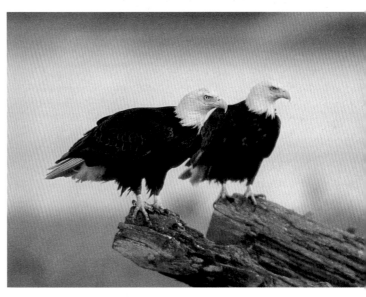

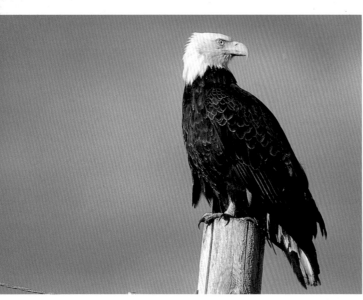

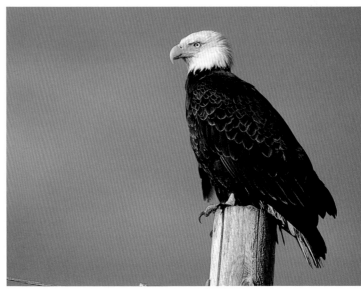

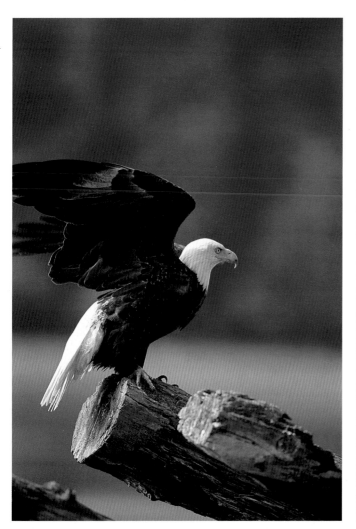
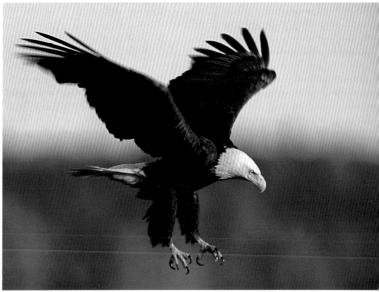
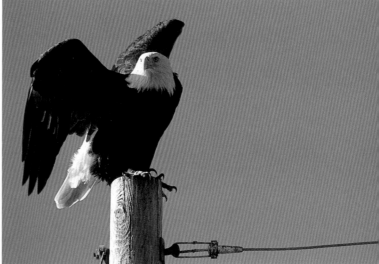
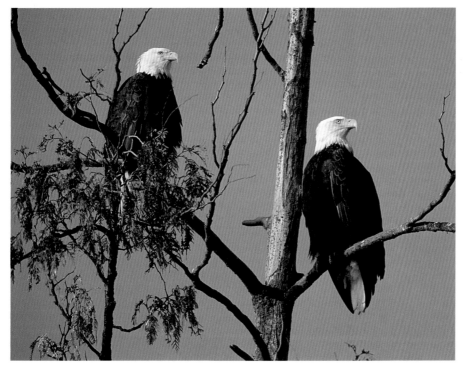
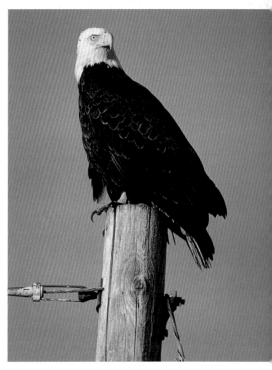

Black-Crowned Night-Heron

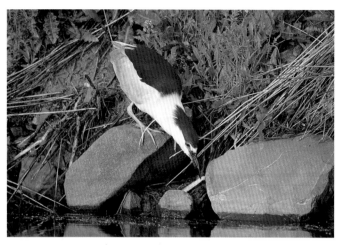

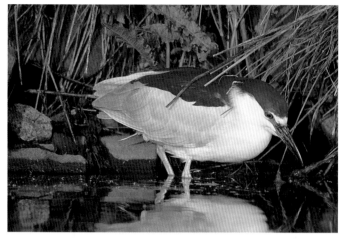

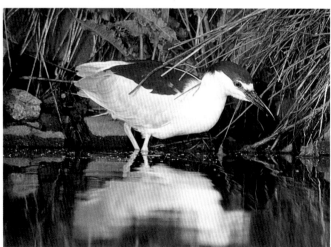

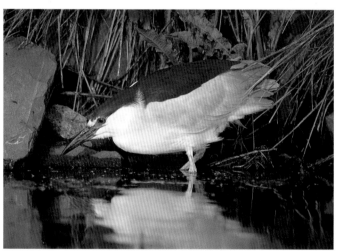

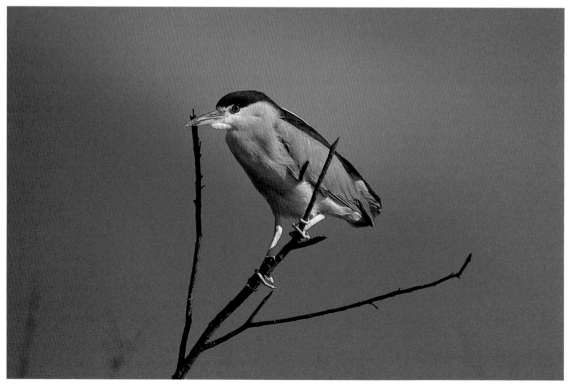

Brown Pelican

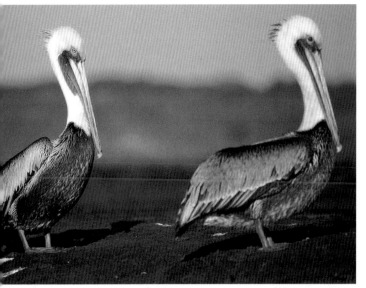

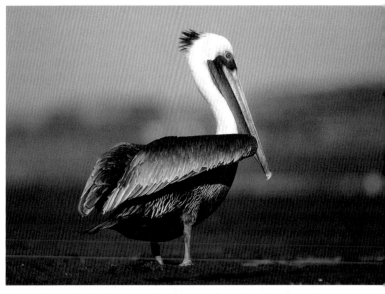

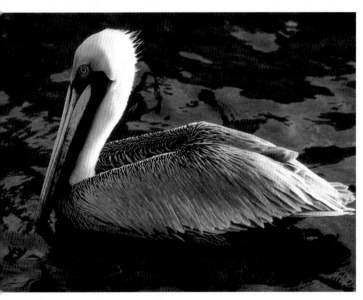

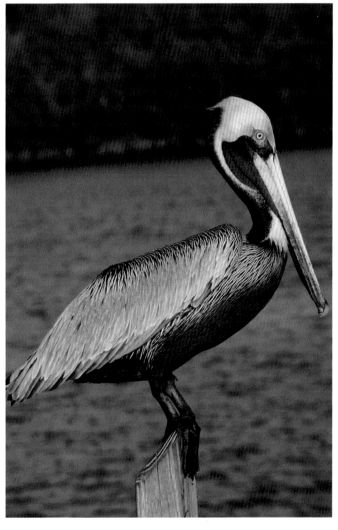

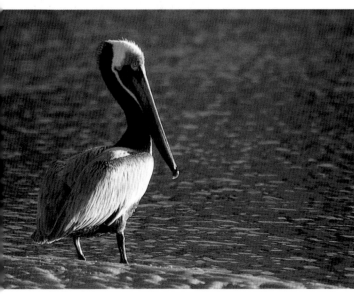

Common Tern

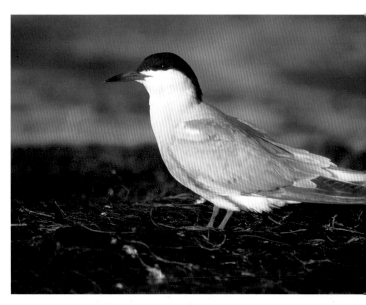

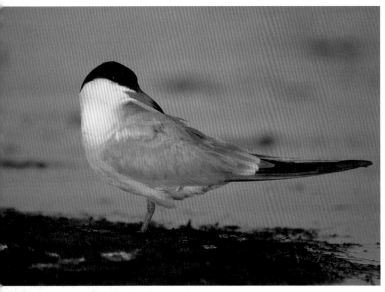

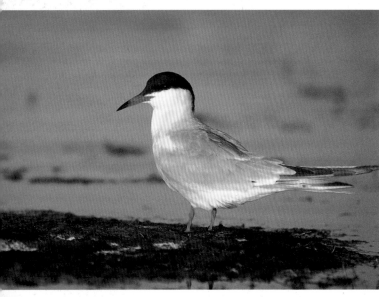

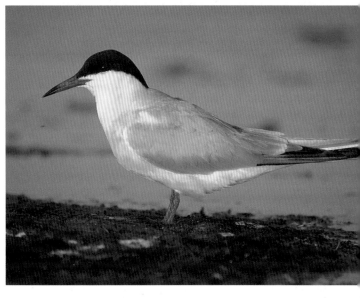

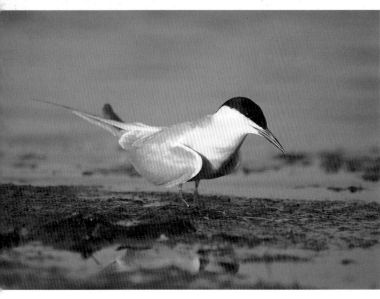

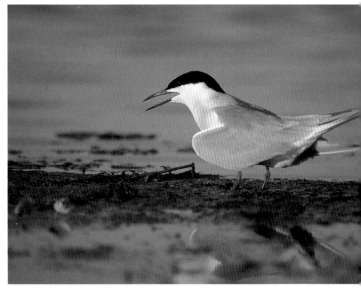

Gambel's Quail

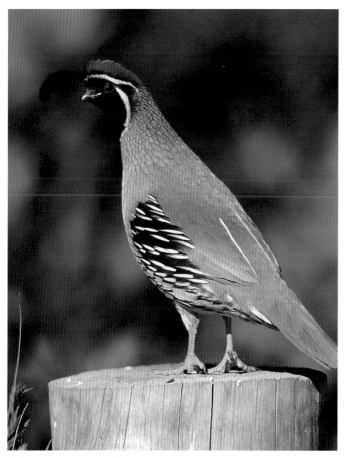

Male

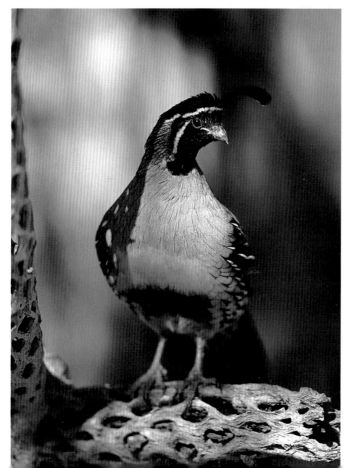

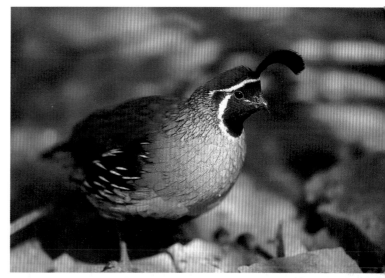

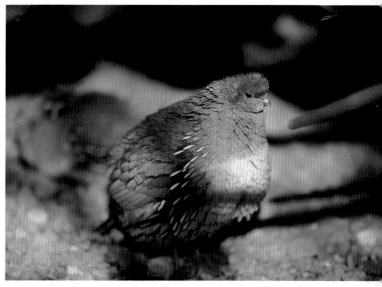

Female

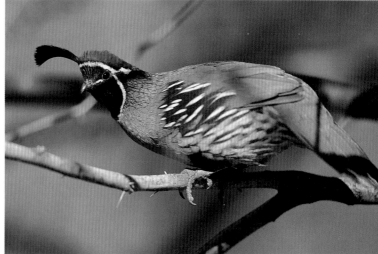

Gila Woodpecker

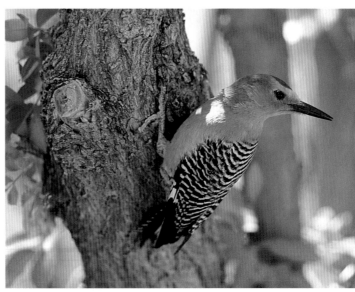

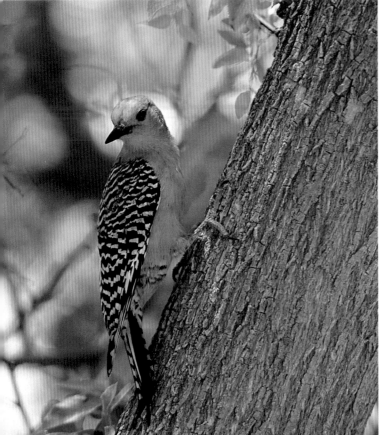

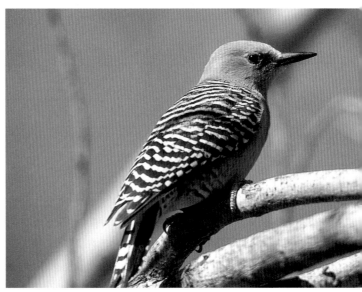

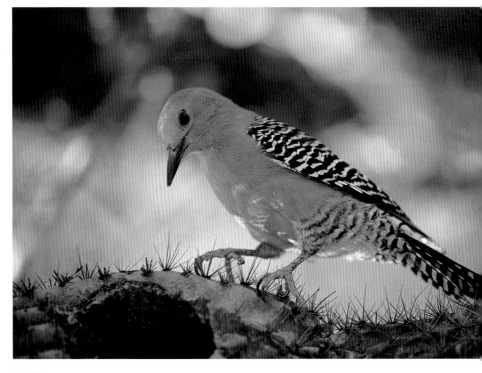

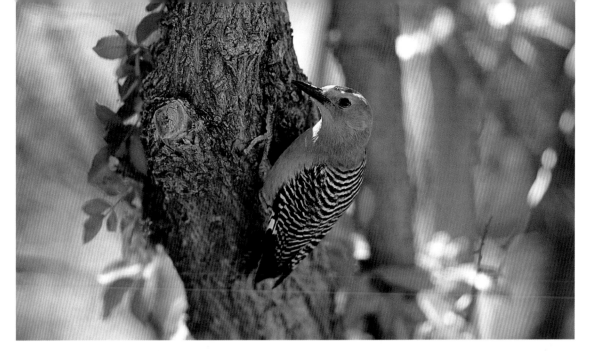

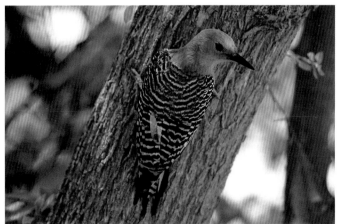

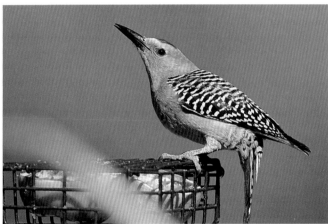

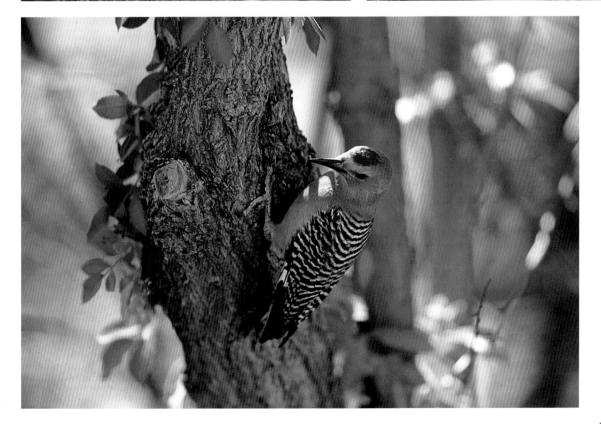

Heermann's Gull

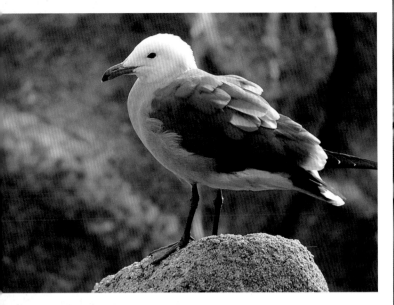

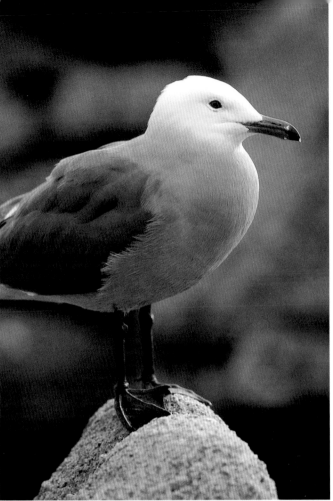

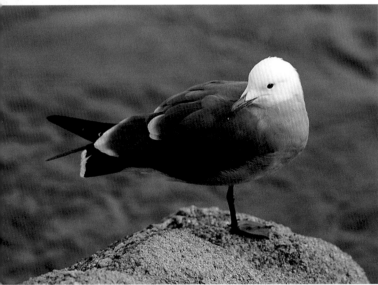

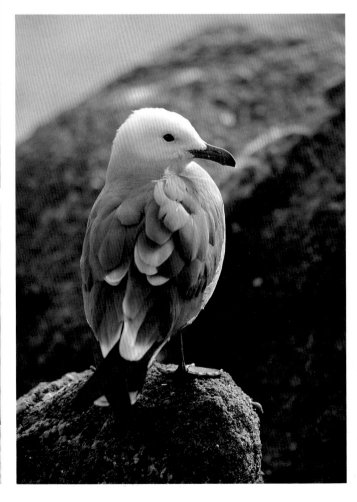

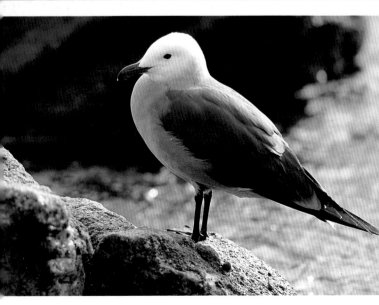

Killdeer

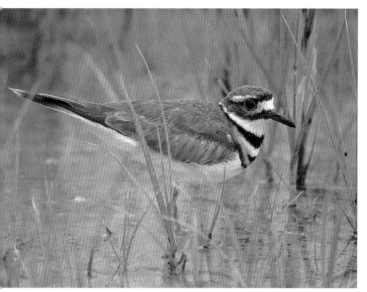

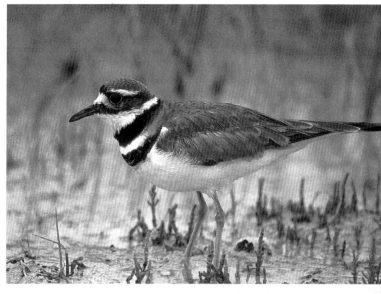

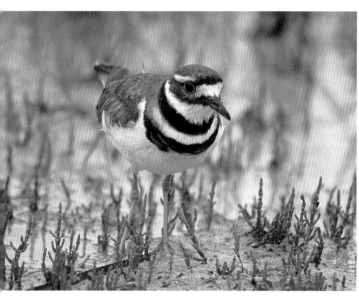

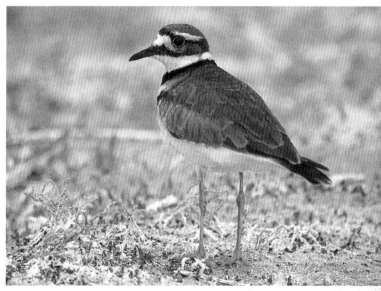

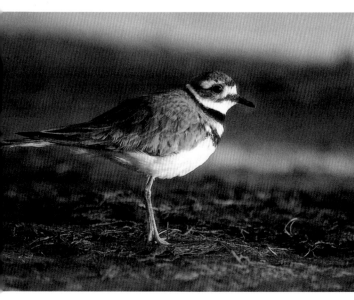

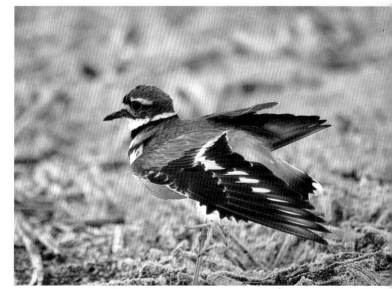

Northern Flicker

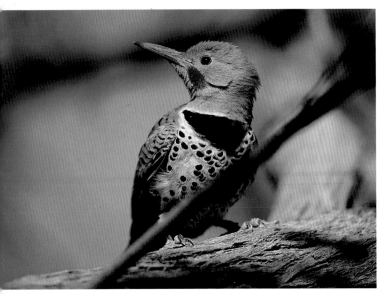

Male

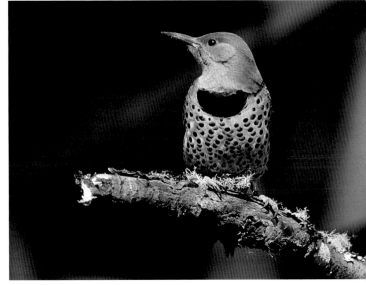

Female

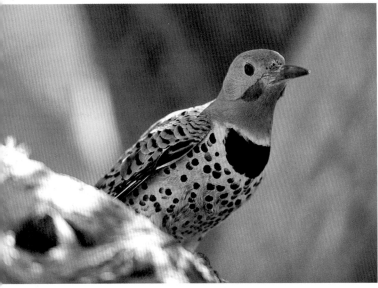

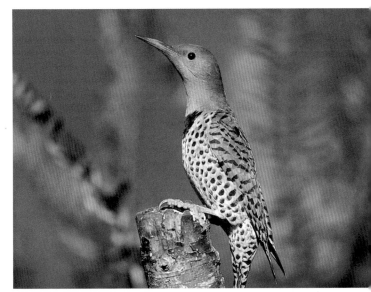

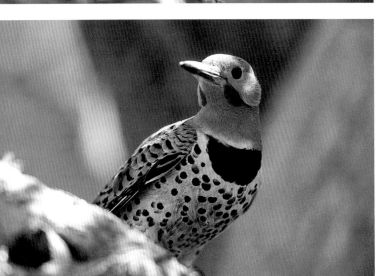

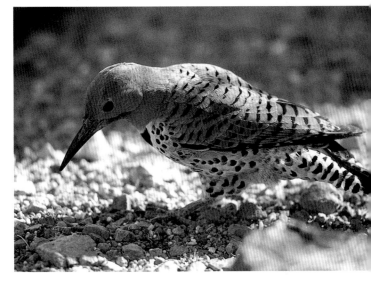

Osprey

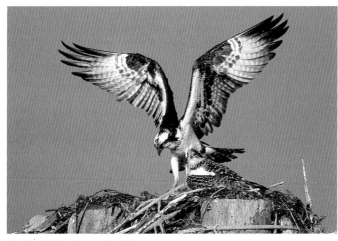

Female (with wings up) with young

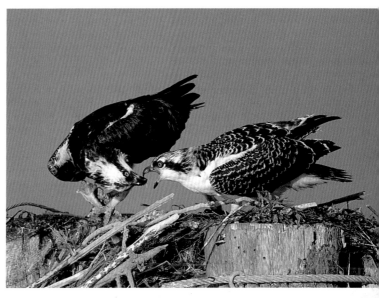

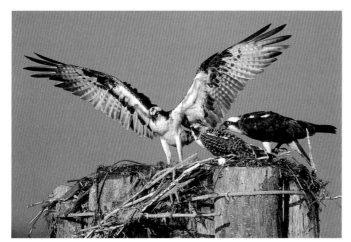

Male (with wings up)

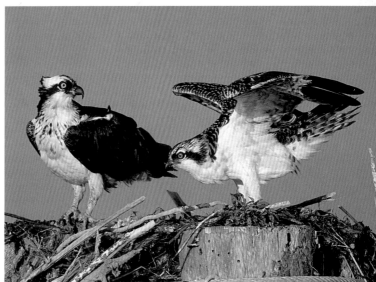

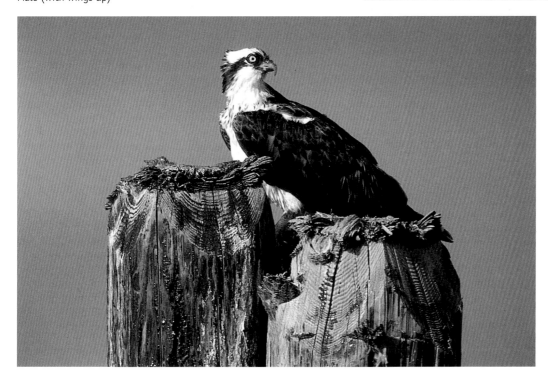

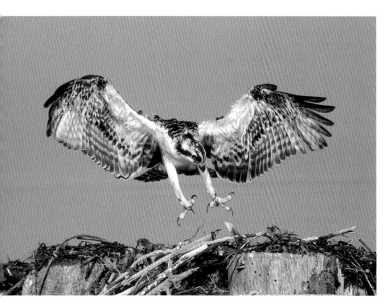

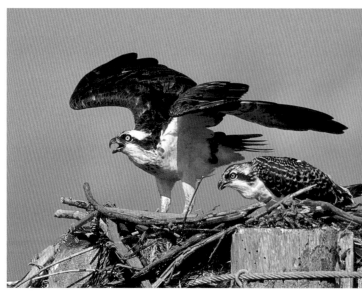

Immature Osprey

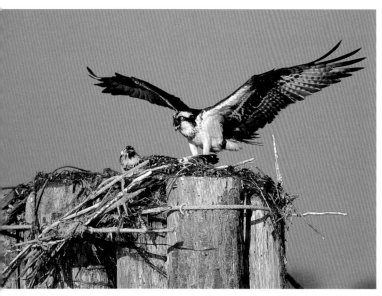

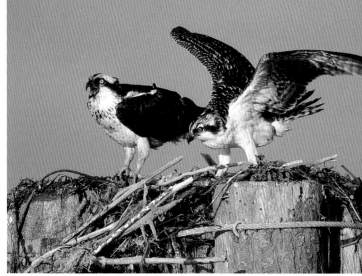

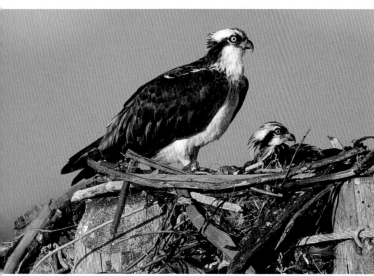

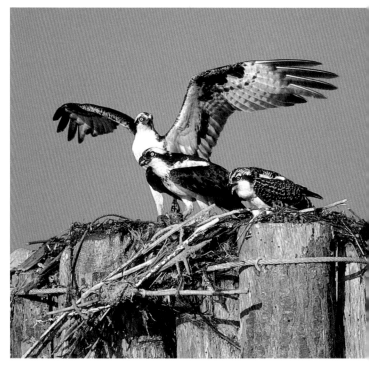

Ospreys in Acrylic

by Bart Rulon

Materials

Surface
24" x 36" (61cm x 91cm) hardboard panel primed with gesso

Palette
Golden Acrylics — Burnt Sienna, Burnt Umber, C.P. Cadmium Yellow Light, Mars Black, Raw Sienna, Raw Umber, Titanium White, Ultramarine Blue

Liquitex Acrylics — Naphthol Red Light

Brushes
filbert nos. 8 and 20, flat no. 12, round nos. 00, 1, 3 and 5

Other
Water used as a painting medium with each painting mixture

Empty film canister

This painting demonstrates how to combine several photos to make an interesting painting that tells a story. I took the reference photos of the ospreys and their nest a few miles from my home. A friend and I paddled a canoe out to an island where we could get close enough to photograph the nesting activities of the ospreys over the period of several weeks. I purposefully picked out photos with light coming from the same direction and time of day for consistent lighting and shadows. The idea of the painting is to show the adult female osprey on the nest with the young birds as the adult male returns from a hunt.

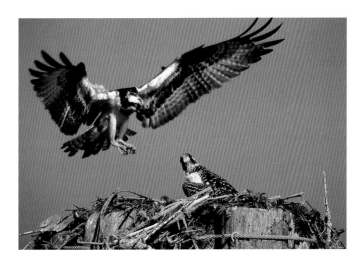

Reference for the pose of the osprey in flight

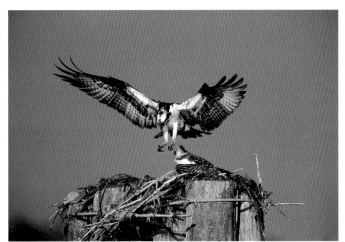

Reference for the lighting and details of the osprey in flight

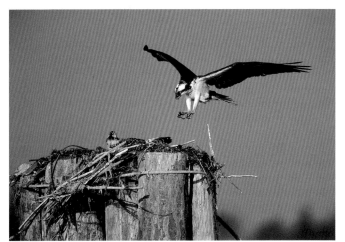

Reference for the nest, pilings and immature bird on the nest

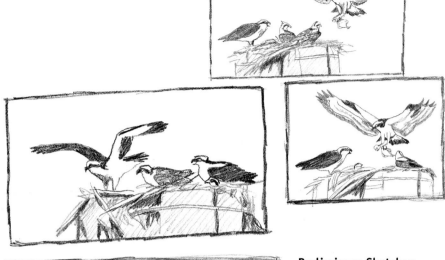

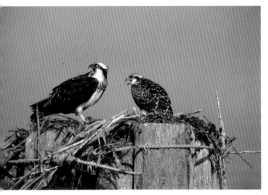

Reference for immature osprey on the nest

Preliminary Sketches
Test different compositions with thumbnail sketches.

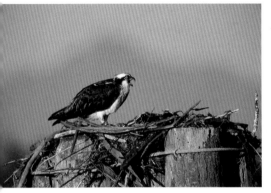

Reference for adult female osprey on the nest

Reference for the clouds

1. Create the Drawing
Work out the anatomy of the birds on scrap paper to make sure they look correct before you transfer them to the board. Be sure to tilt the young bird's head up so that he is looking directly at the male osprey in the air.

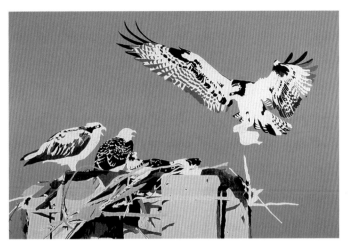

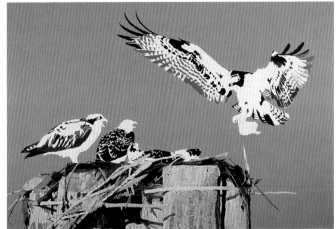

2. Block In

Start by blocking in the color of the sky with a mixture of
Ultramarine Blue, Titanium White and a touch of C. P.
Cadmium Yellow Light. Use the no. 20 filbert and no. 12 flat for
the open areas and the no. 8 filbert and no. 5 round as you get
close to the edges of the birds and nest. Make enough sky mix-
ture to save for later in the painting. Store the excess paint in
an empty film canister with a few drops of water. For the dark-
est feather colors on the ospreys, mix Mars Black with Raw
Umber and paint them with the no. 8 filbert and the no. 5
round. Use the same brushes and dark mixture to block in the
shadows in the nest and on the pilings. Block in some of the
brown colors in the osprey on the left side with mixes of Burnt
Sienna, Burnt Umber, Raw Sienna and Ultramarine Blue. Use
this mix with more Ultramarine Blue and some Titanium
White added to block in the patterns on the wing feathers of
the flying bird with the no. 5 round. Block in a variety of mixes
on the nest material, paying attention to the photo and shoot-
ing for the average color for each branch or area. Use the no. 8
filbert and the no. 5 round. Block in the color on the pilings
with a mix of Raw Sienna and Titanium White.

3. Use Dark and Light Colors for the Nest

In the previous step, you blocked in the average colors. In this
step, you will paint darker and lighter colors on the nest and
pilings. Work back and forth between dark and light for each
area. There are too many different colors in the nest material
to mention them all here, but each mixture includes Raw
Sienna, which helps warm up the colors to indicate late after-
noon sun. Paint the bark on the pilings with a mix of Raw
Sienna, Ultramarine Blue, C. P. Cadmium Yellow Light and
Titanium White for the greenish areas, and Raw Sienna, Burnt
Sienna and Titanium White for the brownish areas. Use a vari-
ety of brushes, ranging from the no. 8 filbert down to the no. 1
round, to paint the details on the nest sticks. The bluish shad-
ows cast by the nest on the pilings take a mix of Ultramarine
Blue, Naphthol Red Light, Mars Black, Raw Umber and
Titanium White.

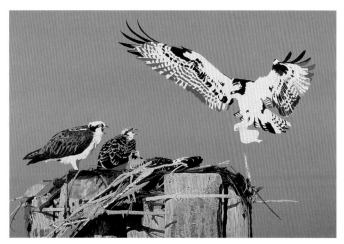

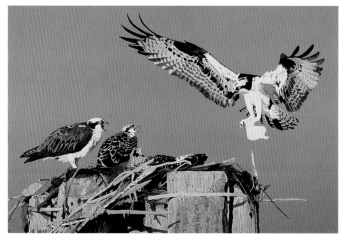

4. Paint the Birds on the Nest

Begin with the adult female osprey on the left side of the nest. Paint her eye with a mixture of C. P. Cadmium Yellow Light, Titanium White and a touch of Raw Sienna using the no. 1 round. Work from dark to light on the feathers of her back and wings with mixtures of Burnt Sienna, Raw Sienna, Raw Umber, Mars Black and Titanium White using the no. 5, no. 3 and no. 1 rounds. Use less Mars Black and Raw Umber, but more Titanium White and Raw Sienna for the lighter feather areas. Mix Ultramarine Blue, Naphthol Red Light, Raw Umber and Titanium White for the shadows on her belly. Use this same mixture with more Naphthol Red Light added to block in her beak.

The immature ospreys in the middle of the nest have different coloring than the adults. Paint the eye with the no. 1 round and a mix of Naphthol Red Light, C. P. Cadmium Yellow Light, Raw Sienna and Titanium White. For the feather edges on their backs, wings and the backs of their necks, paint a mixture of Raw Sienna and Titanium White using the no. 3, no. 1 and no. 00 rounds. Block in their beaks with the same mix used for the adult. Paint the feather details on the top of their heads with a mix of Mars Black and Raw Umber using the no. 00 round. Paint feather details over the darkest parts of their bodies with a slightly lighter mix of Raw Umber, Mars Black and Titanium White.

5. Show the Adult Osprey Landing

My reference photos of the osprey in flight are of the female, but I wanted the painting to show the male coming in to the nest. Male ospreys usually have little or no dark streaks on their chests, so don't paint the streaks you see in the reference photo. Paint the shadow areas on the bird's belly, tail and the white part of the wing with a mix of Ultramarine Blue, Naphthol Red Light, Raw Sienna and Titanium White using the no. 3 and no. 1 rounds. Paint the warm color on the long wing feathers with a mix of Raw Sienna and Titanium White using the no. 5 and no. 3 rounds. Then work in some of the darker feather details in the same feathers by adding Raw Umber, Ultramarine Blue and more Raw Sienna to the mix. Fill in more of the dark pattern on these wing feathers with various colors of brown. Start to warm up the color on the belly of the bird with thin glazes of Raw Sienna mixed with Titanium White. Paint the eye with the no. 1 round and a mix of C. P. Cadmium Yellow Light, Titanium White and a touch of Raw Sienna.

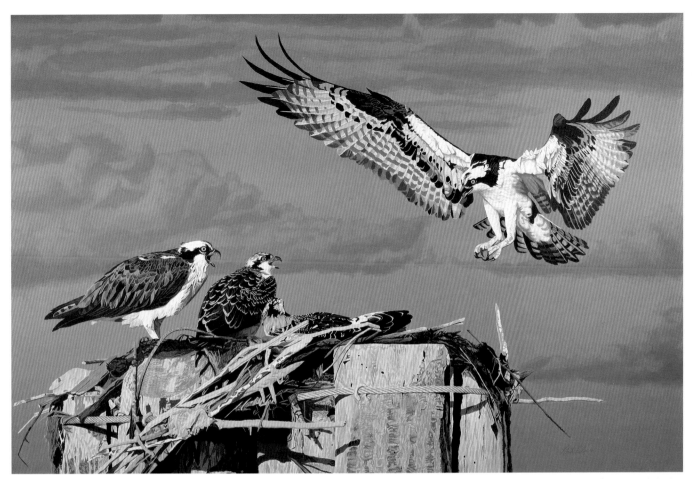

6. Add Clouds and Refine the Details

The sky needs some clouds for interest, and I decided to paint out the fish in the osprey's talons with the sky mixture that was saved back in step 1. Paint over the fish first, then add a little Ultramarine Blue and Naphthol Red Light to the sky mixture. Use this new mix to block in the clouds with the no. 20 filbert and no. 12 flat. Refer to the cloud reference photo to make a pleasing combination of clouds. Add more Naphthol Red Light and Titanium White to the cloud mix to give the clouds form and some light from the sun. Make this lighter mixture subtle, and paint it thinly with the no. 12 flat and no. 8 filbert to keep the clouds soft.

Finish the bird in flight by adding and refining all of the wing patterns and markings, working from dark to light and vice versa where necessary. Pay attention to how the patterns interlock with each other from one feather to the next. Warm up the color on his white belly and the white areas on his wing with the no. 3 round and more thin layers of Raw Sienna mixed with Titanium White. This helps indicate the warmth of the late afternoon sun. Paint more of the subtle shadows on the white underparts with the no. 3 and no. 1 rounds and a mixture of Ultramarine Blue, Naphthol Red Light, Raw Sienna and Titanium White. Add more white for the subtlest shadows. Be sure to stand back often in this step to see if the colors and

values work in the picture as a whole. Start the lower legs with a mix of Raw Sienna and Titanium White using the no. 5 round, then add Raw Umber, Ultramarine Blue and Naphthol Red Light to the mix to paint the shadows using the no. 3 round.

Refine the warm feather edges on the backs and wings of the immature birds in the nest by varying their values relative to the sun using the no. 00 round. Clean up these feather edges against the dark parts of the feathers by carefully referring back to the reference photo. Finish the beaks on all the birds in the painting with mixtures that are darker than the base color, using Ultramarine Blue, Naphthol Red Light, Raw Umber, Mars Black and Titanium White and the no.1 round. Warm up all white parts of the birds on the nest with mixes of Raw Sienna and Titanium White using the no. 3 and no. 1 rounds. Paint this mixture with more Raw Sienna added on the right sides of the birds to help indicate the direction of the sun as indicated in the photos. Finally, paint pure Titanium White highlights in all the ospreys' eyes using the no. 00 round. Be sure to make the direction of the sun consistent in all the highlights.

RETURN TO THE NEST
Bart Rulon
acrylic on hardboard panel
24" x 36" (61cm x 91cm)
Private collection

Rough-Legged Hawk

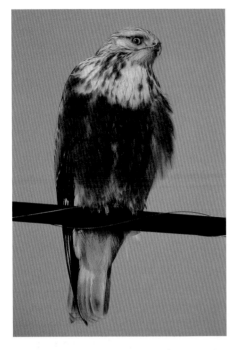 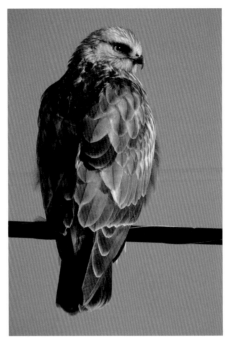 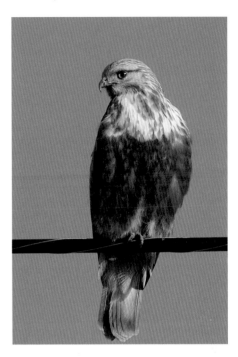

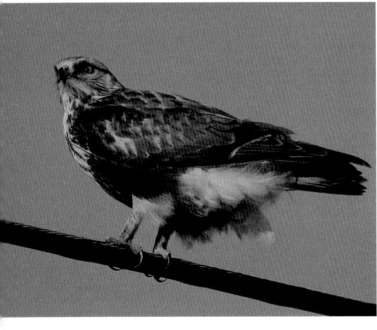

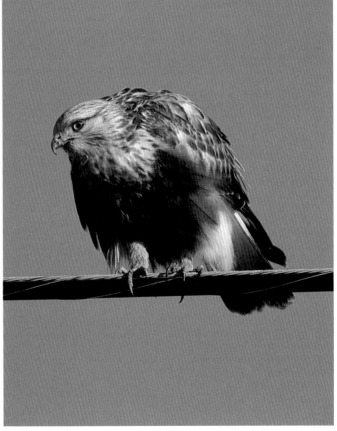

Female

Ruby-Throated Hummingbird

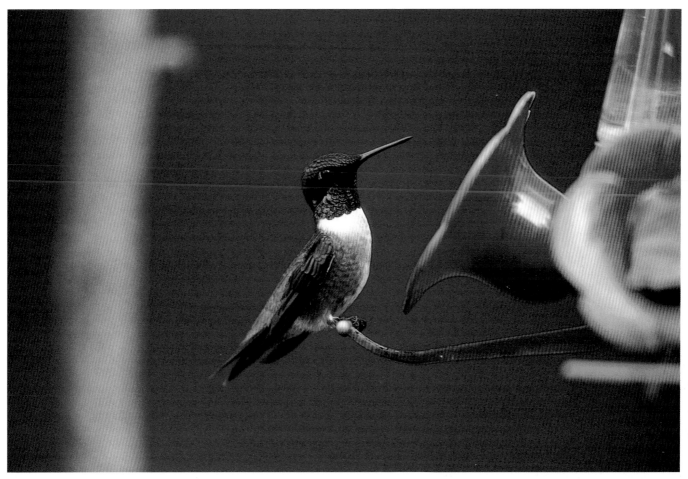

Male

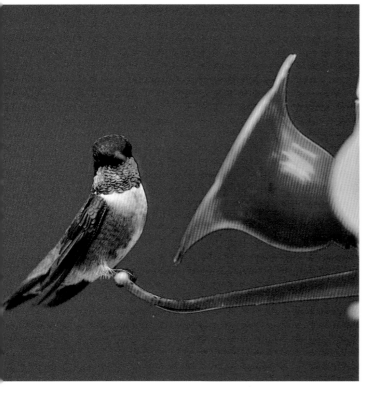

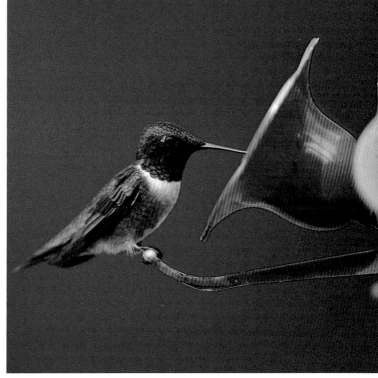

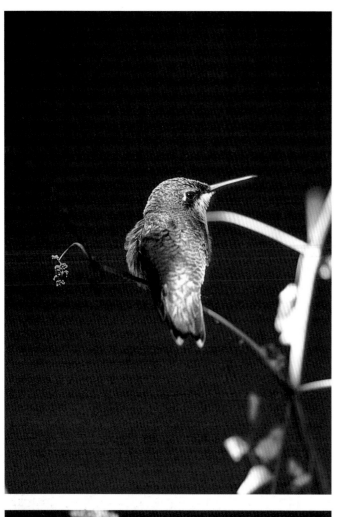

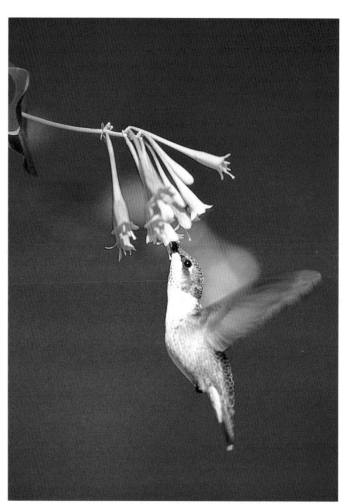

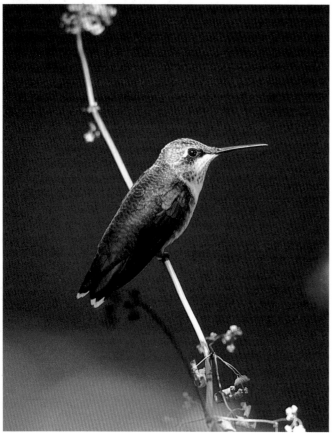

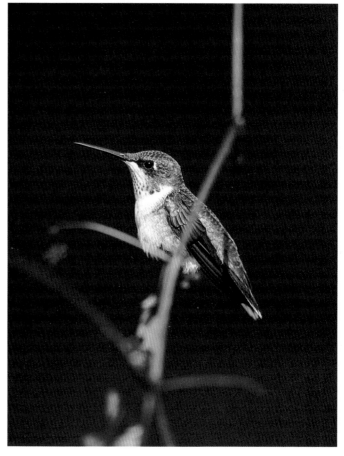

Female

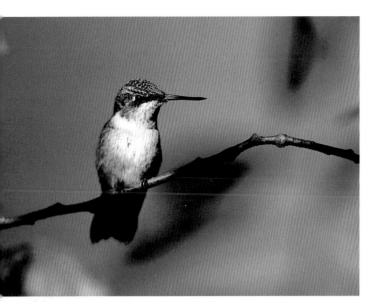

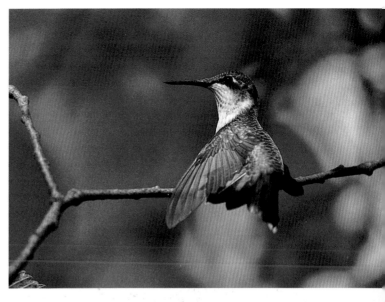

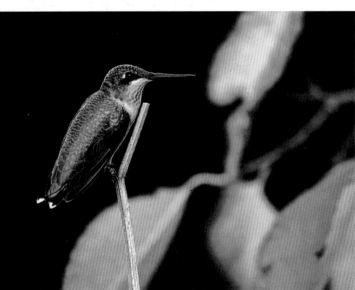

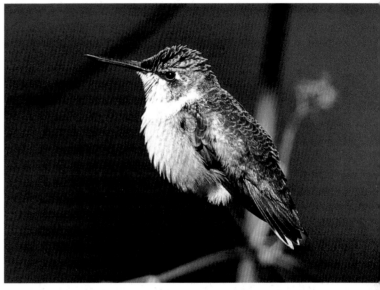

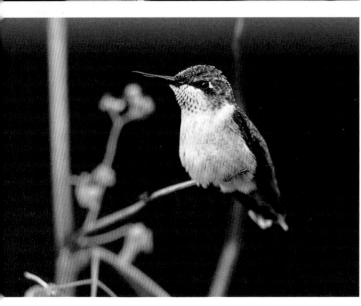

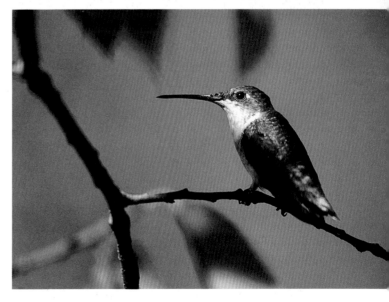

Ruffed Grouse

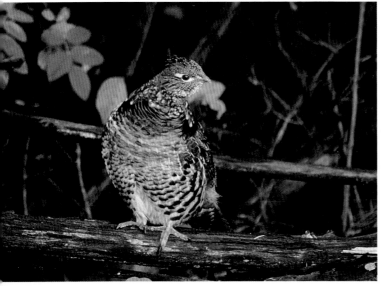

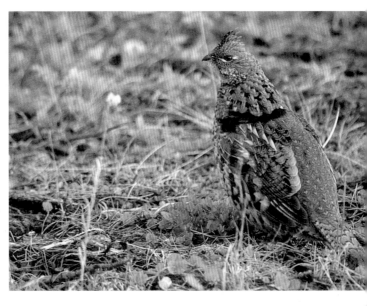

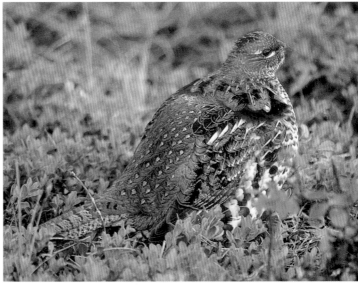

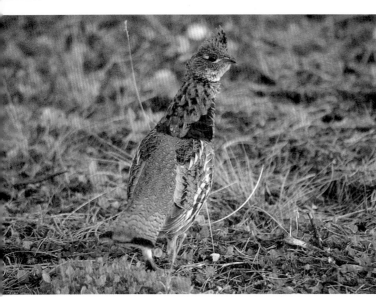

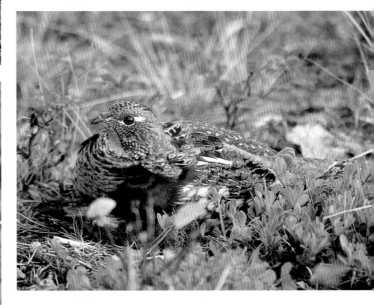

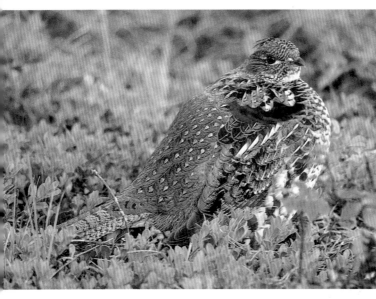

Trumpeter Swan

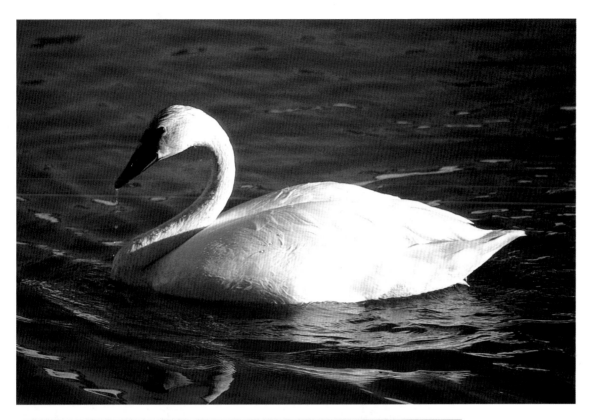

Adult

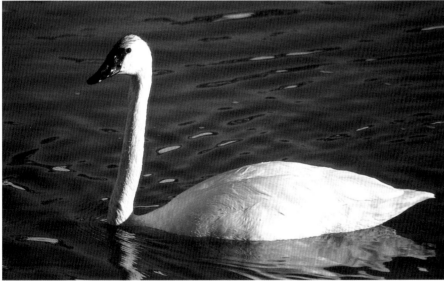

Immature Swan

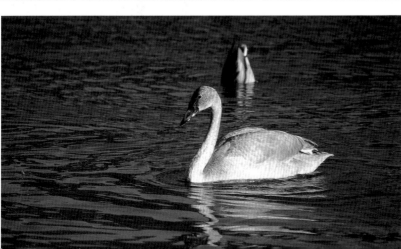

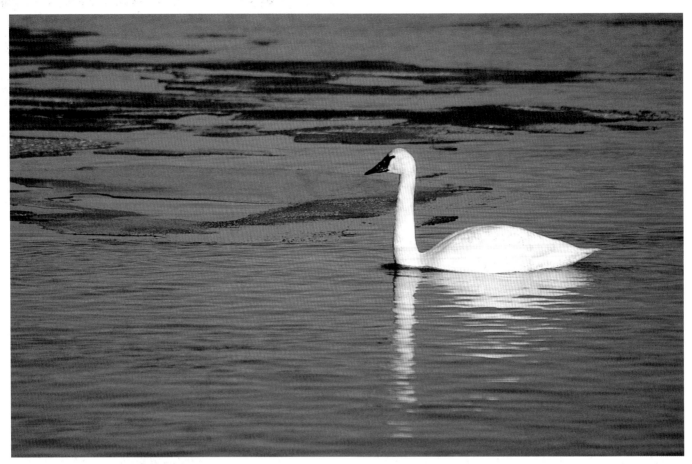

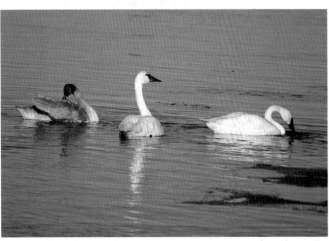

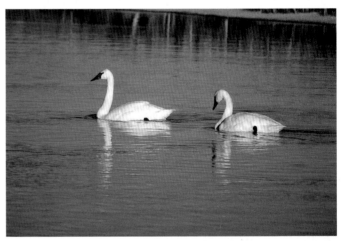

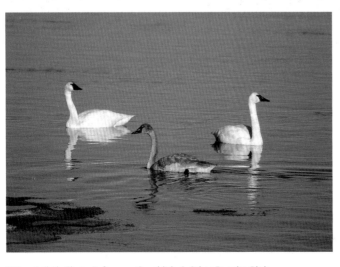

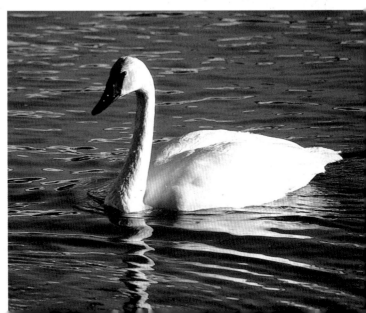

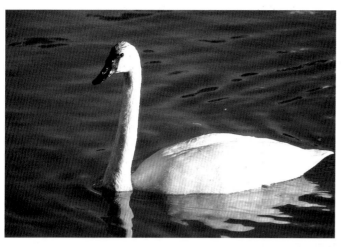

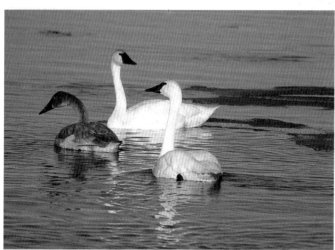

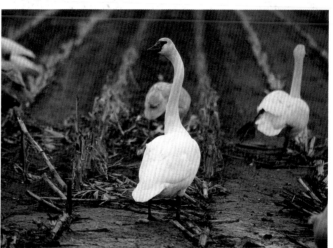

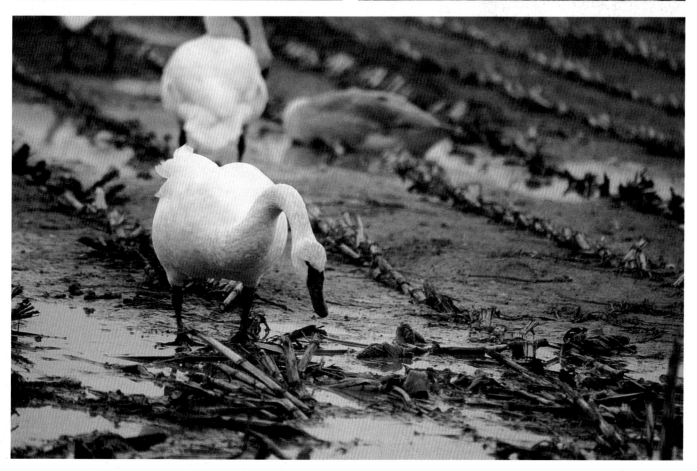

Tundra Swan

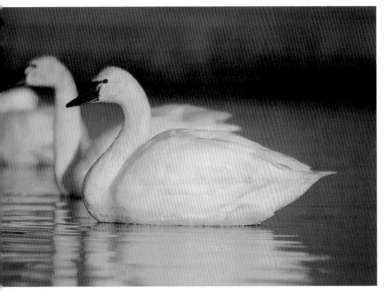

Adult

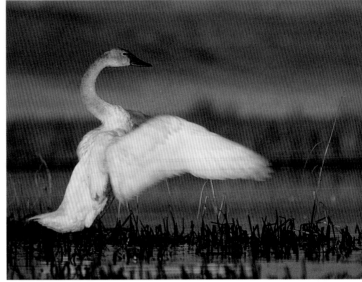

Immature Swan

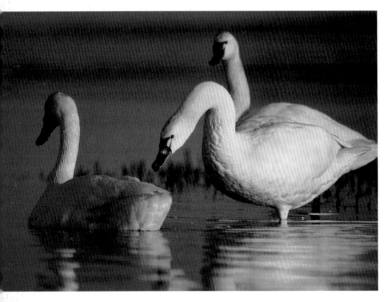

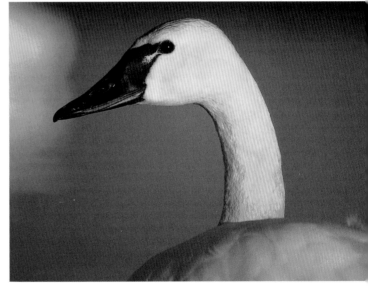

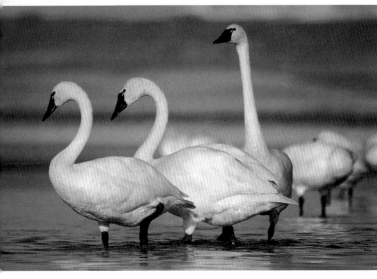

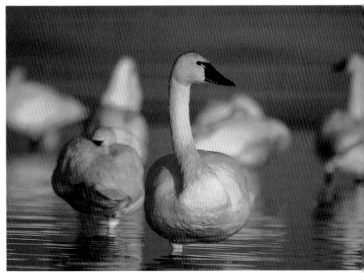

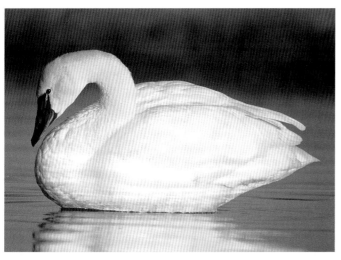

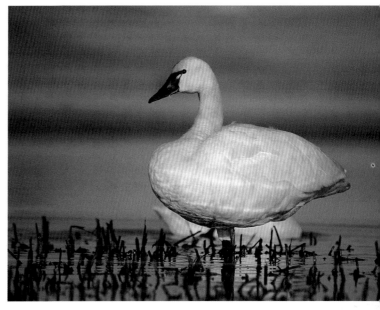

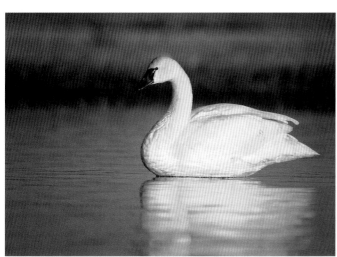

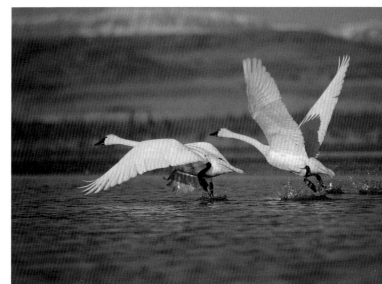

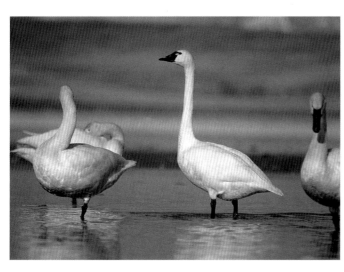

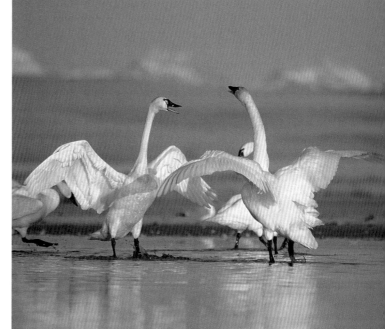

Tundra Swan in Watercolor

by Bart Rulon

Materials

Surface

Arches 300-lb. (640 gsm) cold-pressed paper, 12" x 11" (30cm x 28cm)

Hardboard panel support

Palette

Winsor & Newton Watercolors —
Burnt Sienna, Burnt Umber, Cadmium Orange, Cadmium Red, Cobalt Blue, French Ultramarine, Lemon Yellow, Neutral Tint, Permanent Alizarin Crimson, Raw Sienna, Yellow Ochre

Brushes

round nos. 1, 3, 5, 8, 12 and 14

Other

Incredible White Mask (masking agent) and The Incredible Nib

Two gallon water bucket (for rinsing brushes in between using different colors)

Masking tape

Pencil

This painting demonstrates that sometimes, with very good photos, you don't have to change too much in your photo to make a good painting. I photographed this tundra swan on a lake in Montana from inside a floating blind that I designed for photographing water birds up close. Most waterfowl species are very wary of humans, but with my blind I was able to approach within photo range without disturbing these swans. To make a good painting out of this photo, all you really need to do is clean up the background and make a few other minor changes.

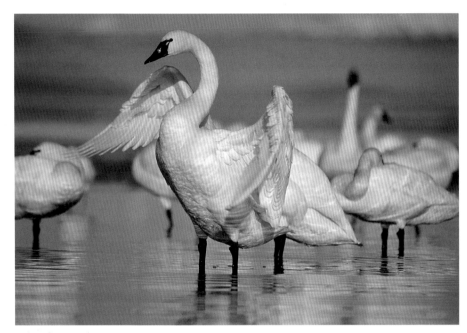

Main reference photo

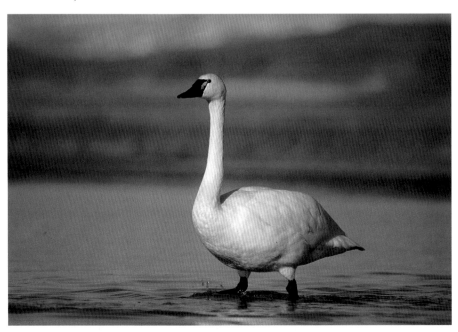

Background reference photo

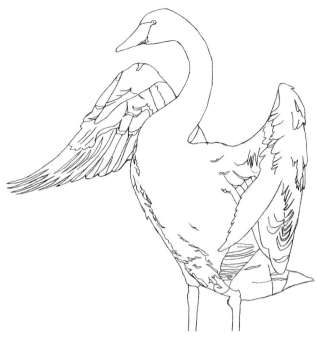

1. Prepare the Drawing

Always work out the details of your drawing on scrap paper first. Transfer it to watercolor paper after you're satisfied with it. Tape the edges of the watercolor paper to the hardboard panel for support.

2. Apply Masking Agent

Use masking tape to mask the majority of the swan, then apply masking agent around the edges of the bird for accuracy.

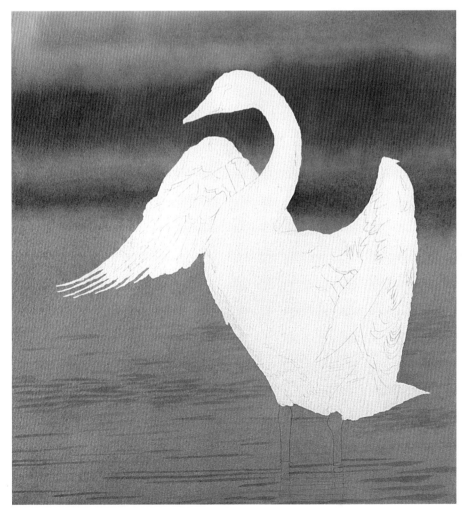

3. Paint the Background

Pre-mix several colors of paint on your palette. Mix French Ultramarine, Cobalt Blue and Permanent Alizarin Crimson for the water. Mix French Ultramarine, Permanent Alizarin Crimson and Burnt Umber for the distant shoreline and the clouds. Mix Burnt Sienna, Raw Sienna, Cadmium Orange and Yellow Ochre for the grasses in the background. Load the no. 14 round with clean water and coat the entire painting. While the paper is still wet, paint in all the mixtures listed above in their respective spots with the no. 12 and no. 8 rounds. Let the mixtures just barely bleed into each other wet-into-wet. You may have to do this several times before you get the colors to their full richness. After the paint is dry, add ripples in the foreground water with the no. 3 round and a mixture of French Ultramarine and Permanent Alizarin Crimson.

4. Start the Swan

After the background looks finished, you can remove all of the masking agent and masking tape. Start on the beak by painting the yellow next to the eye with pure Lemon Yellow and the red with Cadmium Red, using the no. 3 round for both. Paint the warm glow on the belly of the swan with Raw Sienna and the no. 5 round. Pay special attention to the reference photo to know what kind of strokes to use to indicate the feathers and the roundness of the swan. For the shadow areas that help define the feathers, paint a mix of French Ultramarine and Permanent Alizarin Crimson using the no. 3 and no. 1 rounds. For the shadows that have a slightly warmer cast, add more Permanent Alizarin Crimson and some Burnt Sienna to the mix.

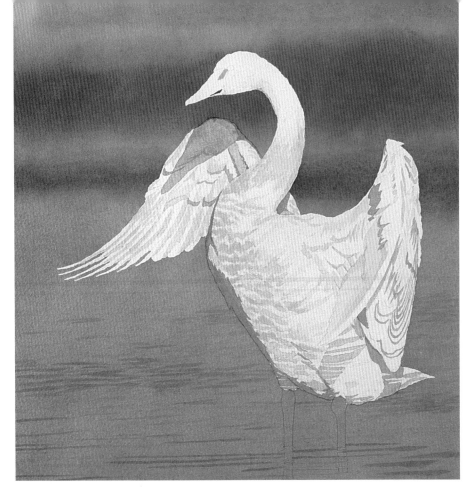

5. Refine the Swan

Paint in the beak and legs of the swan with a mix of Neutral Tint and Burnt Umber using the no. 3 and no. 1 rounds. Make a thicker version of that same mixture to paint the darkest parts of the beak and legs. Continue to darken the shadows and the warm glow on the swan with the same mixtures used in the last step. Some of the shadows are very subtle, so you must approach them carefully.

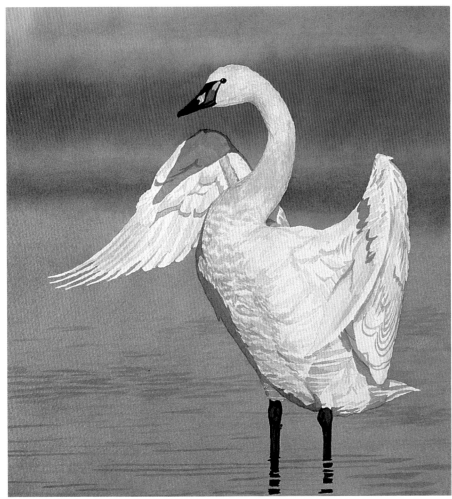

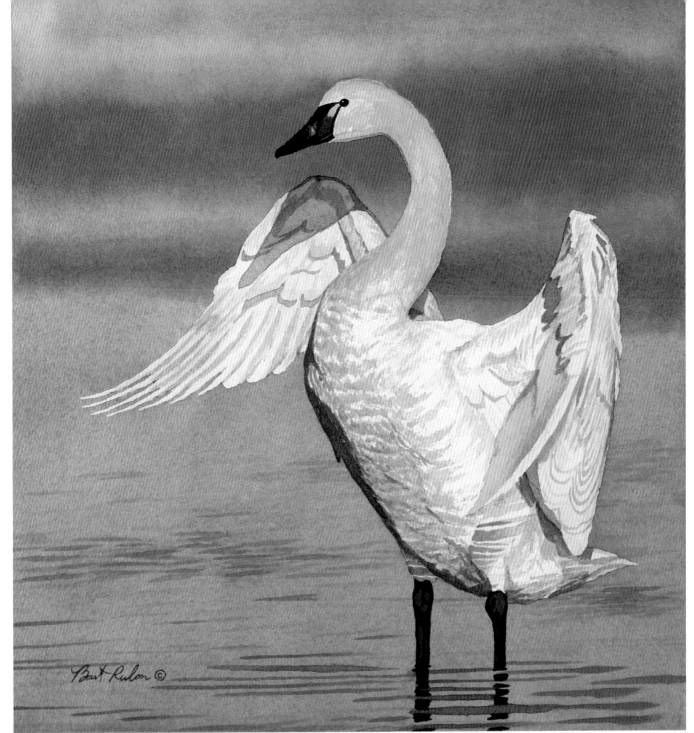

6. Add the Finishing Touches

Continue the refinements on the swan started in the last step until it takes on a realistic look when you view it from a couple of steps back. Redefine the subtle ripples in the water using the no. 3 and no. 1 rounds and a mixture of French Ultramarine and Permanent Alizarin Crimson.

TUNDRA SWAN
Bart Rulon
Watercolor on cold-pressed paper
12" x 11" (30cm x 28cm)
Private collection

White Pelican

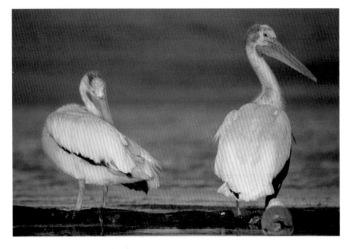

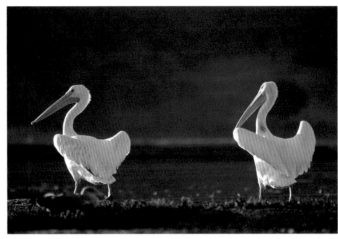

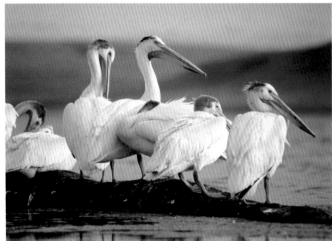

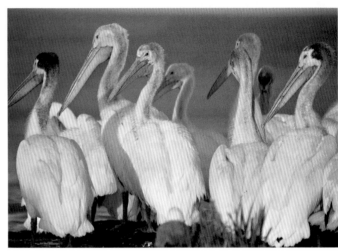

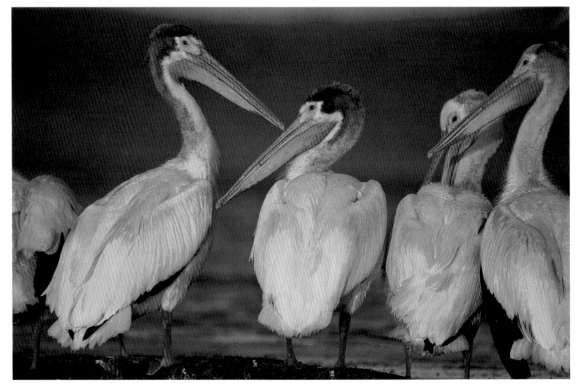

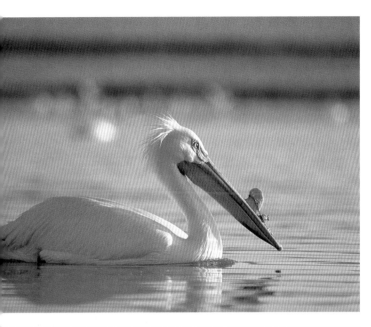

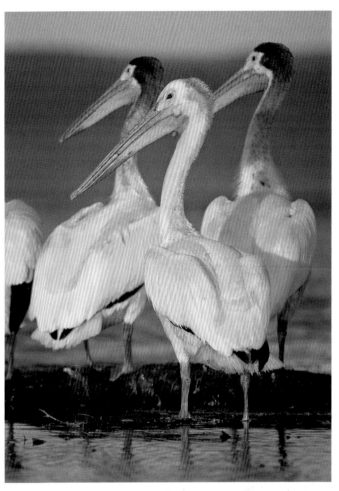

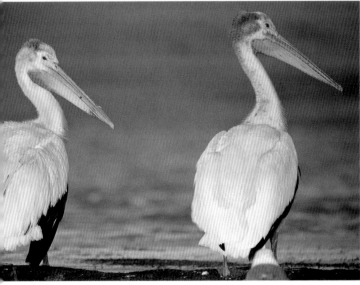

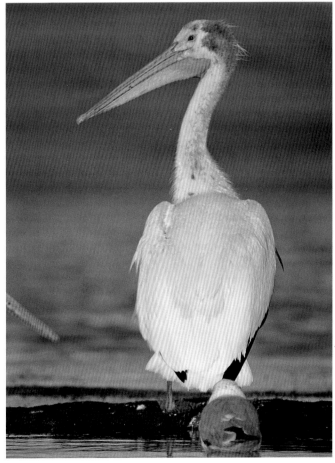

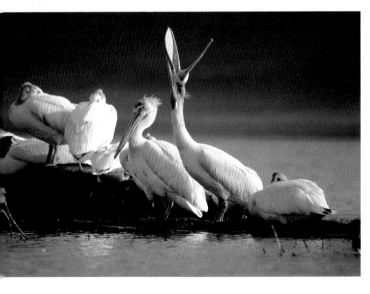

White Pelican

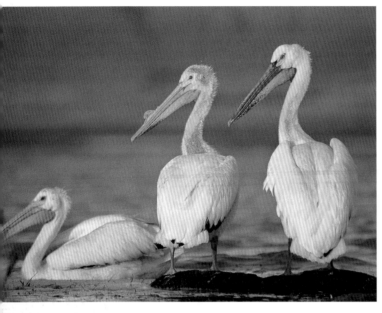

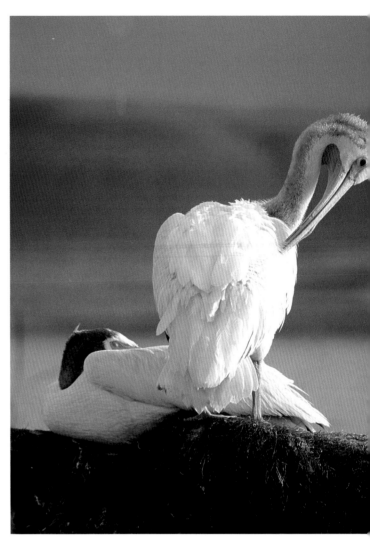

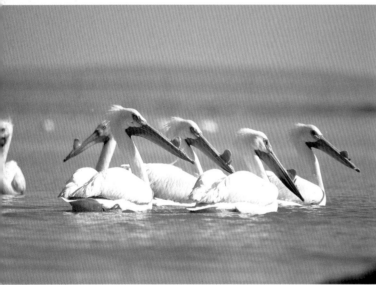

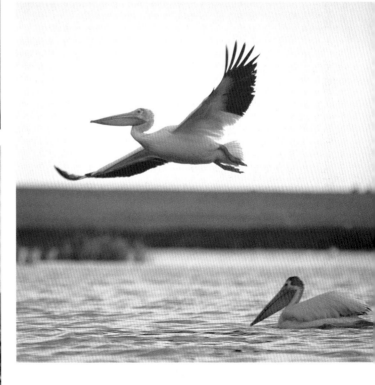

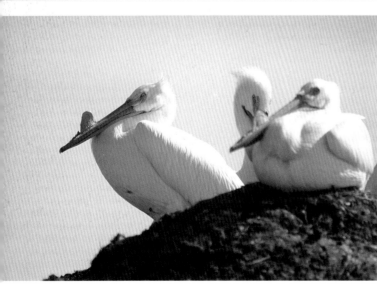

Wilson's Phalarope

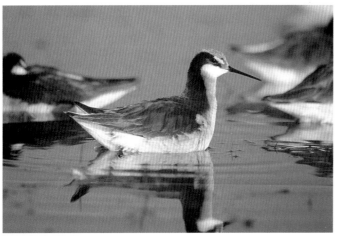

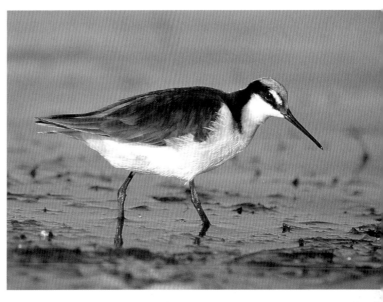

Female

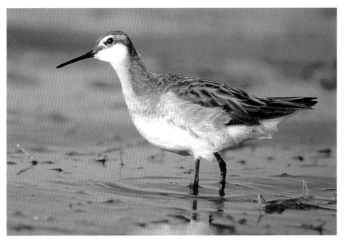

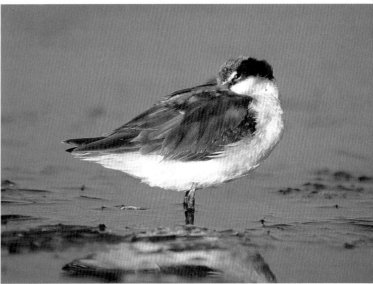

Male

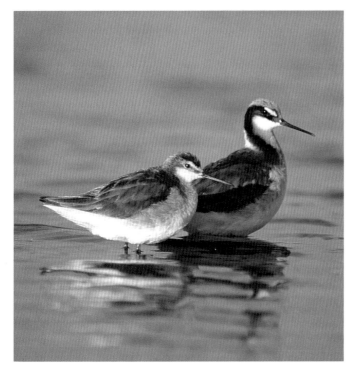

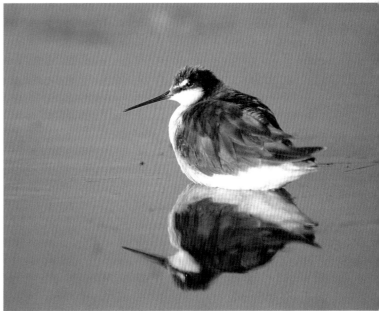

Contributors

Mark Boyle

Mark Boyle's work is held in many permanent art collections including Yellowstone National Park, Leigh Yawkey Woodson Art Museum, Bennington Center for the Arts, Evergreen Hospital, West Coast Paper Company and the Ella Carothers Dunnegan Gallery. Mark has won national awards and appeared in many juried exhibitions, including National Park Association's Arts for the Parks, National Museum of Wildlife Art's Western Visions Miniature Show, Leigh Yawkey Woodson Art Museum's Birds in Art and Wildlife: The Artists View exhibitions. His work has been published in the books *The Best of Wildlife Art* (North Light Books, 1997) and *Artist's Photo Reference: Water & Skies* (North Light Books, 2002). His work has also been published in the magazines *Wildlife Art*, *National Wildlife*, *Gray's Sporting Journal* and *Southwest Art*. Mark has been a member of The Puget Sound Group of Northwest Painters, Northwest Pastel Society and Northwest Watercolor Society.

Sueellen Ross

Sueellen Ross combines her passion for making art with her love of animals to create works of strong design and subtle wit. A few years ago, she was known mainly for her work in original intaglio prints, but she has turned more and more to mixed media paintings. She uses a unique combination of India ink, watercolor and colored pencil.

Her work is often included in shows like Birds in Art at the Leigh Yawkey Woodson Art Museum and Arts for the Parks, and she had a one-woman show at Seattle's Frye Art Museum in 1986. She was the Region One Winner at the Arts for the Parks competition in 1991. Her North Light book, *Paint Radiant Realism in Watercolor, Ink and Colored Pencil*, was published in 1999. Her work can also be seen in the books *Wildlife Art* (Rockport Publishers, 1999), *Artist's Photo Reference: Wildlife* (North Light Books, 2003), *Painting Birds Step by Step* (North Light Books, 1996), and *The Best of Wildlife Art* and *Best of Wildlife Art 2* (North Light Books, 1997 and 1999). Articles about Sueellen's work have appeared in *The Artist's Magazine*, *Southwest Art* and *American Artist*. Her original paintings are represented by Howard/Mandville Gallery in Kirkland, Washington. Reproductions of her work are represented by The Hadley Companies, Bloomington, Minnesota. Her artwork is included in the permanent collection of the Leigh Yawkey Woodson Art Museum.

The best in fine art instruction and inspiration is from **North Light Books!**

Lee Hammond offers encouraging techniques and demonstrations for drawing lifelike birds. You'll find tips and reference photos for creating realistic beaks, wings, and feet with ease. Glorious color, realistic style, and clear, step-by-step instructions makes this the guide you've been looking for to help you draw your favorite birds with accuracy!

ISBN 1-58180-149-1, paperback, 80 pages, #31897-K

Dory Kanter's inspirational guidance is perfect for both beginning and experienced artists alike. *Art Escapes* gives readers a fun, easy-to-execute plan for building an "art habit." Inside, you'll find daily projects for drawing, watercolor, mixed media, collage and more. With *Art Escapes*, you'll experience heightened artistic skill and creativity, and find the time to make a little bit of art everyday.

ISBN 1-58180-307-9, hardcover w/concealed wire-o, 128 pages, #32243-K

This lively, liberating guide will have you shedding your tight painting approaches in favor of what is called "Quick Studies." Craig Nelson's proven method of painting focuses on the essence of the subject and the mastery of the medium, rather than the minute details that seem to mire some artists and prevent them from improving.

ISBN 1-58180-196-3, hardcover, 144 pages, #31969-K

This book is for every painter who has ever wasted hours searching through books and magazines for good reference photos only to find them out of focus, poorly lit or lacking important details. Artist Gary Greene has compiled over 500 gorgeous reference photos of landscapes, all taken with the special needs of the artist in mind. Six demonstrations by a variety of artists show you how to use these reference photos to create gorgeous landscape paintings!

ISBN 0-89134-998-7, hardcover, 144 pages, #31670-K

Find these and other great North Light titles from your local art & craft retailer, bookstore, online supplier or by calling 1-800-448-0915.